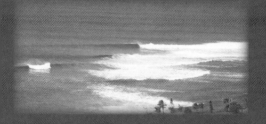

USA - HAWAII

A HEDONIST PRODUCTION

HOW TO USE WAVE-FINDER

How does Wave-Finder Work?
Wave-Finder uses mini **data-maps** and **icons** to help you quickly identify the best conditions for each break. The icons also indicate wave type and direction; see opposite.

What do I look at first?
You can find your desired break by looking at the area map for each section. Find out what area you are in by looking at the contents pages overleaf. All maps face north, and all areas work clock-wise around the country. Alternatively, just check the alphabetical **break index** at the back.

How do I get to the break?
Each spot has its own **data-map** showing the main streets and landmarks nearest the break. Text gives more precise directions if needed. All maps are North oriented unless indicated.

How do I read the break info?
Look for the **icon box** located in the corner (s) of the break map. This contains info on Wave direction, bottom type, best swell direction, best tide, and best wind direction. There will also be a wave locator in each map showing position and direction of the wave. There may be more than 1 break per map; in this case you'll see 2 or more icon boxes, each relating to the nearest locator. If you know the current wind direction (or other conditions), you can flick through the maps in your area, and scan the icons to find a spot that's right. Other info is in the text.

The Icon Box Tells All

Additional Info
Weather and ocean **info-charts** are at the beginning of each state or area, and background info about seasonal conditions, hazards etc. S**urf supplies directories** at the end of each major area help with your hardware needs. Now get out there, be merciful to man and nature, and go surf.

ICON EXPLANATION

Wave Locator
Shows wave pos
-ition & direction Left Right A-Frame R Point L Point

Wave Type - Wave icon shows direction, letter in center shows bottom type. See Below. C= cobblestone etc.

R	Right, R = Reef bottom	B	Right Left Beachbreak
S	Right, S = Sandbar/River	P	Left, P = Pointbreak

Swell Direction - Shows **best** swell direction. **Other swell directions may also work for this wave.**

	North swell is best	SE SW	SE-SW is best
NW	NW -W is best	SW	SW is best

Best Tide - Shows **Optimal** tide heights. **Can change subject to sand movement and swell direction. Other tides may work.**

◐	Low is best	●	High is best
◗	Mid is best	◑	Low - Mid is best

Best Wind - Shows wind direction for a **perfect** off-shore. Long curved beaches will show a range of directions.

→	Westerly (from West)	↓	North to Westerly
↗	Southwesterly	←	Easterly

Special Icons - You will find these at the top of certain spots. They indicate **exceptional** features about the break.

!	Handles huge swells	P	Protected from winds
∩	Swell Magnet	☆	World Class Wave

CONTENTS

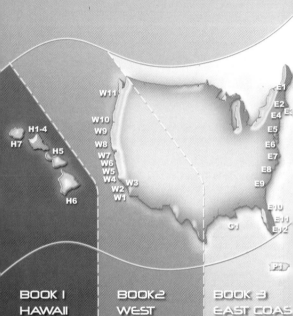

CONTENTS

CONTENTS

Book 3 - USA East & Gulf Coasts, Puerto Rico 232

Photographs from Wave-finder can be obtained via Bernie Baker. Bernie and his wife, Marie, live at Sunset Beach, O'ahu, where he keeps his film studio and files. He can be reached for photo usage sales and archival images at: sevenseas@hawaii.rr.com . Be patient for a reply, if he's not shooting, he's surfing and that could go for days.

THE WAVE-FINDER TEAM

Editorial

Larry Blair, Buzzy Kerbox, Jeremy Goring, Cheyne Horan, Bobby Owens, Ace Cool, Randy Rarick, Adam Coxen, Don Johnston, Ray King, Dan Scott, Jo Oliver, RS Elliott, Blanche Benson, Dave Yester, Fielding Benson.

Art

Colin Rosewell, Nick & Sarah Baron.

Photography

Bernie Baker, Colonel Benson, Bill Alexander, Jeremy Goring

We set out to provide the most compact, complete, easy to use guide for the travelling surfer. The icon and data-map system is designed to save time and get you quickly and simply to the right spot for the conditions. Bear in mind that any break can be great on its day, and banks can re-align between swells to give perfect, but short-lived perfection: Expect the unexpected.

We have covered just about every good spot in this surfer's tool, but have safe guarded some secret spots to preserve uncrowded havens - these are part of the adventure that is surfing. We are pointing you towards some of the best surfing locations in this diverse, great land of the USA. In return, we ask you to respect the surfers who live in each area, and be merciful to the natural environment. We send heartfelt thanks to the many dozens of surfers who have contributed their sketches, words, photos and time.
Dedicated to the late great Colonel Benson.

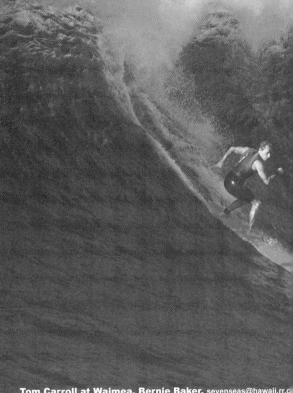

HAWAII

Tom Carroll at Waimea. Bernie Baker. sevenseas@hawaii.rr.c

HAWAII

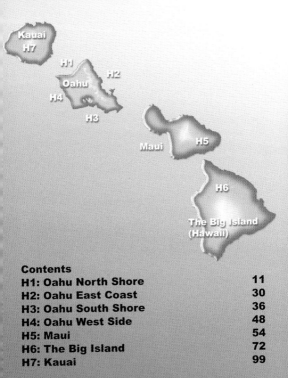

Kauai
H7

H1

H2

Oahu

H4

H3

Maui

H5

H6

The Big Island
(Hawaii)

Contents

HI: OAHU NORTH SHORE

Background
Few places on earth qualify for the term extreme, but this stretch of coast does: Extremely big waves, extremely shallow reef, extremely wide barrels, extremely crowded, extremely seasonal, extremely good surfers.

When to go
The North Shore's best conditions co-incide with the winter season. Northeast trade-winds combine with winter West to North swells to create perfect and often massive conditions between October and March. The closer you are to the middle of this window, the more chance you have of big perfect surf...and crowds. Bear in mind that, as an island in the middle of the biggest ocean, Oahu is rarely flat, and it may pay to check it early or late season. Kona (Southwest) winds can also hit at any time or season, sometimes for a week or more, making most of this coast on-shore. Equally, glassy mornings can occur at any time, making unusual spots perfect. Summer is traditionally small or flat, but mother nature can offer unexpected treats. There's good info on **www.northshorenews.com** (look for surfnewz).

Hazards
Big waves, heavy surfer population, reef cuts, occasional sharks, jellyfish, sea-urchins, currents, some theft, expensive beer. Rapidly increasing swell. There's more and more tow-in activity here these days, and tow-in spots are marked with a jet ski icon.

M	Swell Range		Wind Pattern		Air		Sea	Crowd
	Feet	Dir'	Am	Pm	Lo	Hi		
J	3-20+	n-nw	ne low	ne med	65	77	75	hi
F	3-15+	ne-nw	ne low	ne med	65	77	75	hi
M	2-12	ne-nw	ne low	ne med	65	77	75	med
A	0-6+	nw-sw	ne low	ne med	66	79	75	med
M	0-4+	se-sw	ne low	ne med	66	81	77	low
J	0-4	se-sw	ne low	ne med	70	83	77	low
J	0-4	se-sw	ne low	ne med	68	85	79	low
A	0-4	se-sw	ne low	ne med	68	86	81	low
S	0-9+	sw-nw	ne low	ne med	66	86	79	med
O	2-12+	ne-nw	ne low	ne med	66	81	77	med
N	2-20+	ne-nw	ne low	ne med	65	81	77	hi
D	3-20+	n-nw	ne low	ne med	63	77	75	hi

HI: OAHU NORTH SHORE

3 4 5

2

1
Kaena Point Mokuleia

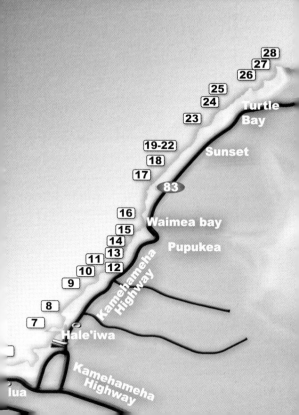

KAENA POINT

Off the Western tip of the island. Go West past Mokuleia to the end of the Farrington Hwy. 3 miles of rough track.

This is a tow-in spot that rarely works in a rideable way. When on, some of the biggest mountains of water on Earth. Works to about 80ft. The rights never close out, wrapping towards Makaha on perfect N swells.

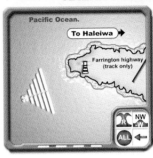

Heavy currents. Offshore spot. Big Fish. Strong possibility of death. To be avoided unless spectating. 12 - 80ft. Uber-expert only, and not on your own. Uncrowded(!) Tiger shark breeding grounds.

ARMY BEACH

Head past the airfield on the way to Kaena Point. Just after Mokuleia Beach Park.

Patchy sand & reef holds swells from NW through NE, and chucks some nice lefts with cover-up sections. There's rights too. Quality spot. Holds 3 to about 8ft nicely, and can be a more relaxing option than heavier breaks from Haleiwa East. Medium powered. Pretty consis-

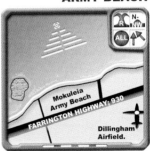

tent. Crowds medium, but kites allover. Intermediates.

West on the coast road from Haleiwa, half way to Kaena Point. Park in camp ground at Mokuleia Beach Park.

2 reef / sand peaks, mostly rights, offshore. Good from 2 - 8ft, and protected from some of the Kona West winds (if they have some S in them). Intermediate level, occasional sharks. Low crowds. Fun option with spread out line-up for a nice low-key session away from North Shore mayhem.

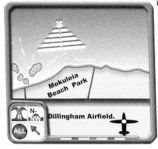

Just east, **The Rock**: off west end of Polo fields. Long hollow fast monster left, 5-20ft WNW swells. Also **Sylva Channel**, a few clicks further east, is another good option in these conditions.

HAMMERHEADS

Opposite the Pu'uiki Base-ball Park at Waialua, off Waialua Beach Road.

Heavy and fast left hand barrels over shallow reef setup. Long rights if swell is more N-NE. Works from 3-8ft plus, and is best on light winds or no wind as Konas (Westerly winds) and Trades (Northeast winds) both affect it. At 10 -20 ft becomes primo outside tow-in land.

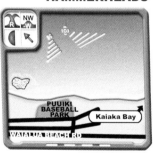

Relatively uncrowded. This is partly explained by the presence of Hammerhead sharks, which find ideal breeding conditions in the area adjacent to the bay. Intermediate.

15

Head North up the Kam Hwy to Haleiwa. Left turn into town towards the harbor. When it's on, it is one of the heaviest, fastest, hollowest rights imaginable. The main peak is about 300m out to sea, and the wave forms heavy sections all the way across to a shallow close-out spot (Toilet Bowl). Best at 6-8 ft with prevailing Northeast trades, and Northwest to West Swell. When bigger, can get very rippy and bumpy, but quality is possible up to 10 -20ft plus. Watch locals paddle-out to gauge current and best route. Flirt into the zone to get your wave, then hang wide between sets. Beginners can check the inside shore break. Crowds; Crazy in winter. Experts only unless small.

Avalanche is a big wave arena several hundred yards further out. Lefts up to 30ft plus are not uncommon in winter. Tow-in spot except Dec-May (Whale season) Unreliable end section means that floggings are common even if you make the initial drop. Moving peak means constant paddling to re-position, and outside bombs are a constant risk. (An Avalanche of water on your head). Experts only.

⟵Avalanche, 500 yds

Haleiwa Beach Park

Waialua Bay

Haleiwa Harbor

Ali'i Beach Park

HALEIWA ROAD

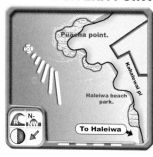

At the Northern end of the Haleiwa Beach Park. Turn off the Kam Hwy at Kahalewai Place.

Often quality long rights on the opposite side of the harbor from Haleiwa main break. Larger NW - W swells hit the point to produce long walls on the outside reef, and smaller filtered right peaks closer to the beach. It's a good option when traditional North Shore spots are getting too big, although inside bowl by rock is purgatory. Also a clean option in heavier more North-oriented trades. Outer reef is awesome tow-in spot at 30-40feet and very N swell. Crowds are a bit lower here. Intermediate.

THE POINT

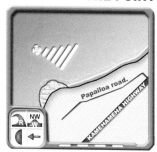

From Hale'iwa, head North on the Kam Hwy. After a mile and a half take a left at Papa'iloa Rd....

A lesser quality option for sandy / reef rights and lefts on smaller days. Papa'iloa Beach is a good crowd avoidance spot. On a 3-8ft North swell, there are punchy lefts peeling off the rock pile, on a mixture of rock and sand bottom. Strong trades are not ideal for this spot so check it early a.m. Uncrowded. Intermediate. Inconsistent.

Opposite the dairy on the Kam Hwy, by street number 61700.

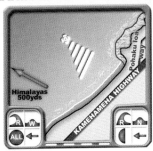

Lani's is one of the first classic North Shore rights. A sometime fatter outside leading to square barrelling vortex on the inside. Likes pure N swell. Will form long walls when on. Intermediate to expert. Crowded, because awesome. 3-15ft.

Outside, you may see **Himalayas,** a few hundred yards to the Northwest. Monstrous long lefts up to 40ft, and some rights, it's a tow-in destination for big to huge days. Likes pure W swell.

HOLTONS

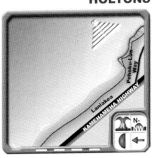

Across from Lani's to the North.

A less frequented little sandbar forms around the rock pile here. It produces variable lefts and rights in moderate 3-15ft NW swells. Connects with Lani's on a good day. Likes an East wind without too much North, and works good on a lower tide. Some short punchy barrels possible. Good channel to paddle-out, but getting in can result in a rock-bashing so be careful. 2-6ft. Crowds OK. Intermediates. You may surf this spot without knowing it.

JOCKO'S & MARLA'S

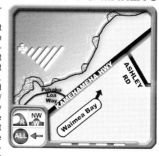

Off the Kam Hwy on Pohaku Loa Way.

Sexy hollow barrelling left that can echo Pipeline on a less crowded, less life-threatening level. Perfect rights can work here, but sometimes they close out. Lefts hold 3- 15ft on a good W swell. Breaks on coral / rock shelf but also patchy sand depending on the day. Rocky outcrops, but good channel helps on the paddle-out. Just east before Chun's is a sandbar peak, **Marla's.** If too north, or v big, Jocko's will close out across Marla's and Chun's. Lesser crowds. Intermediate. Jocko's is another good intro to the North Shore, and semi hidden by houses.

CHUN'S REEF

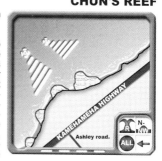

Off the Kam Hwy just North of Jocko's.

Chun's is a good warm-up spot, as take-offs can be relatively easy, and waves more makeable than other North Shore spots. Whilst crowded, surfers are absorbed well across 3 different right peaks. The occasional outside bomb, the long walling middle peak, and the short sharp critical (often jacking) inside peak that fades into channel. Best on 2-6ft days with Trades and NW swell, but any N will do. Can hold 20 feet some days, and look like Sunset! Lefts too although often closed / less consistent. Beginner to intermediate. 19

🅟 LEFTOVERS & RIGHTOVERS

A mile South of Waimea Bay.

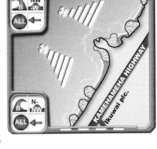

Leftovers: Long whack-able lefts making a welcome change from the heavy suction of some of the spots North of Waimea. There's a good channel, mellow beach and not too much sharpness to the reef. 2 - 6ft. Low crowds. Intermediate.

Rightovers: less reputed, but still great fun rights off the next peak. Often breaking on shallower bottom, so gets closed and hollow at times. 2 - 6ft. Low crowds. Intermediate.

🅟 🛥 ALLIGATOR'S & MARIJUANA'S

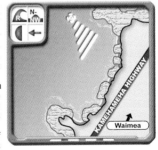

Alligator Rock: Half a mile South of Waimea Bay just before Leftovers.
Right with short left over rocky bottom. Best on medium 4-6ft days with NE trade winds. Fickle but uncrowded. Intermediates.
Outside Alligator's is a tow-in spot half way to Waimea; Rights working in big N swells (W swells close you down!).
Marijuana's; just North of Alligator's: Hard to access fast right-hander breaking over shallow rock. Good on moderate NW swells and Northeast trade winds. 3-6ft. Uncrowded. Intermediates.

20

WAIMEA BAY

H1

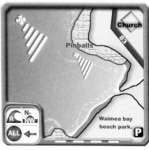

Head North from Hale'iwa on the Kam Hwy, you'll see the bay and the church. Parking lot before bridge.

Justly famed big wave arena, ridden from 6 - 30 foot plus. Waimea proper is a right hand parachute drop monster breaking on a 28ft deep reef ledge. Not the world's longest wave, but perhaps the most exhilarating drop anywhere, followed by a massive wall section and probable annihilation by the foam ball.

Watch sets for at least 20 minutes before jump-off. Ask the lifeguards about the swell forecast; they will have incredibly accurate info from wave buoy, and will be able to tell you when the swell will peak, and how big that will be. There is even a pressure pad by Kaena Point, that gives a few minutes warning if a 30' plus set is approaching. Wave size can increase from 8 to 20 foot in a few hours.

Getting in; wait for a lull, then get in by running down the bank by the rocks at the Northern end and jumping / paddling like crazy. Keep right; current will sweep you left into the channel. Too far left and you could be in the horrid dumpers at the South end.

Getting out; get a wave, then try to ride the foam ball back into the North end to beat the sweep, and hug the rocks. This is your best shot at escaping the shore-break, which is at it's most spine-snapping in the middle of the bay . Watch the approaching shore break and try to get in on the back of the last wave of the set.

Crowds. Drop-ins. Experts only. If in any doubt, stay on the beach. On smaller days, **Pinballs** is an option on the inside. Shore break is notorious and menacing, although occasionally surfable.

21

LOG CABINS & OFF THE WALL

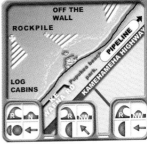

Head N from Waimea on Kam Hwy. Log Cabins is at the Ke Waena Rd turnoff. **Log Cabins**; heavy, hollow rights on pretty shallow pointy reef. Best on medium/small swells.

When huge, **Outside Log Cabins**, off Keiki Beach, comes into its own. Now ridden by tow-in teams, this is a big wave right, rideable up to 60ft or more in NNW swell. **Rockpile**, off the lifeguard tower, is a power left in NW swells from 6 to12ft, and rights in a N swell. This is the spot where the Kam Highway gets cut off in big swells as waves wash over the road. **Off The Wall**, the last wave before Pipe/Backdoor, is a hard-core right (+ slight left) on nasty reef. Fast steep take-off, quick-fire barrel. Fickle, but worth a look if you're at pipe and the crowds are up.

Pipeline reef cracks. Bernie Baker

⭐ P

At the Southern end of Ehukai Beach Park. Going North from Waimea about 2 miles, small alley on left before Sunset Beach Elementary.

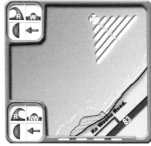

Pipeline; Probably the squarest barrel on earth. ..when it's on. Pipe needs trades, and the right swell (W to NW at 4 - 25ft) to work properly. Take one of these away and you can have a shapeless, punishing mess. The rule of thumb is; the more west the swell, the heavier and hollower the wave.

Pipeline is a series of 3 reefs working from the inside to the outside as the swell increases. **First Reef**: At 4 ft, you can have the most perfect barrels followed by a short whack-able section here. The crowds at this size will frustrate, and the dropping in is blatant. The wave is so close to the beach that spectators can get closer to the action than any other surf spot. At 6-8ft, the peak appears close to dry sucking off the reef, and the drop is a free-fall. A mistake could see you jammed into a crack in the lava reef, but successful riders will make the bottom turn, and stand tall in a super-wide almond shaped barrel. Then it's a speed-race out onto the shoulder, which eventually tapers into a sandy channel.

Second Reef: From 10 or 12 ft plus, another crop of lava pushes up bombs another 100 yards out to sea. These can be mountainous jacking peaks which reform on first reef giving 2 rides in 1. Take-offs here are more critical than any wave anywhere. Timing, commitment and a heavy board are essential to manoeuvre into the elusive time-space window between being pushed over the back by the gusty winds funneling up the face, and too-late drops straight to the bottom. The entire length of the wave is a full-power situation, with the

23

lip ready to cut a surfer down at any moment, and even the latter half of the ride can produce truck-sized barrels. There's an occasional **3rd reef** too, for monsters up to a much contested 30 feet. Now a tow-in domain, and quite rare to see it perfect.

Paddle-out fast, West of Backdoor. Current will sweep you East of the peak into the channel. Crowds to the extreme. Drop-ins are the rule not the exception. Frustrated caged battery-chicken surfing. Experts only.

Backdoor: The right off the same peak as first reef, is an equally if not more heavy tube machine, with even more shallow reef and rocks to contend with. Backdoor tubes often end in shut-down or dry-suck, and the successful surfer will make speed his friend. No time for turns here. Works on similar swells, although likes more North than Pipe itself. Too much West in the swell, or too much size, and it will be a dangerous close-out. From 3 to 10 ft. Crowded to the extreme. Drop-ins from body-boarders and surfers better than you. Shallow reef with deep cracks to get stuck in. Current. Thick guillotine lips.

Both these waves have claimed lives, and may be best experienced vicariously. Try to catch them early or late season or you may not get a single wave.

If you want expert tuition to help get your confidence up (or are prepared to admit that you need some lessons), The Hawaii Surf School is based on the North Shore, on 808 638 7845. Beccy Benson and her team of pros will hone your skills whatever your level.

What is all the fuss about? Bernie Baker

🅟 🅝

North from Pipeline just after Sunset Beach elementary. At the northern end of Ehukai Beach Park.

Pupukea; Rights and lefts on reef and varying amounts of sand. 2 - 8ft, and good on moderate North swells. Crowds; acceptable . Shallow reef patches. Intermediate.

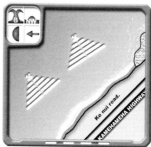

Ehukai; Series of peaky beach / reef waves. Usually there's a nice shaped option here on smaller days. 3-6ft. Intermediates. Crowds in season but shifting peaks absorb well.

🅟

GAS CHAMBERS

North from Pipeline just after Sunset Beach elementary. At the northern end of Ehukai Beach Park.

Just up from Pupukea is **Gas Chambers**. Known for the lefts which are super hollow on NW - W swells, but has good rights too. Both break on shallow coral, and are genuine barrel machines.

Paddling out can be a nightmare as the channel is ill-defined, and there are some very shallow zones. 3-6ft best, but can handle bigger. Crowds; heavy. Intermediate.

25

ROCKY POINT

By houses 59200 - 59300 off the Kamehameha Hwy. Shares a channel with Gas Chambers.

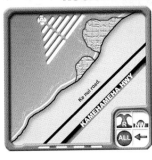

Quality right wall wave and some hard core hollow lefts. On North-Northwest swells, the rights come into their own, with long rides possible, and multi-second tubes. With more west in the swell, there are fast, sometimes long lefts at the apex of the reef that demand down the line speed. 3 - 6ft plus. Maximum crowds. Shallow rocks. Intermediate to expert. Towards Kammies is **Monster Mush**: R & L beach peak if sands that wash down from Pipe are in good shape. All levels.

KAMMIELAND

Just N of Rocky Point on the Kam Hwy, opposite the food market.

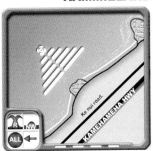

Mostly right (and some) left reef setup, with shallow sections. Take-offs are steep, barrels common. 3 - 10 ft or more possible. Can offer rare moments of uncrowded perfection, and as you can see it while checking Sunset, it may pay to just get in quick if you spot a gap in the population. More N the swell, better the rights, more NW, better the lefts. Strong currents. Crowds. Intermediate to expert.

26

SUNSET BEACH & BACKYARDS

Up the Kam Hwy till you see the parking spaces on the left after Kammies.

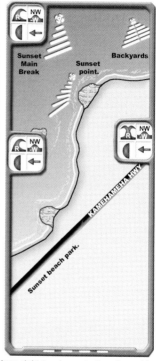

Sunset; Set of reefs dealing with swells from N through W. Northerly swells break the wave up into different peaks, and make the place a little more sharing as a result. On a classic big West swell with trades, Sunset is a heavy, jacking peak that develops into a hollow, sucky, thick lipped beast. These swells catch the trades side-offshore, and the result means heavy long-boards and serious intent are required to get you into the wave. 4-15ft. Major Rips. Crowds. Expert.

Sunset Point, further inside, is a quality R breaking at 3-6ft on NW - W swells. It can lose shape on N swells. Crowds. Intermediate.

Just East is **Backyards**; fickle, often shifty proposition that goes left and right, and works from 4 to 12 ft. Currents and unpredictable peaks absorb surfers well. Expert or tow-in.

Finally, **Outside Sunset**: Huge right tow-in spot when Sunset is closed out. Can work all the way through **Outside Backyards**, which is a right / left outer monster too, with shallow reef under the end section. Hell-men only!

27

VELZYLAND & REVELATIONS

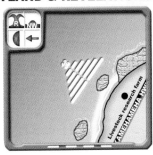

Off the Kam Hwy, down a track opposite the Livestock research farm. Known as a small (er) wave spot, **V-Land** is a shallow reef producing square tubing rights into a healthy channel, and good but sometimes close-out lefts. Great from 3-6 ft. Crowds. Expert level. Show maximum respect here. Locals only. The outside reef, **Revelations**, lies 1200 yards offshore, and is a tow-in / big wave right. Can get windy as hell, and trades are side-shore on this reef. Long paddle thins the crowds, but kites / sail boards might still land on you. Expert only. Sharky. **Freddieland**, west of V-land is a good intermediate spot.

KAWELA BAY

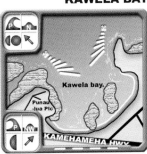

Head North from Sunset on the Kamehameha Hwy. Just after the Waialee Beach Park behind some private property.

Right and left reef / point setups that work well in south-westerlies. Mixed rock / sand bottom means variable wave quality, and of course the trade winds damage the wave, so it's only worth checking on peculiar conditions. 3 - 8ft. A mission to get to, so less crowded. Intermediate. Fickle. Inaccessible.

Head through the Turtle Bay golf course, it's at the western end behind private property.

Patchy reef and sand bottom holding approachable lefts and rights on smaller days. A few rocks, and some hopping over them is required on the way out.

This spot need winds with a bit of South in them, so is rarely clean. It grabs swell from West to North though,

so fires mostly in winter. It's a good warm-up wave when arriving on the North Shore. 6ft. Acceptable crowds. Fickle. Intermediate.

KUILIMA

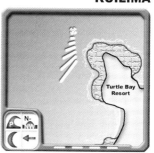

Head to the Turtle Bay Hilton. Rights off the lagoon, and nice lefts called **Little Brazil.**

Breaks on patchy reef, but reasonably forgiving and uncrowded. Good in rare Southwesterly winds when the North Shore proper is blown out, and of course, it's onshore in the Northeast trades. Handles 2 - 6ft swell from Northwest through Northeast. Crowds; moderate. Intermediate.

Background

A coast forgotten - almost. Thanks to the trade-winds that create on-shore slop conditions most of the time, the East Side has long been ignored as a surfing destination. This is a major relief for locals, because there are some gems here. In fact the very trades that are notorious for ruining the waves actually create them when all else is flat. In addition, Swells with a lot of North on them can hit this coast and refract to form perfectly sculpted surf.

When to go

The East side works well on huge wrapping NNW swells, or solid North through to moderate East. This means that it gets quality in winter and summer. The trick is finding the gap in the prevailing wind pattern. This means two strategies: 1- wait for Kona conditions (the arrival of Southwest to West winds and nasty weather caused by local fronts). 2- Keep your radar tuned to spot an early morning glass-off. These happen between weather patterns in any season, and if there's enough swell in the right direction at the same time, you may just experience the bizarre scenario of surfing uncrowded perfection in Hawaii.

Hazards

Theft. Coral. Urchins. Currents.

M	Swell Range	Dir	Wind Pattern Am	Pm	Air Lo	Hi	Sea	Crowd
J	0-12+	n-nw	ne light	ne med	65	77	75	med
F	0-12+	ne-nw	ne light	ne med	65	77	75	med
M	0-10	ne-nw	ne light	ne med+	65	77	75	med
A	0-5+	nw-sw	ne light	ne med+	66	79	75	med
M	0-4+	se-sw	ne light	ne med+	66	81	77	med
J	0-4	se-sw	ne light	ne med+	70	83	77	low
J	0-4	se-sw	ne light	ne med+	68	85	79	low
A	0-4	se-sw	ne light	ne med+	68	86	81	low
S	0-6+	sw-nw	ne light	ne med	66	86	79	med
O	0-10+	ne-nw	ne light	ne med	66	81	77	med
N	0-12+	ne-nw	ne light	ne med	65	81	77	med
D	0-12+	n-nw	ne light	ne med	63	77	75	med

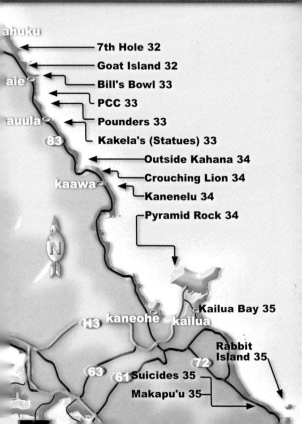

ahuku

7th Hole 32

Goat Island 32

aie

Bill's Bowl 33

PCC 33

auula

Pounders 33

Kakela's (Statues) 33

83

Outside Kahana 34

Crouching Lion 34

kaawa

Kanenelu 34

Pyramid Rock 34

Kailua Bay 35

kaneohe kailua

H3

Rabbit
Island 35

72

63

61 Suicides 35

Makapu'u 35

Head into Kahuku, and turn off the Kam Hwy into the golf course main parking lot. Series of reef peaks that work in extra large North swells and Kona West winds. Lefts or rights dominate depending on swell direction and size. Check this when it's massive on the North Shore, or there is lots of North or a bit of North East in the swell. Run across green, hobble over urchin infested ledge, flop into lagoon, paddle-out

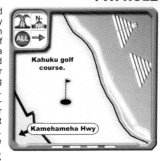

to channel. Crowd factor quite low if you catch it on a new swell. Hazards include angry golfers and their missiles. Intermediate. Beautiful spot. Giant tow-in spot offshore off prawn farm.

GOAT ISLAND

Head S past Kahuku on Kam Hwy, park after Malaekahana State Park, or in the Park if gates open.

Quality long lefts that work over coral off the island on huge N or moderate NE - E swells. Hollow peaky sections that occasionally link. 2 - 10ft. Another good check when North Shore is massive, and when Westerlies blow. On NW swells, will always be lots smaller than 7th hole. Get in at the

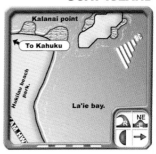

southern side of the break, or risk the paddle-out closer to the island, and hop off and go for it. Low Crowds. Intermediate.

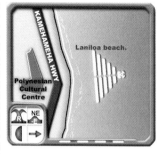

AKA Polynesian Cultural Centre, as is located opposite this. L and R coral peak, with steep take-off and hollow barrelling sections. On NE swells, the lefts can be 100m or more. Rights often short and closed, although can get good. 3 - 6ft+. Outside bommie rarely ridden. This is another spot that works on west winds, although inconsistent on the prevailing NW winter swells. You need massive NW, or NE - E swells to catch it on. It's out of the way so can be a risky and frustrating check. Crowds; moderate. Intermediate. North is **Bill's Bowl**: quality fickle lefts off south side of Laie Point. NE swell.

POUNDERS & STATUES

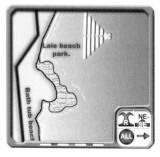

Head Past Laie and the PCC on the Kam Hwy. Pounders Beach is after the boat ramp. Heavy shore break that will break you in half on a solid NE swell! Nearby outside reefs have rumored quality too. Mainly a body board spot. Works on swells North through east, and west winds. All levels. Moderate crowds. Body boarders abound. **Kakela's (Statues)** is a V-land like right way outside off the southeast point. Hollow, fast, 5-10ft but needs big north swell to work. Long paddle. Uncrowded. Fickle.

KAHANA BAY & CROUCHING LION

Just North of Kaaawa.

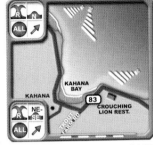

Outside Kahana Bay: outside the northern end of Kahana Bay. On huge N swells, a tow-in sized right peeling into the bay channel. A left too off this peak, but not always makeable. Experts. No crowds.

Crouching Lion: Opposite the Crouching Lion Restaurant on the eastern apex of Kahana Bay. Right-hand hollow barrelling coral reef, on Kona conditions and solid NE or E swells. All levels. Currents. Low crowds. Great spot.

KANENELU BEACH

South on the Kam Hwy past Kaaawa Beach Park, after the Seawalls.

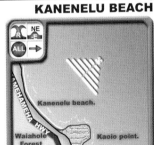

Another good spot in westerlies. Mainly right inside point / reef setup. Crowds manageable. Intermediate.

There's a superb, illegal reef left on the northwest tip of Mokapu Peninsula, on military land. **Pyramid Rock** delivers fast lefts, and needs huge NW or solid N /NE swells to get going. You can get there by boat from Ulu Mau Village or Kane'ohe. Advanced. Currents. Military only.

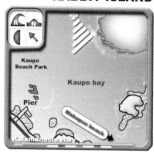

South from Waimanalo on the Kamehameha Hwy to the pier by Kaupo Beach Park. Very long paddle / boat. Right reef break off west side of island. Almost a mile from the mainland, and subject to open ocean currents. A beautiful place. Beautiful long hollow walls, shallow rock and uneven coral bottom. 3 - 12ft. Low crowds. Expert. Plan your paddle back by leaving some gas in the tank. Sharky. North of here is **Bellows**: Beach-break peaks on kona conditions. Then **Kailua Bay**: Reef / Beach left / right combo at N end of bay in Kailua. All levels.

MAKAPU'U & SUICIDES

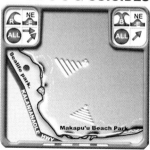

About 3 miles South past Waimanalo Beach on the Kalanianaole Hwy. Just after the Sea Life Park.

Known as a series of heavy beach-break peaks suited to body boarders. However, **Suicides**, on the western point by the Sealife park, offers super hollow, fast reef rights breaking on shallow rocky bottom. Needs North through East swells on West winds.

3 - 10ft. Crowds moderate to high. Expert. Consistent.

barbers
point

ewa beach

airport

23

22
21
20

24

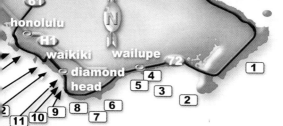

honolulu

61

H1

waikiki

wailupe

diamond
head

72

1

4

5

3

2

6

8

7

9

11 10

Background

The city meets the beach. The South Side does have great waves. Ala Moana Bowl and Populars are but a couple of the coral driven, green-walled jewels of this coast. Whilst the south has a name for small punchy reef breaks, there are some big drop options offshore, and heavy dredging board-breakers like China Walls to batter your ego.

When to go

The South gets sporadic swell all year round, but comes into it's own in summer, from April to around September. It is then that Southeast to Southwest swells from the tropics and the Southern Ocean are most prevalent. Trade-winds from the East/Northeast blow fairly consistently at this time of year, meaning that a large chunk of the South Shore is off-shore semi-permanently. Sadly it's not the most consistent wave magnet on the planet but you can drive to any other shore within 2 hours, so this is a good base if you like to party.

Hazards

Crowds, coral cuts, more crowds, strippers. Waikiki, perhaps the most famous beach in the world, accounts for over half the tourists visiting all Hawaiian islands yearly. There are over 800 places to eat and drink and 65'000 tourists on any given day. Think Newport summer crowds plus Gold Coast high rise, with a little flowery shirt 'n' camera thrown in.

M	Swell range		Wind pattern		Air		Sea	Crowd
	Feet	Dir	Am	Pm	Lo	Hi		
J	0-4	n-nw	glass	ne med	67	79	75	hi
F	0-4	ne-nw	glass	ne med	67	79	75	hi
M	0-4	ne-nw	glass	ne med	68	81	75	hi
A	0-6+	nw-sw	ne light	ne med	70	81	75	hi
M	0-6+	se-sw	ne light	ne med+	70	85	77	hi
J	0-8	se-sw	ne light	ne med+	74	85	77	hi
J	0-9	se-sw	ne light	ne med+	74	85	79	hi
A	0-9	se-ws	ne light	ne med+	74	86	81	hi
S	0-6+	sw-nw	ne light	ne med+	72	86	79	hi
O	0-4+	ne-nw	ne light	ne med	70	81	77	hi
N	0-4	ne-nw	glass	ne med	70	83	77	hi
D	0-4	n-nw	glass	ne med	67	79	75	hi

PIPE LITTLE'S & SANDY BEACH

Off the Kalanianaole Hwy, opposite the Hawaii Kai Golf Course.

Pipe Little's; Fast, hollow barrelling left-hander, on shallow coral. Steep take-offs. 2- 5ft. Rocky. Crowded. Intermediate plus.

Full Point; Reef rights and lefts, best early morning before the winds arrive. Can link up with the next spot inside, **Half Point**, which in turn may link through to Pipe Little's. 3 - 8ft. Crowded. Intermediate. Next door is **Sandy's**, body boarder heaven in the shore-dump. Crowded. Best in summer on south through east swells.

CHINA WALL

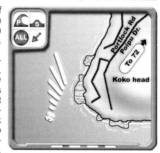

Off the Southwestern tip of Koko Head. Head South from Portlock to the South end of the Hanapepe Loop, into Koko Kai Beach Park. Long bowling lefthanders. On medium swells, take-off point is alarmingly close to rocky cliff. Needs early morning glass or light North winds. Best paddle-out is by jumping off rock ledge, but watch locals to gauge timing. Strong currents. Can get very windy. Intermediate to expert. 3 - 10ft plus. Crowded. From here you can see **Manatans (Kulioulou Point)** to the west: Super-long outside right in Maunalua Bay.

WAILUPE & SECRETS

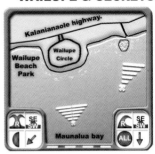

Head West out of Aina Haina on the Kalanianaole Hwy and take the left into Wailupe Circle.

Rare but good off-shore spot that only works in early morning glass or rare North to north west winds. If working, steep left and right reef break. 2 - 8ft. Currents. Intermediate. Medium crowds.
Secrets; Reef peak to the East. Predominantly rights over shallow coral. Can get hollow if winds are right (northerly or glass). Inside is **Misery**, a fast, hollow reef section often ending in close-out and a flogging on the coral. 2 - 6ft. Intermediate to expert.

BROWNS & BLACK POINT

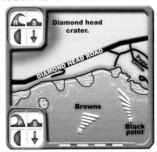

Head to Black Point, then to the Southern end of Kaikuono Place.

Big right reef break, over coral platform well off-shore. If lucky, major drop on take-off, hollow jacking section, tapering off into fatter shoulder. Needs rare North wind (or glass) combined with big South swell. Catches the trades full-tilt, so rarely perfect. 5 - 12ft+. Currents. Low crowd factor. Experts.
Black Point, just South, can produce a good quality Left over coral/rock. 2-6ft. Low crowds. Intermediates.

KUILEI CLIFFS

Off Diamond Head Road, at the East end of Kuilei Cliffs Beach Park.

Lefts and rights peeling into a channel in the reef.

Easy paddle-out to long walled waves that are rarely super-hollow, but catch most swells with any South in them.

. Catches the prevailing winds side-shore, but great in North winds, or early morning glass. 2 - 8ft. Consistent. Crowded with kite / sailboarders but wide expanse of waves absorbs well. Intermediate.

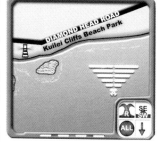

LIGHTHOUSE & SUICIDES

Lighthouse: Head West from the Diamond Head lighthouse, along Diamond Head Road. Left at Beach Road.

Consistent, hard - core right-hander peeling across coral reef. Jacking take-off, then hollow shallow sections. Needs some North in the wind, or early morning glass. Consistent. 2-6ft. Crowds. Expert.

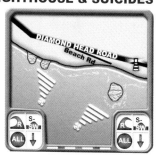

Suicides: less than a half mile West. Fast hollow lefts on shallow reef. Some rights. 2-6ft. Intermediate.

TONGGS, THE WENCH & ZEROS

A mile west of the Diamond Head Lighthouse off Kaluahole Beach. You can paddle from Makalei Park.

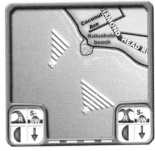

Series of reef breaks that work when there is North in the wind, and South in the swell. With these conditions, on a middling to low tide with 4-5 ft of swell, there are barrel sections to be had on lefts and rights.

Located near town, so crowded. Some rocks about. Moderately consistent. 2 - 6ft. Intermediate.

OLD MAN'S & RICE BOWL

Old Mans: Head South out of Waikiki to the Outrigger Canoe Club.

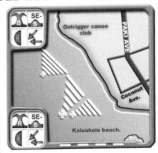

Mellow lefts and rights on sandy reef pass. Easy paddle. 3-8ft. Intermediate.
Ricebowl: Shares a channel with Tongg's to the East. Head out of Waikiki on Kalakaua Ave past the Marc Hotel. Take the right into Kaluahole Beach. Hollow jacking long left over coral reef. Tubey short right peak. Inconsistent, as best on North winds with South - Southwest swell. 2 - 8ft. Moderate crowds. Intermediate. Experts if low tide and bigger.

PUBLICS & CASTLES

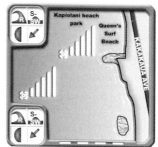

Off the saltwater swimming pools at Queen's Surf Beach in Waikiki. Where the Duke trained for his Olympic swimming feats.

A pair of super-long reef waves that work on S-SW swells and prevailing Northeast trades. **Publics**: Hollow left that reels across coral, and gets serious and shallow when the tide drops. It's not a swell magnet, but when on is reminiscent of Indo. 3-8ft. Crowds. Intermediate to expert. Next door is **Natatoriums** right and lefts. Then **Castles**. Outside publics is a rare left reef-break that comes alive on 6-12 feet. Crowds; moderate. It's open ocean surfing, so experts.

QUEEN'S & CUNHA'S

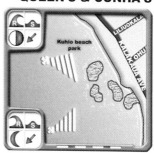

Queen's: at the right hand end of Queen's Surf Beach in Waikiki.

Small bashable rights over low risk reef. Long rides possible through to the inside section. Often cleaner than neighboring spots, but maxed out at 6ft. Crowded. Beginner to Intermediates.

Cunha's: deepwater offshore reef worth a check when other south shore breaks are maxed out. It gets windy and fat, but if you catch it on lighter Northeast trades, low tide and a solid 8ft plus swell, you have a serious wave. Crowds. Intermediates to experts.

43

CANOES & POPULARS

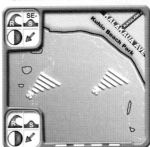

Canoes: Head south down Kalakaua Ave in Waikiki. Just after the Royal Hawaiian Centre.

Perfect barrelling right breaking on reef. Busy town spot. Best at 4 -6 ft, in South swell and NE trades. 2-10ft. Crowded. Intermediate.

Populars (Pops): Outside and to the right of Canoes.

Mellow right reef. Often less crowded than closer inshore spots, but when on it can be a parking lot. Best on 4-6 ft with North wind, SE swell. 3-8ft. Intermediate.

THREES, FOURS & KAISER'S

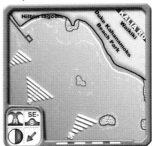

Threes: Off Gray's Beach in Waikiki. Fast, hollow, right-hander (and lesser left over reef). 3-7ft. Crowded. Intermediates.

Fours: Half mile West of threes. If you must go left, check this spot. 3-8ft. Crowds. Intermediate.

Kaiser's: Inside Fours at the Duke Kahanamoku Beach Park. Long lefts, moderate rights, both hollow and tubey over reef, 2-8ft. Crowds +. Intermediate. If Kaisers overpopulated, check **In Betweens** across the channel; often good rights at 2-6ft.

☆ Ⓟ ALA MOANA BOWL & ROCKPILE

Ala Moana Bowl: Outside the Ala Wai harbor at Ala Moana.

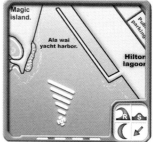

Lengthy tube-lover's left-hander over reef with patchy sand, forming various different sections, the last of which can suck and pitch some beautiful glassy chambers. Eventually fading into the harbor channel in time for the paddle back. 3 - 10ft. Crowds +. Intermediate to expert.

Rockpile: Good lefts (and rights) just south, breaking towards Bowls, with good barrel potential and considerable risk of hitting bottom. 3-8ft. Crowds. Expert.

Ⓟ BABY HALEI'WA & BOMBORA'S

Baby Hale'iwa: At the East end of Ala Moana Beach Park. One of the South Shore's good options when the swell is getting big. Pitching right on reef, with sections both bashable and hollow. 5 - 10ft. Crowds. Experts.

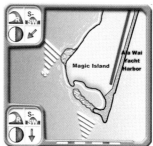

Bombora's: At the Southeastern end of Magic Island. Hard-core option in a South swell and North winds. Fast jacking lefts to 5/6ft. When bigger, outside reef (**Secrets**) starts to work with some solid lefts that throw out square on lower tides. The combo good in 3-10ft. Crowds. Expert.

45

H3

KEWALO'S

P

Kewalo's: Outside the yacht basin at West end of Ala Moana Beach Park. Gnarly left-hander breaking on uneven coral, through sketchy section with occasional shut-down. Then its into the rippy channel and back again. Rights too. Consistent. 3-8ft. Crowds and some aggression. Advanced.

Fear not, there are a half dozen good peaks within in view: **Tennis Courts** serves up great rights and some lefts in a rocky reef setting, at 3-6ft. Outside this is **Concessions**, for left / right combos in a less crowded setting. One stop further is the hollow and often sizey **Big Rights.** All advanced.

FLIES & POINT PANIC

P

Flies: at the West end of Kakaako Waterfront Park. Head West out of Ala Moana, go Left on South St, before Fort Armstrong.

Pretty consistent right-hander on sandy reef bottom. 2-5ft. Intermediates. Next door is the fast, quality right **Point Panic**. This is a tubing speed-ride, officially out of bounds to hard surfboards. Shame, as this wave reels in over the reef off the seawall, tempting law abiding citizens to transgress. 3-6ft. Inconsistent. Intermediates.

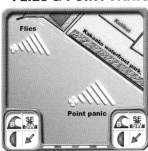

SAND ISLAND

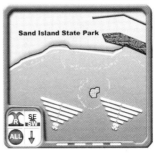

From Kapalama, head round the Military Reservation to Sand Island Road. Go Left and across the drawbridge onto the island. A heap of nice reef breaks that slip by often unnoticed due to the mission to get here. With any North wind and any South swell you will find good waves at 2-8ft here. With the heavy traffic channel into the harbor, there isn't the cleanest water, a fact that does not go unnoticed by feeding fish and the attendant sharks. All levels. West is **Outside Keehi Lagoon**. Lefts and rights either side of harbor channel off the airport. Massive. Mostly tow-ins. Experts. Well off-shore.

BARBERS POINT

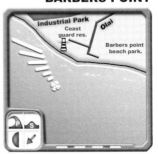

If heading East on the H-1 out of Pearl City, exit on Kalaeloa Blvd past the Hawaii Raceway Park. Head for Barber's Point Beach Park and stroll west past the lighthouse.

Some good performance lefts when swell is in the South. Currents, sharks. Low crowds. 2-8ft. Intermediate. Spots East of here tend to be wind-blown in the trades, but if wind is North you can check **White Plains** Beach (Sand and rock bottom with many peaks 2-4ft, plus outside reefs) or **The Cove** at the West end of **Ewa Beach**.

47

H4: OAHU WEST COAST

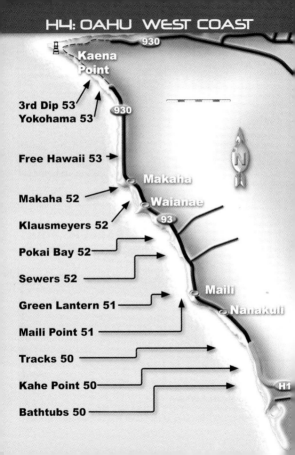

930

Kaena Point

3rd Dip 53
Yokohama 53

930

Free Hawaii 53

Makaha

Makaha 52

Waianae

Klausmeyers 52

93

Pokai Bay 52

Sewers 52

Maili

Green Lantern 51

Nanakuli

Maili Point 51

Tracks 50

Kahe Point 50

H1

Bathtubs 50

H4: OAHU WEST COAST

Background

Plenty of surf, some un-crowded spots, almost always off-shore, gets swell from north through south; a fantastic stretch of surfing domain. From freight-train Makaha, to punchy Yokohama Beach and fun, mellow Tracks. Worth getting to know.

When to go

This is an all-year round surf zone. Winter swells from north to west, as well as summer south swells all hit the west side. Prevailing trade-winds from the east-northeast are off-shore everywhere. Only those horrid kona west winds, which can crop up any season, will ruin the fun. It's a good off-season option (spring and fall), and also can offer escapism when the North Shore winter season is in full swing. Another bonus is that on huge north swells when you are terrified, some of the spots here filter out the swell into something more approachable.

Hazards

Coral cuts, currents, shore-pound in places, some sharky spots, big waves. Please show the usual respect to other surfers; there are some tight local crews.

M	Swell Range		Wind Pattern		Air		Sea	Crowd
	Feet	Dir'	Am	Pm	Lo	Hi		
J	3-15+	n-nw	ne low	ne med	65	77	75	hi
F	3-15+	ne-nw	ne low	ne med	65	77	75	hi
M	2-12	ne-nw	ne low	ne med	65	77	75	med
A	0-6+	nw-sw	ne low	ne med	66	79	75	med
M	0-4+	se-sw	ne low	ne med	66	81	77	med
J	0-4	se-sw	ne low	ne med	70	83	77	med
J	0-4	se-sw	ne low	ne med	68	85	79	med
A	0-4	se-sw	ne low	ne med	68	86	81	med
S	0-9+	sw-nw	ne low	ne med	66	86	79	med
O	2-12+	ne-nw	ne low	ne med	66	81	77	med
N	2-15+	ne-nw	ne low	ne med	65	81	77	med
D	3-15+	n-nw	ne low	ne med	63	77	75	hi

TRACKS & KAHE POINT

Head up the 93 from Honokai Hale. First up on left is Kahe Point Beach park, then Tracks, at Kahe Beach Park.

Tracks: Long reef left-hander with sandy inside sections, best in S-SW swell.

The reef also hosts good punchy steep rights that get better the more North the swell. Consistent spot in any swell from NW to S, and this is the beauty of it. Also offshore 75% of the time. 2-8ft. Consistent. Crowds. Intermediate.

Kahe Point: just South of the Power Plant. Worth checking when tracks is crowded. Its a mixed sand/rock bottom wrapping wave, with good lefts in a SW swell. Consistent. 2-8ft. Intermediates.

Also good rights at **Bathtubs**, inside the point and just South. NW swells work well here from 3-6ft. Inconsistent. Crowds acceptable. Intermediates. There's a fair stretch of reef/beach-break options North of this setup. You can take the drive up and check for a lonely peak.

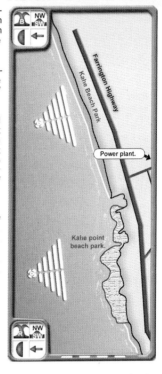

Maili Point: Head South from Maili on the 93. Over the river bridge to Lualualei, and it's on the right.

A screaming left-hander that wraps around the coral reef to form long, walling barreling racetracks. The coral is never too far from the surface and on large days the peak shifts across the break zone making it hard to be in the right spot. Sketchy getting out there, as you need to make a jump off the rocky area by the channel, which is thankfully quite deep. Good on a bigger SW swell and trades. Crowds medium. 4-15ft. Intermediate + to Expert.

Up North a few hundred yards lies **Green Lanterns**, opposite the break wall. It's consistent right-handers are good on a small day, and there's a heavy outer reef here that works on 8-20ft SW to NW swells in Northeast trade winds. Rocky spot. Sharks. Crowds when good. Intermediate to expert.

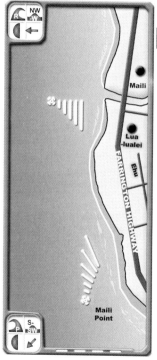

POKAI BAY & SEWERS

P **Pokai Bay**: North of the Pokai Bay Harbor in Waianae.

Nice mellow beach-break lefts and rights breaking on NW to S swells. Consistently offshore, and multiple peaks thin the crowds. 2-6ft Beginner to intermediate.

Sewers: A half mile South of the harbor.

Rocky reef break close to shore, spawning a sharp fast hollow left / right combo. With North in the swell, the natural footers enjoy reeling rights, but as the waves start to come from the South, the lefts open up. 2-8ft. Crowds. Intermediate.

KLAUSMEYERS

P The left-hander on the South side of the channel to Makaha rights.

Makaha's alter-ego. When Makaha is furiously spitting out 15ft rights, **Klausmeyers** can offer long, solid but ultimately more approachable lefts. Forms over sand/reef bottom, and lacks the hollow barrel-machine precision of Makaha. Likes NW swells, but takes all from SW to N. Currents. Pounding shore break. 3-12ft. Crowds acceptable. Intermediate to advanced.

MAKAHA

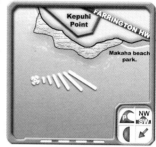

Kepuhi Point

FARRINGTON HWY

Makaha beach park.

NW SW

Head to the North end of Makaha town, to the Beach Park.

Long, often huge, hard-core right-hander that speeds over a rocky / reef point for over 100m. Heavy steep take-off, pressure bottom turn, then possible tube followed by desperate race down the line. Then there's a 50/50 chance of a barrel or a close out inside. On huge days the channel to Klausmeyers closes out. On smaller days it's less of a threat, with 4-6ft west swells producing nice makeable performance waves. 4-25ft. Currents. Moderate crowds. Intermediate to expert. 4 miles N in Ke'eau Park is **Free Hawaii** for lefts over reef / sand on NW swells. 3-8ft. All levels.

YOKOHAMA BAY

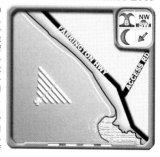

FARRINGTON HWY

ACCESS RD

NW SW

Head N up the Farrington from Makaha for 4 miles, past the military reservation onto dirt track. At last we drive past a series of beach-breaks that are often off shore, and may not kill you. Then there's Yokohama. The most advanced of the waves in this area. It peaks on a rock ledge, then reels into a sandy zone followed by 2 good channels. Lefts predominate, good from 3 - 10ft of SW swell. Rights too, particularly in the N-NW swells of winter. Uncrowded. Intermediate to advanced. Just N is **3rd Dip** (at 3rd dip in road): Hollow rights for locals only.

53

Background

It's the second largest Hawaiian island, and stunningly beautiful. Deep verdant valleys, huge volcanic mountains and some of the best waves on earth.

When to go

Traditional winter surf season is less of an issue here. The same swell patterns apply as for Oahu: Summer swells from the South quadrants, and Winter swell from the North quadrants. Winter swells with too much West in them punish the other islands and arrive on Maui panting and limping. North to Northeast are at full power. Southeast get beaten down to manageable size or just plain blocked by the big island. All this means that a subtle understanding of swell direction and wind patterns is required. You are more likely to see good surf on southwestern shores from Lahaina to La Perouse in Summer, and North shore spots from Honolua to Hana Bay in winter. Many good north shore spots need to be surfed early; trades pick up by 11am.

Hazards

Reef cuts. Distance from medical help. The Aloha spirit is alive and well here, but has been stretched in recent years by development and surf invasion; bear this in mind when paddling out and be generous with smiles and waves.

M	Swell Range		Wind Pattern		Air		Sea	Crowd
	Feet	Dir'	Am	Pm	Lo	Hi		
J	2-20+	n-nw	ne low	ne med	65	77	75	hi
F	2-15+	ne-nw	ne low	ne med	65	77	75	hi
M	2-12	ne-nw	ne low	ne med	65	77	75	med
A	0-6+	nw-sw	ne low	ne med	66	79	75	med
M	0-4+	se-sw	ne low	ne med	68	81	77	med
J	0-4	se-sw	ne low	ne med+	70	83	77	med
J	0-4	se-sw	ne low	ne med+	68	85	79	med
A	0-4	se-sw	ne low	ne med+	68	86	81	med
S	0-9+	sw-nw	ne low	ne med+	66	86	79	med
O	2-12+	ne-nw	ne low	ne med	66	81	77	med
N	2-12+	ne-nw	ne low	ne med	65	81	77	med
D	3-20+	n-nw	ne low	ne med	63	77	75	hi

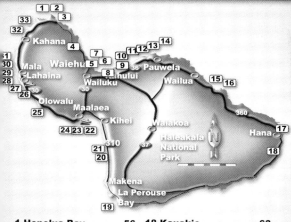

⭐ 🅿️ ❗

Off Honoapiilani Hwy (30) past Fleming Beach Park on the Northwest tip of Maui. Through village of Honolua and up to the cliff top parking lot; stumble down path(s).

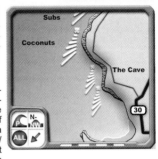

An awesome, peeling flyer of a right-hander, dishing out considerable tube time, over a rocky reef / point setup. Honolua takes a huge NW or any W or N swell, and refracts it into long walls that run from way outside the bay (**Subs**), through to and often linking with the apex of the bay (**Coconuts**), and then starting again at **The Cave** (named for a rocky hole that tends to catch surfers like a Venus fly-trap), then finally the **Keiki Bowl** which is the last section before the channel. One of the most perfect, long rights in the islands.

The wave has power in good supply and you'll need a longish board if over 5ft, when it really comes into its own. It's rideable in anything up to about 15-18 ft, when the currents are outrageous and tow-in surfers have ridden the whole 4 sections as 1 long ride. Equally, there are fun days to be had at around 3-5ft. NW swells are blocked by Molokai unless huge, but Norths wrap in unimpeded. ENE trade winds funnel up the valley and blow perfect offshore, The Cave section tends to be cleaner, and smaller than its outside counterparts, as well as attracting the biggest crowd density. All tides are pretty good, with the lower tides tending to make the inside section a bit critical. Entrance into water is either by lengthy paddle from channel in the middle of the beach, or daring rock-hop from Northern end of the bay. Moderately consistent winter spot. Hazards include currents, dense crowds and rocks. Intermediate level on small days. Experts only when over 8ft. Classic beautiful spot. This wave has been towed in, from way out the back at **Impossibles** and **Super Impossibles**.

WINDMILLS & HORSESHOE

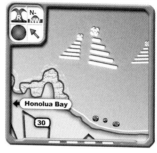

On the North side of Lipoa Point after Honolua. Look for faded Private Property sign.

Cranking power reef that handles any amount of raw swell and converts it into throwing peaks that work left with length, but also right. Rocky hazardous arena with sketchy entry and exit to & from the water, and has the depth to take waves up to 8 feet or more. A magnet for N or W swell. Has scant protection from the trades. Early morning glass or a light East and you're in business. Consistent. Remote. Sharks. Low crowd. Advanced. East side is Horseshoe; awesome right (and left) reef

HONOKOHAU BAY

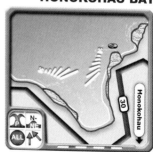

About 8 miles past Honolua on the 30. Bottom of ravine. Respect private property.

Rights on the eastern point inside the boulder (often solid power waves) and occasional lefts opposite. Lava pebble / boulder / sand bottom. Any North swell will work here, but Kona west winds mess up the rights.

High cliffs with the odd rock to crack a board / head on. 2-10ft. Low crowds. Rocks underfoot on way out. Advanced. A good pressure reliever after Honolua Bay next door.

H5

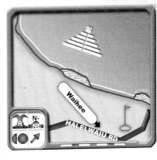

Head to town of Waihee, and then past the golf club to Waihee Beach Park.

Shallow off-shore reef throws varying rights and lefts up on N-NE swells. Mid to high tide is good as lower tides can close out the wave. This is a spot for early morning glass or Kona winds. Trade winds mess it up to the maximum extent, which means it gets ignored for the first few days of West wind periods; hit it at these times and you can avoid crowds. 2-8ft. Low crowds. Seaweed. Intermediate. If a hell man, check **Churches** to the S, heavy rippy R at the end of Church St. Local spot!!

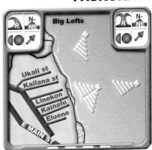

Head North from Kahului. Main Street towards West Maui Mountains. Right at Shell station.

Boulder beach with a selection of options, notably a left & right rocky / reef break, good on mid to high tides from 3-6ft. Then **Big Rights**, the outside reef, starts working at 6ft plus, to about 15. On your left you'll see **Big Lefts**: Heavy longer lefts working up to 15ft in N swells over lava boulder bottom. Tradewinds mess this spot up; another Kona option. 3-15ft. Consistent. Crowds. Show respect. Experts. Big days close out the channel.

KAHULUI HARBOR

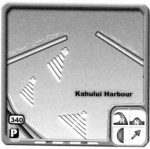

Head to Kahului, then to the ramp inside the break wall of the harbor.

A spot to turn to when its howling SW Kona wind and Massive North swells have closed off all options. Harbor walls filter out other wind directions, as well as combing out of control monster waves into manageable sizes. Great long left with hollow sections over reef by west wall. Mellow rights on the harbor beach. Crowded if good. 2-8ft. Advanced. Show respect. 200 yds outside is the tow-in cloudbreak **Pier 1**. Awesome right for N swells and Kona, but sharky. 3-30ft. Experts. Tow in mostly.

SPRECKLESVILLE

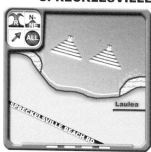

Off the Hana Hwy (36) North on Sprecklesville Beach Rd....

This reef-fringed beach is perfectly set to catch swells NW through NE, but sadly heavily affected by trade winds. Catch it on Southwest Kona conditions or early morning glass though, and there are some great left / right reef peaks that throw up barrelling perfection in most tides. If you do come here during trades, watch out for sail craft jumping over and possibly landing on you. 3-12ft. Crowds. Intermediates. **Outside Sprecklesville** is a tow-in spot, mostly rights, that appears on smaller swells than Jaws.

BALDWIN BEACH PARK

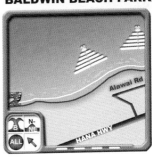

Head East from Kahului on the Hana (36). Road signs after 5 miles.

Shore dump for spine-snapping loonies, and mainly a sail board spot. A variety of beach-break with a bit of reef thrown in . Works from 2-6ft. If not quality, then quantity; heaps of peaks and rarely flat. Trades are semi-OK here unless howling. Must surf early before 11am. Consistent. Crowd absorber. All levels. **Outside Baldwin Beach** Park is a tow-in spot on the outer reef, mostly rights, best in rare SE winds but OK in light trades. **Tavares Bay**, by the baseball field before Paia, is a mellow beach-break.

KUAU & OUTSIDE MAMA'S

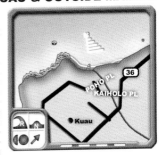

Head west from Hookipa into Kuau (1/2 mile). Take right into Kaiholo Pl. 1st Right into Poho Pl. Opp. Mama's Fish House.

Gnarly left that dishes out barrels on N swell & S wind. Long paddle with current. Heavy drop, then power sections often leading to a flogging on the reef. Lower tides avoided for this reason. Inconsistent. Medium crowds. Currents. Advanced. There's a nice right on the west side of the headland, less crowded. Also **Outside Mama's** is a good tow-in spot, lefts and rights with punishing shallow inside.

LANES &HO'OKIPA

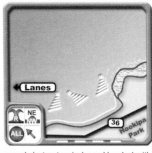

A mile North of Kuau on the 36. Parking lot. Most consistent spot on Maui. **Pavilions**, the right-hander at E end is pure reef quality but localized. **Middles**, in the middle (!) is a left reef, mellower crowd and more spread out zone. **The Point**, a right at the west end, is shallow and fast. 3-12ft. Consistent. Crowds. Currents. Long Paddle. Advanced. To the west of all this, off the map, the excellent **Lanes** absorbs crowds but gets windy and loaded with sail-craft. Its a great left reef in west swells. Surf all these spots early / in south winds. Blown out by 11am. **Outside Lanes** and **Outside Hookipa** can both be towed in right conditions.

JAWS

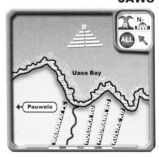

If you can handle it, launch your jet ski at Maliko Gulch and god be with you. One of, if not the world's biggest and best tow-in / big wave locations. Known for it's capability to convert gigantic winter N swells into condo-block sized right-handers and longer lefts that hold their shape up to 50ft plus. N swell is OK, NW is best, but WNW ignites the lefts, which can be awesome and very long. OK in trade winds. First named and surfed in the '70's, before hell men Laird Hamilton and Buzzy Kerbox really gauged it's potential by riding it at 50 ft plus. It is being pushed further each year.

HONOMANU BAY

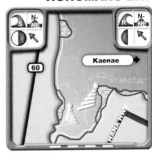

About a half hour east from Ho'okipa on Hana Hwy. You'll see it below you. Take left at base of ravine.

This spot is a getaway. Honomanu stream forms the reef pass / pebbly bottom into some quality long lefts on the right day, that vary from fun & fast, to hollow speed runs. The right under the cliffs is a good option if the trades are blowing, and works over a rocky ledge / boulder set-up. Not the best wave on Maui, but pretty and a good adventure. Fairly consistent. Medium to uncrowded. Protected from winds. Currents. Sharky after rains. Car theft. Remote. 3-10ft. Advanced.

KEANAE

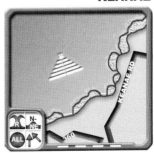

In Nuaailua Bay, North from Keanae on the 360.

Some sheltered waves in the bay, from the Rivermouth to inside the point. Pebbly and reef bottoms. Another pretty spot with average waves, worth a look to escape the crowds. On Kona days there are waves on the East side as well, worth a check. Medium crowds. Rocks. 2-8ft. Intermediates. Not far away, the **Three Sisters**, is a triple rock formation out at sea that hosts an absolute monster of a wave, not yet surfed...not yet.

HANA BAY

Middle of the Harbor at Hana Bay.

A fun option for those huge, huge days. A rivermouth style left-hander that can form some long quality walls, breaking on lava pebble bottom.

It's destroyed by trade winds and conversely good in Kona conditions with some East in the swell. Huge N swells can just about wrap in. 2-8ft.

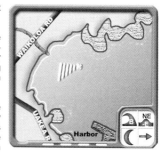

Low crowds. Plenty of peaks. Intermediate. Big fish on occasion.

KAUAKIO

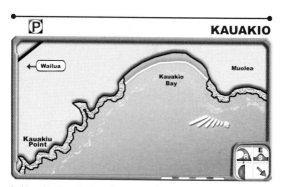

In Kauakio Bay. Left reeling across lava and coral point. Needs straight south or east swells and is fickle. 3-8ft. Advanced. Shallow reef. Uncrowded.

LA PEROUSE BAY

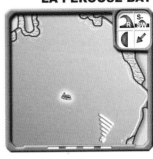

From Kihei, head south to Makena, then continue to end of sealed road. Tortuous 4WD or walk for 1/2 mile.

There ain't a lot of beach or surf between here and Hana. La Perouse though, offers a the best south shore wave there is, and it's usually much bigger than anywhere else. Screaming left at the south end of the bay, over lava reef. Swells from South through West, and good in Trades. Usually offshore here, and uncrowded. Help is far away. Inconsistent. 4-12ft. Intermediates plus. **Big Beach** and Little Beach in Makena are fun body-surf spots.

KALAMA PARK

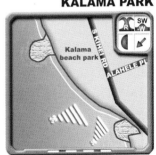

From Kihei, head south to Kalama Park. It's at the southern end.

There's a nice reef left-hander off **The Point** in the South, that can be a lengthy hollow option. This is a busy little beach. 3-8ft. Intermediate. Crowds. Usually pretty small.
Also rights and lefts over sand further up, sometimes known as **The Cove**. 3-6ft. Crowds. Beginners to intermediate. Usually pretty small. All these spots work in NE trades, with swell from West to South. Any tide, but too high isn't always too good.

MA'ALAEA BAY

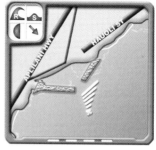

Off the Northeast end of the breakwater at Ma'alaea.

Arguably the world's best and fastest right-hander, this beauty breaks when very big south swells wrap and refract off the lava stone bed on which the break wall is built. Super-long cover-ups are possible, exits are rare unless you have enormous speed. hollow, spitting beast from 4-10ft. Crowded like hell if on. Low tide risky. Advanced. Landowners want to extend the marina for their boats despite its status as both marine park and sacred surf site. Ludicrous. Plans get re-drawn. The battle goes on.

LITTLE CAPE ST FRANCIS

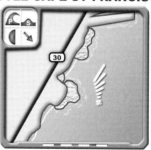

About 3/4 mile South of Ma'alaea on the 30, off the low-lying cliffs.

Also known as **Cliffs**, this is a fickle but superb right-hander with all the qualities of a good point break. Long tubey rides possible if solid South swell powers in and bends around the point. The base is bouldery lava and the consequences of a fall are dire on certain parts of the wave. It's a powerful speed machine starting with heavy drop. 2-10ft. Inconsistent. Crowds when on. Advanced. Summertime. Fickle. Needs big south swell.

Just over a mile South of Ma'alaea on the 30. You'll see the point sticking out.

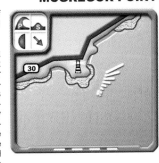

More right hand racetrack extends from the apex of the point. McGregor Point, or **Lighthouse**, requires solid South swells to wrap around the rock-ledge point. When they do there's a rocky take-off zone followed by some whackable sections. Fickle wave due to narrow swell window (Straight South is about it, or rare huge Southwest). 4-10ft. Medium crowds. Advanced.

North from Olowalu 500yd past Jetty. Park your car under some trees.

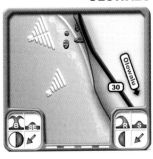

Of note, there is a great left-hand reef break that can be handled by long-boarders. Then there's a right/left beach-break with peaky barrel sections - a great fast wave on a 3-5ft swell; bigger swells make it v heavy. South swells are best. Northeast trades are off-shore. Heavy North swells can also wrap in. Low to mid tides good, with lower tides exposing the reef and making the wave sectiony. A few rocks underfoot on the way out. 3-8ft. Medium crowds. All levels.

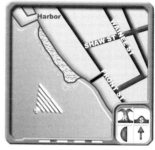

SHARK PIT

P Lahaina. At South end of town beyond some residential property. Access path from Front Street.

A-frame reef peak that delivers throwing barrels both left and right, in straight north, south or southwest swells. Shallow ledge reef means sucky heavy sections, especially on the lefts. Rights taper into channel (which is where you paddle-out). Mid tides OK, but more fun on high and shallow on low. On larger swells it's a heavy spot. 3-8ft. Summer best. Consistent Low crowds. Advanced. Sharks. Just south is a harsh left reef; **Acid Drop**, similar to Kauai's original.

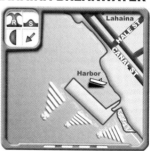

LAHAINA BREAKWATER

P Head to the town of Lahaina. The harbor is at the North end of Front Street.

Superb left and some rights. Long, fast hollow barrel machine handling up to 10ft and more in Summer South swells. Conversely, winter North swells can squeeze between the islands and wrap to produce rare quality rights. Either way this is an advanced wave usually shared with crowds. Pretty consistent. Shallow paddle-out south of harbor. There's a mellower right on south side, and some fun waves further south by the surf schools.

LAHAINA HARBOR

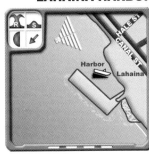

To the North side of the harbor at Lahaina, breaking into the channel.

Steep right peak followed by barrel section & tapered shoulder. Best at low, although high tide can produce the option of a nice little left. Summer S swells are best here, but winter Norths good too. Paddle out in channel right next to the ancient whaling ship. Crowded. Consistent. 3-10ft. Intermediate. Head 2 miles S to the 18 mile marker for **Launiupoko**, a fun, consistent, mellow reef break for all levels off a pretty beach with showers & shade. It's also home to Buzzy Kerbox's surf school.

MALA WHARF

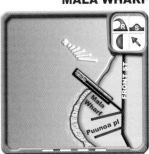

Head South on the 30 out of Mala. Get to the wharf on your right.

Long left-hander to the East of the dilapidated old wharf. It is the opposite of Ma'alaea, producing fat, super-lined up, mellow waves over a reef. It likes solid summer South swells which wrap, but winter can be OK too. Easterly winds are good, with too much North tending to create chop. A shallow spot at low tide though; surf it mid to high. Many longboarders. 2-10 ft. Fickle. Intermediates. Crowds.

SAND BOX

South of the Kaanapali Golf Course South section, off Nohea Kai Drive.

A selection of reef breaks with a fickle quality right-hander as the gem amongst the dirt. It filters huge N swells into manageable reef / beach peaks that are sometimes the only option on massive days. 2-6ft plus. Good on most tides. Inconsistent. Intermediate. Low crowds. Nice spot if on, and multiple peaks in the area.

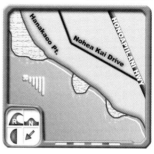

OSTERIZERS & RAINBOWS

Off Honokowai Point, about a mile North of Kaanapali.

Osterizers: Powerful long rights peel on North or big Northwest swells. Shallow reef, meaning high risk waves at low tide, with steep take-off often straight into the barrel. A splendid wave when trade winds are on, and occasionally uncrowded. Beautiful piece of coast too. Also works on South

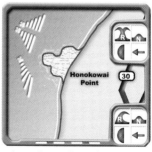

swells. Just up from Osterizers is another quality reef break, **Rainbows**. Reeling rights in North or big Northwest swells, and punchy short lefts. Both options are power waves. Hard-core spot. Current. 2-10ft+. Consistent. Medium crowds. Advanced.

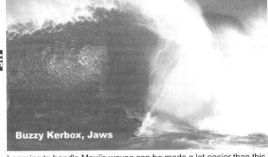

Buzzy Kerbox, Jaws

Learning to handle Maui's waves can be made a lot easier than this, at Buzzy Kerbox's surf school. You can get through on (1) 808 573 5728 or look at www.buzzykerboxsurf.com . It's for experts seeking to hone their skill, or beginners, kids and intermediates. Located at Launiupoko, 2 miles south of Lahaina.

LITTLE MAKAHA

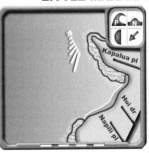

Head to Napili. At the North end of the bay off the point.

Screaming right-hander wrapping around the rocky point. Critical take-offs, then fast long ride through multiple barrel sections. Works on straight North, Huge Northwest, or straight West swells. Can get huge; up to 15 ft. Crowds medium. Quality wave if on. A bit fickle. Advanced. Rocks.

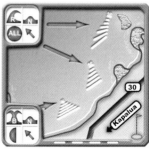

FLEMING BEACH PARK

Head North on the 30 from Napili. Left after Pineapple Hill, park up. Behind Ritz Carlton Resort.

3 main options: Dumping spine-snapping beach-break mostly at west end, variable quality, for body boarders and occasionally surfers. 2-5ft. Heavy. Consistent. Experts when large. Middle has a right reef peak. Good on any N swell. Hollow. Consistent. Intermediates. Far east corner has great right reef/point break on big N to NE swell. Protected from trade-winds. 2-12ft. Inconsistent. All levels. Crowds well absorbed by numerous peaks.

Honolua Bay. Bernie Baker

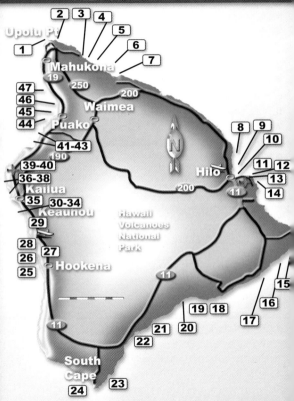

Upolu Pt

1
2
3
4
5
6
7

Mahukona
19
250
200
Waimea
47
46
45
44
Puako
41-43
190
39-40
36-38
Kailua
35
30-34
29
Keauhou
28
26
27
25
Hookena

8 9
10
11 12
13
14
Hilo
11
200

Hawaii
Volcanoes
National
Park

N

11

15
16
17
19 18
20
21
22
South
Cape
24 23
11

H6: THE BIG ISLAND

1	Upolu Point	75	25	Hookena	88
2	Kohala Mill	75	26	Palemano Pt	88
3	Pololu Bay	76	27	Manini Beach	89
4	Honokane Bay	76	28	Kealakekua	89
5	Honopue Bay	77	29	Kahaluu	90
6	Waimanu Bay	77	30	Magic Sands	90
7	Waipio Bay	78	31	Lymans	91
8	Honolii	79	32	Banyans	91
9	Tombstones	79	33	Generals	92
10	The Bay Front	79	34	Honls	92
11	Blonde Reef	80	35	Hulihee P'ce	92
12	Hawaiian Vlg	80	36	Old Kona Apt	93
13	Kealoha	80	37	Honokohau	93
14	Richardsons	81	38	Pinetrees	93
15	Kapoho Bay	82	39	Mahaiula	94
16	Shacks	84	40	Makalawena	94
17	Pohoiki	83	41	Kiholo Bay	95
18	Apua Point	84	42	Keawaiki Bay	96
19	Keauhou Pt	85	43	Anaehoomalu	96
20	Halape	85	44	Browns	97
21	Punaluu	86	45	67's/68's/69's	97
22	Honuapo Bay	86	46	Spencer Bch	98
23	Kaalualu Pt	87	47	Kawaihae	98
24	Kahuku Ranch	87			

H6: THE BIG ISLAND

Background

Bubbling craters, huge peaks, deep valleys and imposing cliffs. Add to this the fact that much of the place has no sealed roads and you have an all-time surf safari.

When to go

Winter northwest swells get blocked by Maui meaning that The Big Island doesn't adhere to the Hawaiian winter stereotype. In addition, the most north-exposed coast is almost totally bare to the northeast trades. Great surf, therefore, relies on some quite contradictory conditions. In winter, the west side of the island can fire if there is huge northwest, perfect north, or solid northeast swell. For the northeast shore to be surfable, Kona west to southwest winds or glass are required, the latter of which is a distinct possibility: Hawaii's size and mountainous features create offshore breezes quite often in the morning. **Summer** southwest to southeast swells hit uninterrupted, so its no surprise that the west coast is flush with great surf then. There may not be the mack-truck size of winter, but it is pretty consistent on the southwest coast, and certain corner spots in the southeast. There's no doubt that the most powerful summer surf in the islands is right here.

Hazards

Big waves, heavy surfer population, reef cuts, occasional sharks, sea-urchins, currents, some theft, remoteness, boulders, incineration in lava flows.

M	Swell Range		Wind Pattern		Air		Sea	Crowd
	Feet	Dir'	Am	Pm	Lo	Hi		
J	3-15+	n-nw	ne low	ne med	65	77	75	hi
F	3-15+	ne-nw	ne low	ne med	65	77	75	hi
M	2-9	ne-nw	ne low	ne med	65	77	75	med
A	0-6+	nw-sw	ne low	ne med	66	79	75	med
M	0-4+	se-sw	ne low	ne med	66	81	77	low
J	0-8	se-sw	ne low	ne med	70	83	77	low
J	0-8	se-sw	ne low	ne med	68	85	79	low
A	0-8	se-sw	ne low	ne med	68	86	81	low
S	0-9+	sw-nw	ne low	ne med	66	86	79	med
O	2-10+	ne-nw	ne low	ne med	66	81	77	med
N	0-8	ne-nw	ne low	ne med	65	81	77	hi
D	3-15+	n-nw	ne low	ne med	63	77	75	hi

Head past Upolu Airport on Upolu Point Rd.... Walking trail to the point.

Power left hand point break over bouldery reef bottom. This is wild coast, and a wild wave. Often blown out by trade winds, you need to catch it on a glassy morning, or during Kona west winds with as much South as possible. Straight West, or anything from North to east swells hit with unimpeded power and convert to heavy, thick walls of water. 2-12 ft. Uncrowded. Advanced.

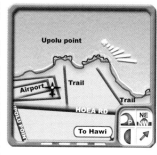

KOHALA MILL

Head east from Kohala on the 270. Left to Halau then up Old Kohala Mill Rd....

A selection of mainly left hand reef peaks that take any north swell and jack it up into steep faces over a fringe reef. It's another pretty remote spot probably best not surfed alone. Powerful wave. Consistent. Low crowds. Shallow reef. Advanced. Car rip-offs in the area. Tight local crew may not always appreciate tourists, so be aware, and extremely polite and clean.

POLOLU BAY

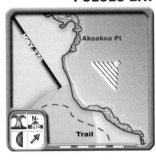

At the end of the line; take the 270 to the Pololu Valley and walk in along the stream bed.

Some quality reef breaks in an out of the way, beautiful setting, far from help. The setup is fringe reef, and this produces fast steep peaks of consequence. Trade winds destroy it, so its Konas or early morning glass/offshore. Consistent spot. 4-8ft plus. Uncrowded and even deserted. Advanced surfers unless small. Winter spot. Watch where you park car and what you leave in it.

HONOKANE BAY

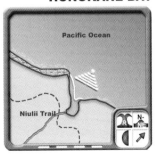

Take the 270 east from Niulii to the end. Then trek almost 2 miles; you'll cross the stream and see the small bay.

Reef peaks left and right giving power waves in a lush, awesome, remote setting. Trade wind affected, but consistent waves. Takes any swell north through east, so can get waves in summer. 2-10ft. Remote spot so go with friends. Intermediate to advanced. Uncrowded or empty! Watch where you park car and what you leave in it.

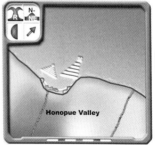

Honopue Valley

Head East from Niulii on the 270, to the end. Take the walking trails past Pololu Valley and Honokane Stream. Another few miles of trekking into Honopue Valley.....

A hard core adventure. If you want to score, check the bays on the way for swell to avoid disappointment. Right-hander in the eastern corner, plus other peaks over reef and volcanic sand. Needs Kona or early morning glass. Power peaks. Do not go alone. Winter and summer. 2-10ft. Intermediate to advanced. Deserted. Watch where you park car and what you leave in it.

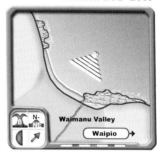

Waimanu Valley

Waipio →

Trek in on foot from Waipio. 4 miles of adventure.

Black sand beach-break off the boulder / volcanic sand beach. A consistent spot all year round, with peaky shifty lefts and rights. Requires Kona or early morning glass, and is badly affected by trades. Another spot of beauty and the usual warnings apply. Uncrowded. Consistent. 2-6ft. Intermediates. Watch where you park car and what you leave in it.

H6

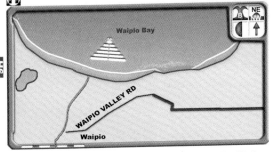

Waipio Bay

WAIPIO VALLEY RD

Waipio

The last accessible spot North of Hilo. Drive up on the 19, then take the 240 through Honokaa and Kapulena to Waipio. 4WD track to edge of beach.

This bay is the beginning of a range of remote valleys leading to often deserted beaches. From here west, there are long treks to beautiful bays. You will have 2 reasons to make these treks. 1; you love verdant scenery. 2; Kona conditions or early morning glass. Trade winds from the northeast wreck almost the whole area.

Waipio is a huge expanse of black sand beach with a heap of options. Best of these tends to be the rivermouth, where the volcanic sand bottom is sculpted by Waipio stream into quality lefts and rights with good channels for paddling. Winter storms ensure that these banks are regularly given a face-lift, making the place vary in quality. It's rarely flat though, and you might find it a good start point from which to assess the conditions for the rest of the valleys. If there's waves here there will be waves everywhere.

HONOLII

Head North from Hilo on the 19. A couple of miles up just before the bridge.

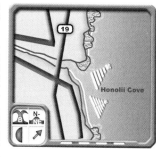

Some quality lefts outside the rivermouth, with varying amounts of lava pebble/rock bottom. Rights also, sculpted by the river outflow. This is another Kona spot, awful in trades. It also requires winter north to northeast swells, or trade-driven easts. Good spot but crowded. 3-8ft or more. Fairly consistent. Intermediates. Around the corner **Tombstones** is hell man paradise; a hard core reef break with heavy thick lip.

THE BAY FRONT

In the town of Hilo, at the West end of the beachfront.

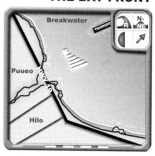

On maxed out North to northeast swells, the harbor break wall combs the energy into manageable beach peaks, with an occasional excellent left-hander that can produce long fast rides. Very fickle. Needs winds in the southerly quadrant. 2-10 ft. Intermediates. Crowded if actually working. Check it when all else is huge madness.

BLONDE REEF

Off the Northern end of the Hilo breakwater.

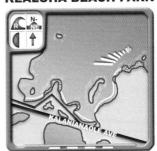

Infamously fickle right hand reef break that peels along the coral reef outside the enormous breakwater. It handles very big NW through NE swells, and can deliver well in excess of 15ft.

Access is by lengthy paddle-out from the protection of the breakwater, and these days towing in is becoming the favored option. This is a pretty far out spot, and a heavy wave when on. 4-20ft. Uncrowded. Absolutely for experts only.

KEALOHA BEACH PARK

From Hilo, head north on the 19 to the park.

Some fast shallow reef breaks in this area, including **Four Miles** (which is also the alternative name for the park). A right hand reef/point setup over rocky bottom. Shoreline here is also pretty rocky so care needed. Best in Kona winds, or early morning glass, and a solid northeast swell. Also, the intrepid can check **Hawaiian Village** just around the western point, for 6-15ft right-handers on reef. Winter waves. Advanced. Medium crowds.

RICHARDSONS

Head out of Hilo on the 19 to Leleiwi Beach Park. Paddle-out by Richardson Ocean Centre.

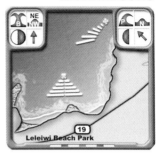

There are several options here. The beach-break directly off the Ocean Centre is a fun black sand (and a few rocks) break with peaky lefts and rights. 2-5ft. Consistent. Crowds. Intermediates. Fun. The point at the eastern end hosts an occasional right-hander if the swell is big enough and hitting from the north to northeast. It likes glassy conditions as slightly affected by trades. 6-15ft. Inconsistent. Medium crowd. Advanced.

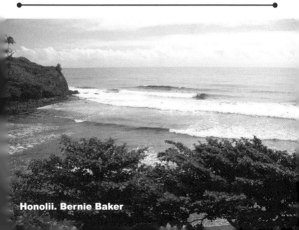

Honolii. Bernie Baker

H6

Head east from Pahoa on the 130. Into Kapoho Bay on the eastern end of the island. Head for Iwo Road in the middle of the bay.

A series of reef breaks dot the bay, and can be a good option when there is a respite from the trade winds. Definitely best to check it during periods of no wind, or Kona winds.

There are setups for all levels here, and best swells come from the southeast.

The reefs handle all sizes, but generally the best conditions are 3-6ft. You can often find yourself in uncrowded conditions here, but when it's on a solid local crew will be there to snaffle the best of it; pay attention to etiquette.

Consistent. 2-10ft. Intermediates. Shallow reef set-ups. Surf it early morning and you could catch it perfect though.

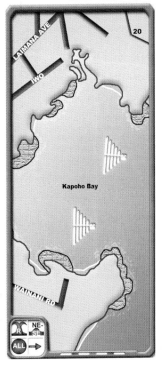

Head to Pohoiki town. Then Isaac Hale beach Park, which extends to the south.

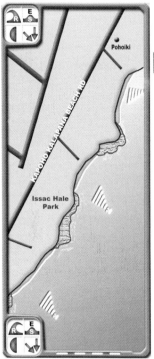

This is one of the last stops on the way south from Kapoho before the road peters out into trails. One of the best and most famous waves on the Big Island, **Drainpipes**, was one of several victims of lava flows that occasionally reclaim land by pouring into the ocean and solidifying. Perhaps with rising sea levels these flows will one day be surfed.

In the mean-time, Pohoiki Bay features 3 small rock / sand beaches, each with quality reef breaks; 2 great rights and a super long left. It needs some solid south or east juice to work properly, as well as offshore winds generated in the brief periods between trades. At these times, cool air can drop down from the mountains in the early morning and be offshore across the whole island. Worth a look. 3-10ft. Low crowds. Intermediates. Consistent.

SHACKS

Head to the little beach just north of Pohoiki.

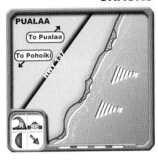

Originally named because there used to be shacks on the beach, this spot now offers shacks of the liquid kind. Fast reef lefts with barrel potential and sucky sections. Best avoided at low tide unless you're good, with mid to high making life easier. The place needs early morning light winds / glass, although the less gusty trades are surfable. 3-8ft. Consistent. Solid local crew. Intermediate.

APUA POINT

A trek on foot. First take the Chain of Craters Road south from Volcanoes National Park. When you see the sign for the Puu Loa petroglyphs, get out and walk west on the Puna Kau Trail...for 5 miles!

Big-wave hell-man spot off the point. Lefts and rights in deep water, working on any swell with an element of south in it. Trades are not a problem for the lefts, but generally best when glassy, early morning. 3-20ft. Remote. Do not go alone, and tell Kilauea Visitors Centre you're going. Advanced only.

KEAUHOU POINT

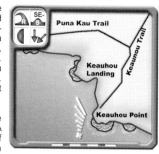

A trek on foot. First take the Chain of Craters Road south from Volcanoes National Park. When you pass the Pauahi Crater, fork right on 4WD track. Then trek the Keaunou trail for about 7 miles. Keep bearing south and it leads you to the point.

Another serious adventure for those tired of crowds. A long left-hand point / reef setup that works on south through southeast swells and winds north through east. A stunning spot, but remote so 2 rules apply; don't go alone, and tell the visitors centre at Kilauea you're going.

HALAPE SHELTER

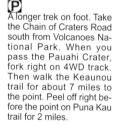

A longer trek on foot. Take the Chain of Craters Road south from Volcanoes National Park. When you pass the Pauahi Crater, fork right on 4WD track. Then walk the Keaunou trail for about 7 miles to the point. Peel off right before the point on Puna Kau trail for 2 miles.

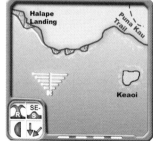

Remote mysterious reef break working on lava and boulders in another awesome setting. Steep hills protect from some trade-winds and encourage early morning glass-offs. As usual, don't go alone, and tell the visitors centre at Kilauea you're going.

PUNALUU

Head north on the 11 from Honuapo, and take a right on Punaluu Rd. to Punaluu Black Sand Beach.

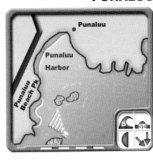

Mellow, predominantly right-hand patchy reef/beach-break working on southeast swells and Kona west winds. One of the last spots on the main road before you're in David Attenborough mode having to battle through the jungle and lava flows, so it doubles as an indicator for the spots further north. 3-6ft. Fairly consistent. Semi-crowded. Intermediates.

HONUAPO BAY

Head into Honuapo on the 11. Then go into Whittington Beach Park at the south end of town.

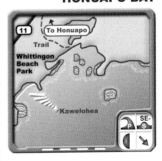

Solid left-hand point break working on south through southeast swells and early morning glass or Kona winds. Adversely affected by trades. Take-off zone is over laval rock, with patchy sand sections. Medium crowds. 3-10ft. Intermediate plus. Solid southeast swells are best in this pretty bay.

KAALUALU POINT

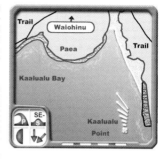

Ⓟ Head East past Waiohinu on the 11. Right turn towards, and past Kipuka Nahuaopala on Kaalualu Waiohinu Rd.. To the end. 4WD/Walk 5 miles south to the bay.

Protected bay features nice left-hander breaking on lava and sand mix, just off the old cattle chute. It offers some protection from the trades, and needs solid south swell to work well. When on, long walls peel into good channel. 3-10ft plus. Low crowds. Advanced.

KAHUKU RANCH

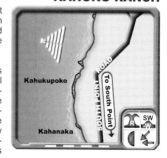

Ⓟ Head towards South Point on South Point Road, from Puueo. Small white sand beach about a half mile before the point.

Pretty consistent rights and lefts over lava / coral reef. Works well in prevailing trade-winds from the east or northeast, producing steep take-offs into the barrel, and critical hollow sections at lower tides. 3-10ft plus. Variable crowds as last spot on the main road but far from town. Intermediate to advanced.

HOOKENA

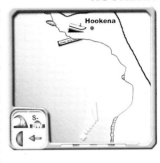

Head to Hookena via the 11. The beach park runs south from the boat ramp.

A nice little corner for surf options during trade-winds. There's a notable left reef that works in any south type swell direction, and produces powerful fast walls with thick barrel sections. Can get waves from 3 to 8ft plus, and pretty consistent for a south facing option. Crowds medium. Best in summer. Intermediates. One of the last spots on the trip south which do not require 4WD or long walks.

PALEMANO POINT

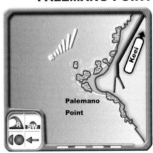

Head north from Honaunau on Puuhonua Rd.... 2 miles on your left through Keei.

Smaller lefts that work pretty consistently on any swell, south through west. Coral reef peak that gets pretty shallow at low tide, and closes out when over 6ft. Good fun hollow waves on prevailing trade winds, with short and sweet barrel experiences possible. Watch the rocks. 2-6ft.

Solid local crew, so observe surf etiquette. Intermediates.

Head south from Kealakekua, and turn off the 11 at Captain Cook, right on Napoopoo Road towards the bay. Take right on Middle Keei Road.

Dramatic cliff-lined bay holds 3 good options for days of trade-winds and any south swell.

Manini Beach has a quality left-hand point set-up over patchy coral detritus, at the end of Manini Road. Solid south swells can wrap here and create long power waves up to 10 ft. All tides, with low tide drawing water up off the reef into fast critical sections.

A little further into the bay, the beach-break called **Ins and Outs** is a backwash body boarder heaven. It's off the bouldery beach at Napoopoo. Amusing to watch the crowds of kamikazes here. 2-6ft. Semiconsistent.

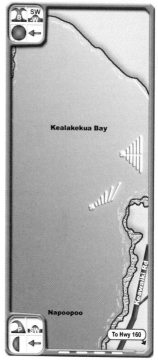

H6

Kealakekua Bay

Napoopoo

To Hwy 160

KAHALUU BEACH PARK

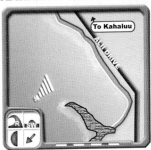

P From Kailua-Kona, head south on Alii Drive to Kahaluu. The beach Park runs south from here.

Some mellow beach / patchy coral waves, with a nice peak near the end of the boulder wall. Likes trade winds and solid southwest swells. 3-8ft, Medium crowds. Fairly consistent. Intermediates. Summertime swells best, but doesn't get as big as breaks further south.

DISAPPEARING SANDS

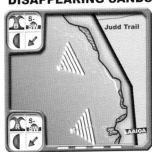

P Head to White Sands Beach Park on Alii Drive, North from Kahaluu by about a mile.

AKA **Magic Sands**, because this beach magically disappears when large swells wipe out the sand base and expose the rocks. The manageable beach-break works in any south to west swell, with peaks breaking left and right. 3-6ft. Crowds. Intermediate. There's also a left and right reef break in deeper water at the southern end. This requires a solid south through southwest swell. 5-10ft. Medium crowds. Intermediate to advanced.

LYMANS & BANYANS

⭐ Ⓟ

Banyans; Off the Kona Bali Kai Hotel, opposite the famous Banyan tree, Alii Drive.

Right & left reef break that hosts some hollow, fast square barrels on trade winds with almost any swell, west through south. On more south swells the lefts come into their own with longer rides and better refraction. The opposite is the case on more west-northwest swells. All tides, but low is fast and hollow. 3-10ft. Consistent. Crowded with a solid local crew who know every take-off spot. Show respect and patience here. Advanced.

Lyman's: off Kamoa Point, a click south on Alii Drive.

Well known busy left hand point break working best on south-southwest wrapping swells. OK take-off leads to long walls tapering off into a deep channel. More west swells can create a wedgy take-off and shorter more critical sections. Most tides work but it's a rocky spot, so low is a bit gnarly when smaller. Fairly consistent. 3-10ft. Crowds to the extreme. Advanced.

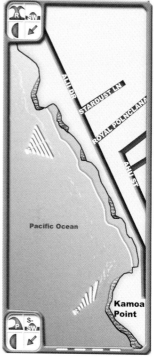

HONLS & GENERALS

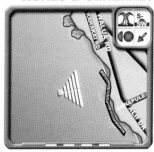

From Kailua-Kona, head south on Alii drive. Its the first wave you'll see, off the rock wall.

Some call it Hanno's. Either way, a great left and right reef break on lava / coral floor. Fast shallow sections working in trade-winds and west to southwest swells. Plenty of locals to share the experience, and you need to heed the usual surf code of conduct to avoid creating your own un-doing. 2-6ft plus. Intermediate to fun. Further south on Alii Drive is **Generals**, a more advanced right hand break peeling off a rocky bottom on more west oriented swells. Crowded. 3-10ft.

HULIHEE PALACE

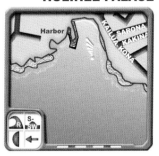

Right in town at Kailua-Kona, named after the museum of the same name, right in front of the sea wall.

Fast, expert left-hander over sharp shallow lava / coral. Some barrels of consequence appear here, with lower tides pretty critical and sucky. A very hollow wave, liking south to southwest swells and a mid tide. Plenty of crowd to share with, and sharing is the code here. 3-8ft. Shallow. Reasonably consistent. Advanced.

HONOKOHAU & PINETREES

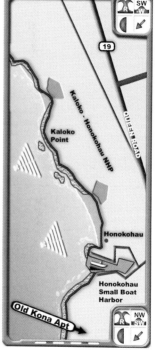

Head North from Kailua-Kona on the 19. Turn off left after 2 miles, to Honokohau Small Boat Harbor.

Honokohau: Just north of the harbor is a lava/sand/rubble beach with a quality setup just off-shore. Breaking over sand and reef mix, there are lefts and rights which vary as the swell clocks from northwest (better rights) through southwest (great lefts). 3-8ft. Moderate crowds. Intermediate.

Further up through the park, off Kaloko Point is the renowned **Pinetrees** break. You can get here by taking the turnoff from the 19, just after the harbor. Known for the hollow, fairly long reef lefts that jack up over the reef, but occasional good rights too. Most tides, although low is a bit critical. Fairly consistent spot. 3-10ft is good.

To the south in **Old Kona Airport State Recreation Area** is a selection of reef breaks that are best tackled at high tide due to the shallowness. They take most swells from northwest through south.

In the Kekaha Kai State Park. Head to Kona Airport, and take the tracks north through the park to Mahaiula.

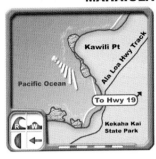

Lava flows and awesome nature characterize this area, and some quality waves. Right hand reef break best in west swells and trade-winds. This spot isn't always breaking right, but when on is a heavy hollow power wave. Take-off zone is near the rocks but shoulder tapers into a channel. 4-10ft. Medium crowds and often quiet. Advanced surfers.

MAKALAWENA

In the Kekaha Kai State Park. Head to Kona Airport, and take the tracks north through the park past Mahaiula, to Makalawena village.

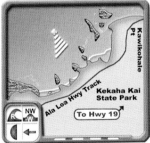

This next stop up the trail is a rocky beach with a nice winter right breaking over lava/patchy sand bottom in west to northwest swells. Plenty of hard surfaces to hurt the shins, but the wave can be curiously benign on the right tide. Works well on the trade-winds. 3-8ft. Uncrowded. Local crew to be respected. Intermediates.

KIHOLO BAY

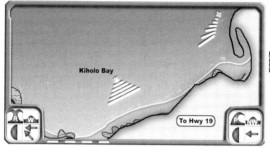

Head north up the 19 from Kailua-Kona, and turn off to Kiholo. Tracks lead to a resort. Reef break in middle of bay by coconut trees. The point is at the eastern end.

Huge 2 mile bay with a pretty black sand and lava pebble beach. Bang in the middle lies a nice a-frame reef break that works with all swells from west to north. It works on all tides and can produce nice fast walls with the odd suction section on lower tides. 3-10ft. Uncrowded. Fairly consistent. All levels.

At the top of the bay is a fickle point break setup. It features rights that work on very big west swells, and some north swells. Breaking from 4-10 feet, it's not always perfect but can create long rides and is protected from trade winds. Uncrowded. All levels.

Several other good options in the area, take your pick.

The wilderness of this spot is punctuated by the smart Four Seasons resort. Turtles abound, as does plenty of sea life in the several good snorkeling spots here. In fact it is a great place to be, waves or not.

KEAWAIKI BAY

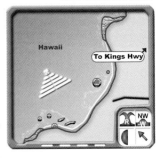

A couple of miles north of Kiholo Bay on the Kings Hwy track. You can also access it by turning off the 19 at Keawaiki.

Nice reef break at the southern end of this black sand bay. Its lined with rocks so a bit sketchy when exiting. Right and left peaks jack up on shallow lava and fringe reef producing fast sharp barrels in easterly winds and westerly swells. Mid to high tide is always a safer option, and this spot handles 6ft plus swells. Medium crowd. Intermediates.

ANAEHOOMALU BAY

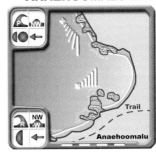

Just North of Keawaiki off the 19, take a left off the Hwy before the golf course.

2 main spots here; the point up at northern end is a quality right-hander on lava and pebbles, that reels in winter on west to northwest swells. Intermediates plus. Medium crowds.
At the south end is a predominantly left hand reef break frequented by sail boarders. It holds solid swells and is best when winds are moderate, on west swells. 3-10ft. Crowded with sail boards / kites. Fairly consistent. Intermediates.

BROWNS

Off the Mauna Lani resort and Golf Club. Take Mauna Lani Road off the 19, 3 miles south of Puako.

Brown's, or **John Brown's**, is a mellow reef break off the resort. Left and right peaks break in west to northwest swells, even north. Most tides are OK for this break. Works at 3-8ft. Crowds when on. Intermediates. Relaxing, fairly consistent winter spot and there's always golf if it's flat. In addition, this is a pretty white calcareous sand beach that's great to hang out at.

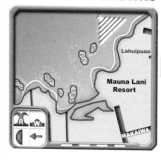

H6

67'S, 68'S & 69'S

Just North of Puako in Waialea Bay.

A series of quality, hollow, barrelling reef breaks in these twin bays. From north to south; **67's**: A quick-fire right-hander near the point over reef. There's also a shore break inside of this. **68's**: Near the rocky outcrop - super hollow over quite shallow reef. **69's**: Another super hollow left spitting out square barrels regularly in winter, and often compared to Pipeline. These waves tend to be best on a 4-6ft swell in trade winds. Semi consistent. Crowds. Advanced.

SPENCER BEACH PARK

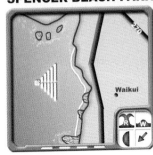

H6

A spit south of Kawaihae Harbor on the 270, and take a right on the beach road.

Sandy beach looks out on a rare reef-break setup with lefts and rights. Needs big winter west swells to be effective. When on, locals know it pretty quick, and it gets packed. Fun spot though, working best in trade-wind conditions. 5-10ft. Intermediates. The beach park is a hub of local activity in a relatively densely populated area, and a fun place to chill out if it is flat everywhere.

KAWAIHAE

Head into Kawaihae. There are a series of reefs off the harbor and it's channel.

A busy smorgasbord of waves when on, which is usually in winter. The reef on which the harbor wall was anchored hosts lefts and rights, notably the left into the boat entrance channel. Varying levels required here, but at the right tide, it's approachable and fun. Needs trades to work well, or early morning glass. Not all swells get through, so winter big stuff is best. 3-10 ft. Intermediate / All levels. Crowds.

Background

Kauai is a natural paradise fringed by calcareous sand beaches and pristine reef. It stands apart from the other Hawaiian islands both in distance and history; Kauai was not truly conquered during the reign of King Kamehameha. You will therefore find that it has a unique and proud history and people, who will welcome you if you show humility and respect towards man and nature. Put simply: "Malama Pono".

When to go

Winter brings uninterrupted swell from northerly quadrants. Many north shore spots, however, are ruined by northeast trade-winds. This means that one of the key factors is how much east or west is in each swell; northwest gives you off-shore options down the westside, and northeast can fire up parts of the southeast coast. Cannons and Tunnels offer some of the biggest squarest barrels anywhere. **Summer** swells from the south ignite some of the best and most gnarly spots on Kauai; Acid Drop and Centers being of note. For this reason, Kauai is outstanding in summer.

Hazards

Big waves, reef cuts, occasional sharks, sea-urchins, currents, remoteness, boulders. Be considerate in the surf, and diplomatic on land, and you'll make friends.

M	Swell Range		Wind Pattern		Air		Sea	Crowd
	Feet	Dir'	Am	Pm	Lo	Hi		
J	3-20+	n-nw	ne low	ne med	65	77	75	hi
F	3-15+	ne-nw	ne low	ne med	65	77	75	hi
M	2-12	ne-nw	ne low	ne med	65	77	75	med
A	0-6+	nw-sw	ne low	ne med	66	79	75	med
M	0-6+	se-sw	ne low	ne med+	66	81	77	med
J	0-6	se-sw	ne low	ne med+	70	83	77	med
J	0-6	se-sw	ne low	ne med+	68	85	79	med
A	0-6	se-sw	ne low	ne med+	68	86	81	med
S	0-9+	sw-nw	ne low	ne med+	66	86	79	med
O	2-12+	ne-nw	ne low	ne med	66	81	77	med
N	2-20+	ne-nw	ne low	ne med	65	81	77	hi
D	3-20+	n-nw	ne low	ne med	63	77	75	hi

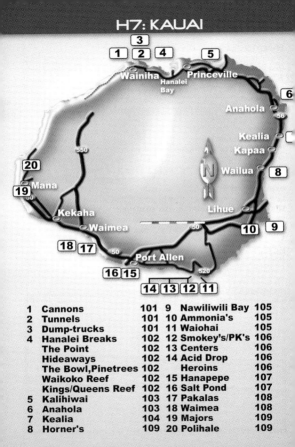

CANNONS

Head to Haena, west of Hanalei on the Kuhio Hwy. It's 1/4 mile off Haena Beach Park.

A lava ledge extends off-shore and takes west through north swells and throws up jacking, bar-relling lefts from 4 to 15ft plus. Wave named due to similarity between exit-ing its heavy tube with the spit, and being fired out of a cannon, and due to the booming sound of the lip exploding. This is a hard core winter wave with currents, reef sharks, a long paddle and some very big waves possible. Consistent but trade affected. Advanced to hell man level. Pretty, tree-fringed sand beach.

TUNNELS

Head to Haena Beach Park, next to Cannons.

The big sister of Can-nons. Very big rights pos-sible here, giving equally gaping barrels over the offshore lava reef. Out-side sets break at **Dump-trucks**, and can reach 20ft. Possible Kauai's primo tow-in spot, but paddle surfing opened the way. Likes northwest to west winter swells, although the summer throws up trade-wind generated northeast swells too. Unlike Cannons, trade winds are fine here, with a straight east being perfect. 4-20ft. Moderate crowds. Currents. Expert. Another beautiful beach.

Hanalei itself is a right-hand point break on a reef at the northeastern end of the bay. It peels for several hundred yards from **The Point** way outside, through to the crowded, hollow **Bowl** section on the inside. On smaller days it's an easy wave and super-crowded, but it handles up to 20ft plus in winter north swells. All levels. Further inside the bay, near the rivermouth, is **Pinetrees**, a fickle, mostly left hand sandbar setup which is classic given the right conditions: solid north swell with east to south winds. 2-5ft. Shifty. Currents. Intermediates. **Hideaways**, north around Puu Poa Point by the Pali Ke Kua apartments, is a reef setup with some quality waves too, predominantly right, breaking on coral. 3-10ft. Intermediate. Off the western point of the bay at Makahoa Point, **Waikoko Reef** pushes up a good, huge left-hander breaking into the cliffs and wedging if the conditions are perfect. Fickle wave needing solid N swells and Kona or glassy conditions. Way outside, **Kings Reef** and **Queens Reef** are tow-in spots these days. Beautiful mountainous back-drop.

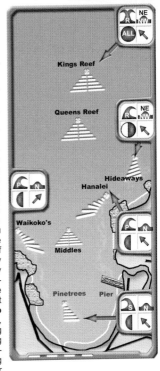

KALIHIWAI

5 miles east of Hanalei, take the Kalihiwai turnoff after Princeville Airport.

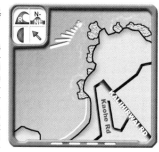

One of the few good spots on this stretch, thus heavily guarded by tight local crew. Western point has a wave, as does the beautiful, forest-fringed calcareous beach in the middle. Of note however, is the right-hand point-break at the eastern end. This is a hard-core, wedging take-off close to rocks, into a power wall that holds up to 15ft. The spot needs glassy mornings or south to southeast winds, and a lot of swell. Inconsistent. Maximum care required in observing surf etiquette. Crowds. Advanced.

ANAHOLA

To the town of Anahola, then take the road to Kahala Point.

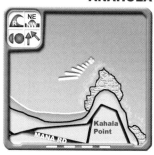

There are expanses of beach-break here in the beach park. Among the best however, is the right-hander at Kahala Point. Breaking over shallow reef, it requires Kona conditions from the south. Pretty consistent year-round, as takes winter north swells as well as trade-wind generated easts. Handles size well. All levels. Great place to take a picnic.

KEALIA

Head into Kealia on the 56, beach visible from road.

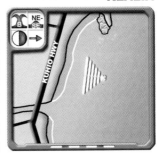

Series of beach peaks across this rivermouth and coral detritus beach. Trade winds tend to blow it out if they are very east, but northeast winds are fine, and there is some protection from the derelict landing at the northern end. Can be fun on kona days or early morning glass. Tends to max out at over 4ft, but consistent, punchy little waves. Vibrant local crew and often crowded although peaks absorb it well. Beginner to intermediate.

HORNER'S

Head south of Kapaa on the 56. At the northern end of the beach at Wailua.

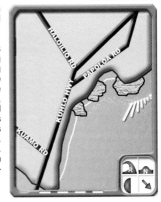

An often heavy, sometimes fat left-hander wrapping into the bay and breaking over reef. Trade winds rip it up and kona winds are good. This makes it fickle, as winter north swells tend to wrap in best. Low tide is pretty rocky, but all tides are OK. Intermediates. Medium crowds. 3-10ft. Beach-breaks to the south are occasionally fun if desperate for a quick surf.

NAWILIWILI BAY & AMMONIA'S

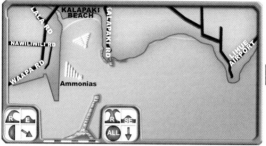

Kalapaki Beach: N end of bay, off resort. Ridiculously mellow reef-break inside the protected bay. Blocked from most swells, but gets remnants of big summer SE swells. 2-4ft. Beginners. Crowds. Screaming kids. **Ammonias**: off the seawall on Waapa Rd. Fast, wedging rights slam into the wall. Needs solid ESE, E, or truly monstrous NE swells. Trades choppy. Powerful, throwing, mutated barrels for experts only. 3-6ft. Crowds. Rocks. Advanced.

Ⓟ WAIOHAI

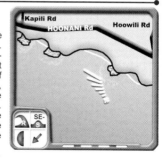

Poipu, out the front of the Waiohai Beach Resort. Good summer left-hander on south to southeast swells. Breaks on reef setup inside a small point, and works well in trade winds. Very crowded spot. All levels. A mile outside id First Break, maybe the biggest south shore wave in the islands. Sunset style right and a short left at 3-15ft. Dangerous, Expert only, and never alone.

From Koloa, head south to Koloa Ramp and take a right along Lawai Road. The first wave is off the seawall at the Beach House Restaurant, just west of Baby Beach. **PK's**, a hard sharp left breaking on shallow coral heads into the bay. Take-off at the outer peak (**Smokeys**) is super-steep, often straight into the barrel with a hard charge to the shoulder. The end reforms into a grommet-filled right, breaking close to the wall. SE swell & NE winds. Rocks underfoot. Advanced. Very crowded. 3-8ft. Next up to the west is **Center's Beach**. Critical, hollow right exhibiting gaping barrels over coral reef. Likes southwest swell and northeast trade-winds. In these conditions it's a fast long wave tapering into the channel. More south and the wave gets slightly less tapered, and can close out on the shallow inside. Lefts start to fire when the swell veers in from the southeast. 3-6ft plus. Tight individual crew for both lefts and rights. Advanced. Finally, **Acid Drop**, or **The Drop** is the most critical wave of the lot. Somehow the sharp reef that creates this wave has regenerated after hurricanes Iniki and Iwa, and still bring us a right-hander that sucks up into a thick battle-axe lip followed by yawning, almond shaped barrel and...that's usually it. The end section can notoriously close out over sharp shallow coral heads. 2-8ft. Usually makeable. Semi consistent. Crowds. Tight local crew. Expert. If these are not enough, **Heroin's**, around the point to the west, is one of the most dangerous waves anywhere, breaking parallel to shallow reef.

HANAPEPE

Head to the port of Hana-pepe. Numerous reefs in the area.

Fairly murky and sharky spot due to rivermouth and harbor pollution / fishing. There are a set of reefs here that work on southwest to southeast swells and trade-winds. You can check it from the break wall, and take your pick. All levels. 3-8ft. Consistent. Summer spot.

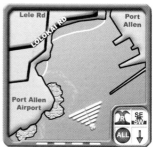

SALT POND

West from Hanapepe on the 50. Turn off to Salt Pond Beach Park.

Named after the salt producing ponds behind the beach. Great spot during trade-winds, which can combine with summer south through southwest swells to create jacking tubes over the reefs here. Right and left setup in front of the salt pond wall. 3-10ft. Consistent enough. Crowds from town. Intermediates plus.

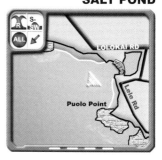

PAKALAS

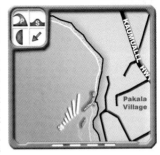

Head west out of hana-pepe on the 50 for 5 miles to bridge over A'akukui Stream. Path on left leads to Pakala Point.

Long, fast, hollow left also known as Infinites due to its lengthy walls. Breaks over ledge reef, working on south to southwest swells. 2 or 3 separate peaks around the point can join into 1 long barrel fest in perfect conditions., i.e. big south swells and northeast trade-winds which wrap around the setup. The lower tides make for a shallow inside section, but super hollow waves. Higher tides are safer but fatter. 3-12 ft. Major crowds. Intermediate plus. Beautiful.

WAIMEA RIVERMOUTH

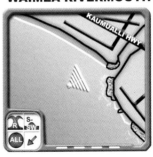

Head west to Waimea on the 50. Cross Waimea river and take left to the beach.

Sharky spot by the river-mouth. Lefts and rights over reef that gets sporadic coating of sand. Works on any swell from west through south, and northeast trade-winds. Be extra careful surfing after rains, which bring extra feed to awaiting sharks. 3-8ft. Consistent. Intermediates.

A 15 mile beach runs north of Kekaha, with a military missile testing facility at it's heart. When it's open, present your I.D. and head for rec area 3. Major's is a long right at the top of the bay. 3-10ft. Scarey paddle with heavy current. Likes straight north swells and easterly winds. Advanced surfers. Access Thurs thru Sun, & now requires application at neighborhood centers. 10 min walk south for **Family Housing;** lefts and rights to 6ft, summer and winter.

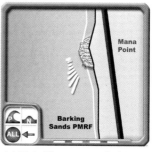

POLIHALE & KINI KINI POINT

Polihale State Rec area. Beach-break peaks along beach at bottom of cliffs; Immensely beautiful. Often wind affected. 3-6ft plus. Intermediate to advanced. Dangerous currents even when small, and far from help. Dirt road impassable if rainy. **Kini Kini Point**, at the northern end of the beach and the gateway to the Na Pali coast, is a huge, super-long right-hander that gets towed in. It handles any amount of straight north swells, and trades. 6-20ft . Advanced. 109

HAWAII SURF SUPPLIES

OAHU - DIAL (1) 808

Aiea
Hawaiian Island Creations, Pearlridge Center, 483-6700
Town & Country Surf Shop, 98-1005 Moanalua Road, 483-5499

Haleiwa
North Shore Ohana Surf, 56-176 Kamehameha Hwy, 638-5934
B.K. Ocean Sports, 66-215 Kam Hwy, 808-637-4966
Barnfields Raging Isles, 66-250 Kam Hwy Bldg B, 808-637-7707
Beach Road Island & SurfWear, 66-412 Haleiwa Road, 808-637-4375
Hawaii 50, 66-145 Kam Hwy, 808-637-3266
Kammie's Market, 59-176 Kam Hwy, 808-638-8131
Northshore Boardriders, 66-250 Kam Hwy #G-100 808-637-5026
Planet Surf North Shore, 59-246 Kamehameha Hwy,808-638-5648
Rainbow Bridge Gift, 62-620 Kam Hwy, 808-637-7770
Strong Current, 66-208 Kam Hwy, 808-637-3406
Surf & Sea 62-595 Kam Hwy, 808-637-9887
Surfers Paradise, 55-730 Kamehameha Hwy, 808-293-4883
Tropical Rush, 62-620 Kam Hwy, 808-637-8886

Honolulu
Basil Hawaii, 1001 Dillingham Boulevard, 842-0034
Blue Hawaii Surf, 2330 Kalakaua Ave, 923-2583
Blue Planet Surf Gear, 813 Kapahulu, 845-4721
Boardriders Club Hawaii, 2301 Kuhio Ave, 922-5900
Boardriders Club Hawaii, Waikiki Town Center, 924-8100
Boardriders Club Waikiki, International Market Place, 926-5800
Chans Surf, 134 Kapahulu Ave, 922-5664 / 7873
Classic Surfboards, 451 Kapahulu Ave, 735-3594
Clips, 1221 Kapiolani Boulevard, 589-1351
Downing Hawaii, 3021 Waialae Ave, 737-9696
Drift Surf, 1442 Kona St, 941-6699
Function Surf, 2424 Kalakaua Ave, 922-5717
GDG Gravity Defiance Group, 1724 Kalauokalani Way, 946-9478
Go Bananas, 799 Kapahulu Avenue, 808-737-9514
Go Nuts Hawaii, 159 Kaiulani Ave, 926-3367
Ground-swell Hawaii, 46-018 Kamehameha Hwy, 247-9184
Hans Hedemann Surf Hawaii, 2586 Kalakaua Ave, 926-8816
Hapuna Surf Wear, 831 Pohukaina St, 597-1866
Hawaiian Island Creations, Ala Moana Center, 973-6780
Hawaiian Island Creations, Pearlridge Center, 483-6700
Hawaiian Island Creations, 2617 South King St, 971-6715
Hawaiian Rush Surfboards, 525 Cummins St, 596-0580
Hawaiian Southshore Outlet, 320 Ward Ave, 597-9055
Hawaiian Surf, 66-250 Kamehameha Hwy, Building G, 637-8316
Headside Snowboard Shop, 499 Kapahulu Ave Suite 102, 739-1317

HAWAII SURF SUPPLIES

Honolua Surf Co, 1450 Ala Moana Boulevard, 946-0794
Honolua Surf Co, 2335 Kalakaua Ave, 921-3489
KOA Board Sports, 2420 Koa Ave, 923-0189
KOA Surf Classics, 909 Waimanu St, 593-0747
Local Motion, KOKO Marina Center, 396-7873
Local Motion, 1958 Kalakaua Ave, 979-7873
Local Motion, 428 Sumner St, 523-7873
Local Motion Girls, 2166 Kalakaua Ave, 926-7873
Pipe Dreams Surf Co, 1 Aloha Tower Drive, 550-0275
Planet Surf Hawaii, 159 Kaiulani Aveste 108, 924-9050
Makaha Quiksilver Boardriders Club, 1714 Kapiolani Boulevard, 951-7876
QS Boardriders Club, 2301 Kuhio Ave #307, 808-924-8102
Russ K Boardriders, 1714 Kapiolani Blvd, 808-951-7876
RV's Ocean Sports, 3348 Campbell Avenue, 808-732-7137
Sand Island Surfboards, 50 Sand Island Access Road, 841-5466
Seawind Challenge, 353 Royal Hawn Ave, 922-0036
Sera's Surf & Sport, 1450 Ala Moana Blvd #1074, 808-949-7828
She Rips, 2143 Kauhana St, 739-2838
Soul Surfing Crew, 875 Waimanu St, Warehouse 504, 597-8804/8801
Splash Hawaii, 1450 Ala Moana Boulevard, Suite 1111, 942-1010
Surf Garage, 2716A South King St, 951-1173
Surf Star Hawaii, 3046 Monsarrat Ave, 739-5660
Town & Country Surf Shop, Ala Moana Center, 973-5199
Town & Country Surf Shop, Kahala Mall Shopping Center, 733-5699
Town & Country Surf Shop, Pacific Beach Hotel, 971-5419
Town & Country Surf Shop, The Ward Warehouse, 592-5299
Town & Country Surf Shop, Uptown Pearlridge, 483-5499
Town & Country Surf Shop, Waikiki Trade Center, 971-5599
Town & Country Surf Shop, Windward Mall, 233-5799
Turbo Surf, 870 Kapahulu Ave, Suite 110, 738-8726
Waipahu Raquet Surf & Sports, 1831 South King Stream 201, 941-4911
Wave Riding Vehicles, 1888 Kalakaua Ave, Suite C102, 979-4978

Kailua
Hawaiian Island Creations, 354 Hahani, 266-6730
Kimo's Surf Hut, 151 Hekili St, Suite 101, 262-1644
Local Motion, Windward Mall, 263-7873

Kaneohe
Local Motion Surfboards, 46-056, Kamehameha Hwy, 263-7873
Kapolei - Surfboard Factory Outlet Hawaii, 91-270 Hanua, 543-2145
Laie - Country Surfboards, 55-730 Kamehameha Hwy, 293-4883

Mililani
Da Board Shop, 95-1249 Meheula Parkway, Unit D13, 627-0717
Minami Surf, 95-232 Hoailona Place, 637-9994

Waialua
B K Ocean Sports, 66-215 Kamehameha Hwy, 637-4966

HAWAII SURF SUPPLIES

Barnfields Raging Isle Surf & Cycle, 66-250 Kamehameha Hwy, 637-7797
Christian Surfboards, Waialua Sugar Mill, 637-1783
Hawaiian Island Creations, 66-224 Kamehameha Hwy, 637-0991
North Shore Boardriders Club, 66-250 Kamehameha Hwy, Bay G100, 637-5026
Surf & Sea, 62-595 Kamehameha Hwy, 637-9887
Tropical Rush Surf Co, 62-620 Kamehameha Hwy, 637-8886

Waianae
A D Surfboard Productions, 87-658 Manuaihue St, 668-4553
B K Ocean Sports West, 86-120 Farrington Hwy, 696-0330
Hale NALU Surf Co, 85-876 Farrington Hwy, 696-5897
Jammin Hawaiian KINE Surfboards, 66-617 Kaupe Road, 637-7663

Waipahu
Blue Wave Outlet, Waikele Premium Outlet Center, 677-9696
GG Hawaiian Surf Works, 94-1198 Eleu St, 682-3070
Local Motion, Waikele Premium Outlet Center, 668-7873

BIG ISLAND - DIAL (1) 808

Hilo - Big Island Surf Co, Prince Kuhio Plaza, 111 East Puainako St
Local Style, Prince Kuhio Plaza, 111 East Puainako St
Orchid Land Surfshop, 262 Kamehameha Ave, 935-1533 / 9445
SMT Surfboards, 400 Hualani St, 935-3093

Kailua - Hansen Custom Surf Designs, 167 Hamakua Drive, Suite 103, 262-0724
Hawaiian Island Creations, 348 Hahani Street, 808-266-7750
Kimo's Surf Hut, 151 Hekili St, Suite 101, 262-1644
Local Motion, Windward Mall, 263-7873

Kailua Kona
AAMA Surf & Sport, 75-5741 Kuakini Hwy, 326-7890
Big Island Surf Co, Kona Coast Shopping, 326-7199
Honolua Surf Co, Kona Inn Shopping Village, 329-1001
Pacific Vibrations, 75-5702 Likana Lane, 329-4140

Kamuela
Big Island Surf Co, Waimea Center, 885-9283
Spyder Surfboards Hawaii, 64-1035 Mamlahoa Hwy, 887-0711

MAUI - DIAL (1) 808

Haiku - Surfboards by Vedder, 375 West Kuiaha Road, Suite 22b, 575-9960
Hana - Island Unique, Pukaauhuhu, 248-8777
Hasegawa General Store, P.O. Box 68, 808-248-7079

Kahului
Extreme Sports Maui, 397 Dairy Road, 871-7954
Hawaiian Island Creations, Maui Marketplace, 270 Dairy Road, 871-6750
Hawaiian Surf and Sports, 415 Dairy Road, Suite A, 871-4981
Hi-Tech Surf Sports, 425 Koloa St, 877-2111
Lightning Bolt Maui, 55 East Kaahumanu Aveste East, 877-3484

HAWAII SURF SUPPLIES

Maui Tropix, 261 Dairy Road, 808-871-8726
ROXY Quiksilver, 261 Dairy Road, 873-6311
Second Wind Sail Surf & Kite, 444 Hana Hwy, 877-7467
Shapers, Queen Kaahumanu Center, 275 West Kaahumanu Ave, 877-7873
Kihei
Castleton Tommy Maui Wave Riders, 3353 Keha Drive, 875-4761/7797
Honolua Surf Co, 2411 South Kihei Road, 874-0999
Local Motion, 1819 South Kihei Road, 879-7873
Lahaina
Boardriders Club, 851 Front St, 667-6698 / 7978
Boss Frog's Dive Shop181, Lahainalua Rd #B, 808-667-0485
Hawaiian Riders, 900 Front Street #J11, 808-661-1970
Honolua Surf Company, 1000 Limahana Pl. #c808-667-9781
Isana Ocean Sports, 545 Front Street #A808-661-9950
Maui Tropix, 790 Front Street, 808-661-9296
West Maui Sports, 1287 Front Street, 808-661-6252
Honolua Surf Co, Front St, 661-8848
Honolua Surf Co, Lihaina Cannery Mall, 661-5777
Honolua Surf Co, Limahana Place, Space C, 667-9781
Honolua Surf Co, Whalers Village, 661-5455
Local Motion, 900 Front St, 669-7873
Local Motion, 1295 Front St, 661-7873
Maui Island Surf Co, 505 Front St, 667-1813
Ole Surfboards, 277 Wili Ko Place, 661-3459
X It Surfboards, 505 Front St, 667-1813
Makawao
Hawaiian Energy Surf Designs, 1641 West Kuiaha Road, 572-5145
Kazuma Surfboards Hawaii, 2145 Kauhikoa Road, 573-5555
Paia - Hana HWY Surf, 69 Hana Hwy, 579-8999
Maui Tropix, 90 Hana Hwy, 579-9816
Ono Surf Supply, 120 Hana Hwy, 579-6444
ROXY Quiksilver, 22 Baldwin Ave, 579-8315
Wailuku
Valley Isle Surfboards, Kahakuloa Valley Road, 244-5230
KAUAI - DIAL ()808
Hanalei - Hanalei Surf Co, Hanalei Center, 5-5161 Kuhio Hwy, 826-9000
Kaikane Hanalei, 5-5088 Kuhio Hwy, 808-826-6908
Hanapepe - Dr Dings Westside Surf Shop, 335-3805
Kapaa - Holt Rick Sport, 5651 Kawaihoa Road, 822-0842
Tamba Surf Co, 4-1543 Kuhio Hwy, 823-6942 / 8044
Underwater, 4-831 Kuhio Hwy, Suite 154, 822-2111
Koloa - Nukumoi Surf Co, 2080 Hoone Road, 742-8019
Progressive Expressions, Old Koloa Town, 742-6041
Waimea - Wellman Surfboards, 4817 Menehune Road, 338-0888

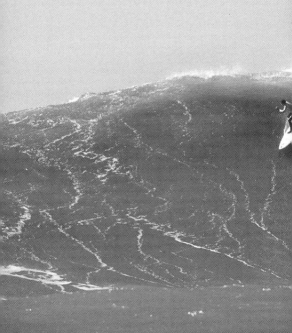

Mavericks. Bernie Baker

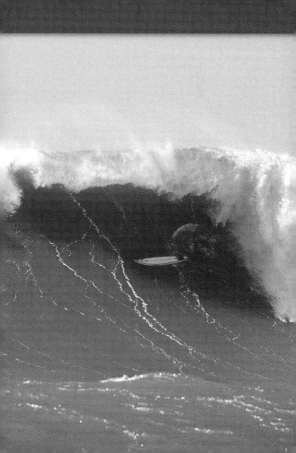

Background

Roughly defined as the swathe of south-facing coast south of Point Conception, Southern California hosts some of the worlds finest point-breaks, and a plethora of quality beach and reef setups. Maddeningly crowded, fickle, often polluted.

When to go

The swell window can be more of a port-hole. Winter swells with too much north are blocked by Point Conception, as are west and even south swells by the Channel Islands. Spots within 10 miles of one another can vary from flat to 6 ft .Swell angles on local forecast sites (see back) are accurately measured in degrees, and it pays to do the geometry here. In essence, summer is dotted with nice south swells from the tropics and Southern Ocean, but terrifyingly crowded and often plain flat. The up-side is regular morning off-shore winds. Winter relies on huge NW swells to wrap, or rogue wests caused by breakaway storm systems. Both of these happen often enough, and the glassiest of conditions occur at this time.

Hazards

Many spots policed by protective locals. Pollution. Temptation. The data chart below refers to Los Angeles waters, so temps vary slightly up and down the coast. For Santa Barbara North, see Central California.

M	Swell Range		Wind Pattern		Air		Sea	Crowd
	Feet	Dir'	Am	Pm	Lo	Hi		
J	3-10	nw	wnw low	wnw low	47	66	55	hi
F	3-10	nw	w low	w low	48	68	57	med+
M	0-6	nw	w low	w low	50	70	61	hi+
A	0-6	sw-s	offshore	onshore	53	71	63	hi+
M	0-4	sw-s	offshore	onshore	56	72	63	hi+
J	0-4	sw-s	offshore	onshore	58	75	65	hi+
J	0-4	sw-s	offshore	onshore	60	80	66	hi+
A	0-4	sw-s	offshore	onshore	60	86	66	hi+
S	0-4	s-nw	wnw low	wnw low	57	80	67	hi
O	2-8	nw	wnw low	wnw low	56	75	60	hi
N	2-10+	nw	nw low	nw low	50	69	60	hi
D	3-10+	nw	nw low	nw low	49	68	58	hi

WI: SAN DIEGO

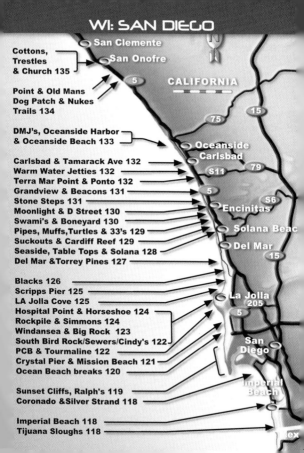

San Clemente

San Onofre

Cottons,
Trestles
& Church 135

CALIFORNIA

Point & Old Mans
Dog Patch & Nukes
Trails 134

DMJ's, Oceanside Harbor
& Oceanside Beach 133

Oceanside
Carlsbad

Carlsbad & Tamarack Ave 132
Warm Water Jetties 132
Terra Mar Point & Ponto 132
Grandview & Beacons 131
Stone Steps 131
Moonlight & D Street 130
Swami's & Boneyard 130
Pipes, Muffs,Turtles & 33's 129
Suckouts & Cardiff Reef 129
Seaside, Table Tops & Solana 128
Del Mar &Torrey Pines 127

Encinitas

Solana Beac

Del Mar

Blacks 126
Scripps Pier 125
LA Jolla Cove 125
Hospital Point & Horseshoe 124
Rockpile & Simmons 124
Windansea & Big Rock 123
South Bird Rock/Sewers/Cindy's 122
PCB & Tourmaline 122
Crystal Pier & Mission Beach 121
Ocean Beach breaks 120

La Jolla

San
Diego

Sunset Cliffs, Ralph's 119
Coronado &Silver Strand 118

Imperial
Beach

Imperial Beach 118
Tijuana Sloughs 118

IMPERIAL BEACH

Around the intersection of Ocean Lane and Palm ave in Imperial Beach.

Powerful fast beach-break peaks. Consistent year round. Breaks on south swells and combo swells too. Short to medium length rights and lefts. Lots of room. Watch for pollution. Quality- Fair to excellent. 4-8ft. Low crowds. Intermediate +. South to the Mex border, off the Tijuana River is **Tijuana Sloughs**: RL combo on outer rock ledge with sand on the inside. Handles size: just breaks further out. NW swell. E wind. All tides. Polluted. No crowds. 3-15ft. Advanced. Quality wave.

CORONADO

Head into Coronado on the 75. South of town.

Peaks on beach that bends from southwest to south facing. South to southwest summertime swells. Short powerful dumpy hollow sections that like a north to northeast wind and a medium tide incoming. Poor to fair. Protected from strong northwest winds. 2-6 ft. Inconsistent winter, best summer. Low crowds. Intermediate. South down Silver Strand Blvd is **Silver Strand**. A lengthy strip of beach peaks, good in S - W swell & E-NE wind. Good crowd avoider.

SUNSET CLIFFS & RALPH'S

From Ocean Beach, head S down Sunset Cliffs Blvd to Sunset Cliffs Park. There are a series of steep cliff trails.

Consistent reef breaks working best in winter NW swells, but OK in SW too. Lower tides generally best, and E winds. Best spots from N to S: **Luscombs**: Winter right and left. Quality. 2-12ft. **North Garbage**: Winter time peak with rights and lefts. 3-10ft. **South Garbage**: Winter peak with rights and lefts. 2-10ft. **Subs**: Winter & summer left and right peak. **Abs**: Summer or winter spot with longer lefts and shorter rights. **Chasm**: Wintertime, lined up reef left with deep channel. 2-12ft. All the above are pretty localised breaks for advanced surfers, and get very busy. Do not make the long paddle-out in a gang or a bright suit.

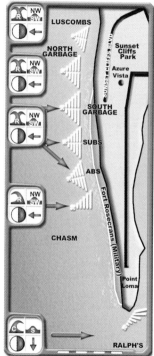

Heading south past the military reserve and some scary cliffs at **Point Loma** are a couple of quality reefs in heavy W or solid SW swells and N-NE winds. **Ralph's** is a great lined up cobblestone/rock right in very big S swells, NE winds and low - mid tide. Uncrowded. Illegal. Military land. Fickle. 6-12ft. Advanced plus. Awesome.

OCEAN BEACH PIER & JETTIES

Series of mixed quality jetty and beach breaks along Ocean Beach, which is due west of San Diego's International Airport on the south side of Mission Bay Harbor. You can park in and around Abbott Street.

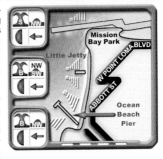

North Jetty: The long jetty on the south side of mission bay. In other words, at the north end of Ocean Beach. Sand bar rivermouth with consistent, year round, any tide peaks breaking off the South Mission Bay seawall. NW to S swells. Best on E wind. The rights can be long to sometimes hollow depending on the river flow of contaminated runoff. Quality; Fair. 1-8ft. Crowds; High. Intermediate. Gets really dirty and smelly in the water here!

Little Jetty: In the middle of Ocean Beach. A rock groyne that holds some sand-bank shape. Breaks consistent year round in northwest to south swells. Lefts fire up in summer SW swells on the north of the jetty, and rights conversely in winter. There are scattered beach-break peaks on each side that prefer smaller swells and max out on larger ground swells. Crowded on weekends, holidays and summer. All levels depending size. 2-8ft.

Ocean Beach Pier: 8 Fwy. To Sunset Cliffs Blvd. To Newport Ave. Consistent short fat to hollow left with a sand and rocky bottom on the south side that breaks into the pier. The sand beach-break rights on the north side stand up more and break better with an easterly wind, mostly walled and closed out above 8 ft. Heavy runoff pollution outlet from San Diego River and Mission Bay. Breaks best in the 2-6 foot with a west to northwest and mid- low tide. Fair quality. 2-8ft. Crowds. Beginner to advanced. AKA **OB Pier**.

MISSION BEACH & JETTY

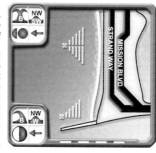

Off Mission Bay Harbor. From Downtown San Diego, Take Mission Bay Drive off the west end of Fwy 8.

Consistent fun year round beach-break that picks up southwest to northwest swells. Best when tide is higher, & closes out on big ground swells. Always a highly congested area with all kinds of beach goers and boardwalk activity. 2-6ft. Crowds. Beginner to pro. **South Mission Jetty**, on south end of beach, hosts good lefts (and a bouncy short cross-grain right into the inlet). Congested take-off zone. Nor west winds blow it out, but souths OK. Advanced. Crowds. 2-8ft.

CRYSTAL PIER

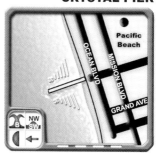

5 Fwy to Pacific Beach. Grand Ave to Mission Blvd. Then Garnet Ave.

Fun to fast hollow consistent beach-break that breaks on any swell direction from the north or south. It prefers the southwest swells and a higher tide. Can handle a northeast to easterly wind. Closes out with large ground swells. Quality-fair to good. 2-6ft. Consistent. Crowds. Beginner to pro...All levels. The pier tends to focus the swells and hold the banks together to some semblance of good shape.

TOURMALINE & SOUTH BIRD ROCK

South Bird Rock: North from Pacific Beach up Calumet Avenue around the point. Then left on Bird Rock ave. Consistent right and left, well shaped flat rock shelf reef break that breaks on north west to south swell, either side of bird rock. Varies with tide and swell direction. Higher tides are softer while low tides yield clean faster lined up sections. Breaks best on powerful southern direction swells with outgo-

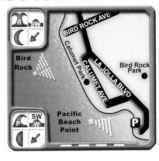

ing tide and a northeast wind. Quality- Good to excellent. 2 to 8ft. Crowds; Medium. Advanced unless small / high tide.

There are a couple of reasonable, crowd absorbing patchy reef breaks just south of Bird Rock, off Calumet Beach Park; **Sewers** and **Cindy's**. Both like winter NW swells and a mid tide, but only take up to about 6ft before losing shape. Not mapped here as fickle spots.

Next, at the southern end of Calumet Park, there is a lined up right point break, **Outsides**, that prefers medium to lower tides with SW-W swell and E-NE winds. Further in, **Pacific Beach Point** is a long, mellow cobblestone and rock right that sections into deep water. There's another couple of left-right reef peaks inside this too. Suited to any kind of thick flotation device, and usually a parking lot for said wave vehicles. Mid to low tide, west swell, northwest to north wind. Fair quality. 1-8ft. Crowds. Beginners.

The beach inside, and south of all of this, **Tourmaline**, is the surfing park at the north end of Pacific Beach. It hosts a series of consistently mushy right and left sandy /patchy reef breaks. These work pretty regularly winter and summer from 2-8ft. Beginners to Intermediate. It's a stones throw from here down to Mission Beach and the beach-breaks of Crystal Pier.

BIG ROCK & WINDANSEA

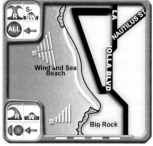

Big Rock: At the south end of La Jolla, go down La Jolla Blvd to Palomar Ave. Southern end of Windansea Beach.

A consistent, classic, extremely heavy, powerful, fast grinding left that barrels over a shallow rock reef ledge. Luckily it backs off into a deep water channel. Breaks year round & prefers a clean west swell at mid to high tide: Reef sticks out of water at low. Dangerous. Experts. Tight locals only vibe. Star quality. 2-12ft. Crowds.

Windansea: In La Jolla, go down La Jolla Blvd. Take Playa Del Norte to the west, to Windansea Beach. Legendary rock shelf reef break with fun to powerful heavy sections & long right and left shoulders. Breaks on any tide year round on NW-S swell. Classic summertime break that likes SW swell. The right peels longer, the left is shorter and more compact with steeper faster sections. Can handle powerful ground swells with size and is always crowded. Tight locals only atmosphere. Quality - good. Crowds. Heavy and thick man!

Old Man's. San Onofre

ⓘ HORSESHOE, ROCKPILE & SIMMONS

Horseshoe: Up La Jolla Blvd and west on to Marine St. Walk N.

Consistent right and left rock shelf barrel machine. Shifty peak is hard to predict. Short quick right into deep water channel, current pulls into the reef. Left lines up and forms a jacking horseshoe bend, and a square barrel across the fast inside section. Breaks best on west to southwest swells with medium incoming tide & an easterly wind. For extreme hard-core only. Locals only. Quality-Excellent. 4-12ft. Crowds. Advanced. Just N is **Hospital Point**: heavy winter rocky point break for 4-8ft winter swells. Right and left.

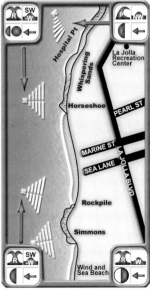

Rockpile: The next reef down from Horseshoe, off Fern. Reef ledge lefts and rights on middle tides and most swells. Wind-exposed. Not too consistent. Check it if crowds are heavy elsewhere.

Simmons: La Jolla Blvd to Nautilus St. Just N from Windansea. Inconsistent right hand peeler that throws a heavy barrel right from takeoff over a shallow rock reef shelf. Needs a solid ground swell. Will show on a northwest swell but breaks best in the winter on west swell with a medium to low tide & an easterly wind. Locals only atmosphere, if you see it uncrowded you know why. Quality- excellent. 4-10ft. Crowds. Advanced.

LA JOLLA COVE

From La Jolla, take La Jolla Blvd to Prospect St. then Coast Blvd.

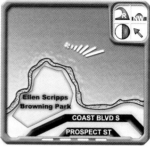

Inconsistent cobblestone and reef that can be transformed into a gladiator pit of a deep water big wave left. For this to happen, it needs huge NW swells. A steep take-off followed by a lined up wall with varying shape, depending on tide. If big enough, it will break on any tide but likes a medium to low . Southeast to south wind will be offshore. Packed with expert big wave riders, on 12ft. Guns when firing. Extremely hazardous. Quality-excellent. 8-25ft. Crowds High. Pro / hell-man.

SCRIPPS PIER & LA JOLLA SHORES

In La Jolla, go N up La Jolla shores Dr. For each go left on Avenida De La Playa. For pier take discovery way by the Scripps Institute.

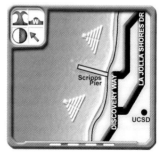

A mellow small consistent year round beach-break alternative to the more challenging waves in this area. Sand bar right and left peaks on either side of the pier. South side of the pier holds cleaner more shapely waves. Likes an incoming to mid-tide, west swell, and SE winds. Walls out on larger ground swells. Quality- Fair to good. 1-8ft. Crowds High. Intermediate.

125

BLACKS

Take La Jolla shores Dr north from La Jolla. Go past Scripps Pier to "glider port". Long walk and dangerous cliff.

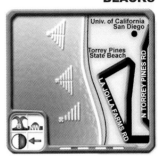

One of the best beach-breaks there is, anywhere. Consistent year round long perfect lefts, and shorter rights. Extremely powerful surf. Best on northwest swell, medium to low tide and E wind. Can pick up swell from the northwest to south. Usually bigger than anywhere else because of the submarine canyon that faces northwest causing the waves to diffract and hit the three shallow giant scalloped sand bars that have been formed. Can hold massive winter time juice with three channels that are capable of closing out at any time.

South Peak; the most perfect left. Barrels, heart-felt drops, dog-eat-dog in the line-up.

Middle Peak; usually larger & less crowded. Short right and longer more unpredictable left that is a toss-up between a glorious speed barrel and an ignominious close-out.

North Peak; better right and a sometimes shorter deeper left. You will get worked here! It's hard to make it out.

All in all, Blacks is a never ending, consistent, pounding impact zone with swirling rip current and undertows. Gets extremely packed with the best that there are and the legendary. A lot of marine life and activity caused by the deep water trench, don't be surprised by what you might see in the ocean and the land, keep your eyes open on the sea and closed on the land. Quality: Excellent. 1-18ft. Crowds galore. Advanced to Hell man.

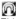

This stretch starts from just past the southern end of Solana Beach, between 29th and 14th St Delmar.

The Rivermouth: South end of Solana Beach by 29th Street and the San Dieguito Rivermouth. Variable rivermouth sandbars, left and right on smaller swells. Can get hollow. Polluted. Fun. 2-6ft. All levels.

The Beach: Small sand peaks in all swells. Needs small conditions and early morning glass, not too much tide. Can get good. Crowd is well spread out, 2-5ft. All levels.

15th Street: Well known rock formation gives nice lefts on south-southwest swells 3-6ft plus. All levels. Crowded because usually pretty good. Beach peaks around here in abundance.

Torrey Pines: Off south end of this map through the torrey pine forest...pretty! Relaxed series of average beach peaks. Good to avoid crowds...if you catch it on. Magnetizes small swells from NW, and early

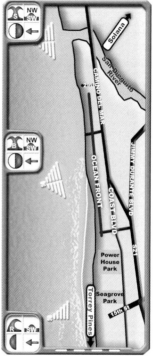

morning glass at mid tides can produce lined up fun waves for intermediates. 2-5ft. Uncrowded.

SEASIDE REEF & TABLE TOPS

At the south end of Encinitas. Head north up Old 101 from Solana Beach. **Seaside Reef** is just before the San Elijo Lagoon bridge.

Consistent, powerful outside bomb that sucks out on a shallow rock ledge forming a right and better left. Fat middle section that backs off, then a fast inside race course with double up sections. Any swell from NW to S, but best on W swell with medium to low tide and an E. Picks up more swell than other spots in the area so large aggressive crowds squeezed into small zone. Quality-excellent. 2-12ft. Crowds high. Advanced. If too small or crowded, Check the beach-break at **George's** just to the north.

Just S, at the top of Solana Beach off Pacific Ave is **Table Tops**. Consistent shallow flat rock shelf with a better right and left peak a quarter mile out. Swell from the NW to SW. Barrels at take-off then backs off and reforms into a lined wall across inside.

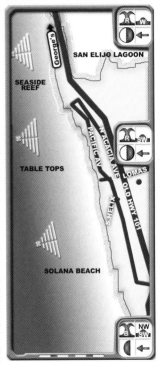

Best on SW with a low to medium tide and an E wind. Respect local crew. Good / Excellent. 4-12ft. Crowds high. Advanced/pro.

CARDIFF REEF & PIPES

For Cardiff Reef: North from Solana up San Elijo ave. Cross the San Elijo Lagoon and Park up near Chesterfield Dr.

Pipes, by the San Elijo camp Grounds, is a hollow, mostly left barrel sections & a smooth lined up inside section. Breaks on all tides but prefers W swell with a mid to low tide and an E wind. Reefs including **Muffs, 33's** and **Turtles,** to the south, are fickle but occasional star spots breaking in similar conditions, although more of a fun style wave.

Suckouts Reef, level with the 7-11, is a fickle but tubey right reef just north of Cardiff Reef. Tight knit local crew of advanced surfers there though. Quality-excellent / good. 2-10ft. Crowds. Intermediate/pro.

Cardiff Reef: Quality reef peaks with some hollow sections & well shaped lines. On small swells, a soft lined up right and left. Bigger swell means even longer walls. Breaks year round on NW to S swells & any tide, but prefers winter NW to W with E wind. Quality-excellent. 2-10ft. Crowds. Intermediate.

⭐ ❗ SWAMI'S, D STREET & MOONLIGHT

Swami's: Off Sea Cliff Park, at west end of J street in Encinitas.

A world class wintertime rock ledge right point. Smaller swells yield softer lined up sections with an outside double up & a shapely inside bowl. Takes big swells. 2 main areas, the **Boneyard,** a wedging peak with steep take offs & barrel opportunities on the outside, and **Swamis**, the inner point. The inside forms a powerful double up section with long but tapering wall. Likes larger swells, the bigger the better. Always packed. Swells from NW to S and any tide, but best in the winter on W to NW swells with a medium to low tide and an easterly wind. Quality. 2-20ft. Crowds. Advanced.

Moonlight Beach, heading up 3rd street from Swamis, past D street, is a Consistent, fast beachbreak year round on NW to S swells, with summer SW best. Does not hold large ground swells. Will break on any tide but likes medium. 1-8ft. Crowds. Intermediate. **D-street** itself leads to a sexy little strip of beach with some of the better banks around here in similar tide and swell conditions.

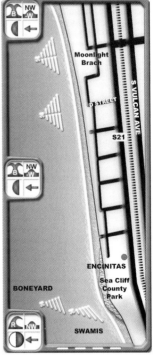

These breaks start from north end of Leucadia State Beach by the lagoon.

Grand View: Consistent fun cobble stone rock reef R & L with some sand. Breaks on any tide & swell year round . Summer S swells produce better lefts with shorter rights. Winter N swells opposite. Versatile wave for short & long-boards. More similar waves to south that vary on swell direction size and tide. Closes out on larger ground swells. Quailty spot. 1-8ft. Crowds high. intermediate / advanced.

Beacons: Consistent fat / fun cobble stone & sand rights and lefts. Takes swell from NW to S but prefers wintertime NW to W. Gets packed. More similar setups up the beach to the N. Closes out on larger ground swells. 1-8ft. Crowds. Intermediate.

Stone Steps: Consistent hollow beach-break with some cobblestone. Likes a medium tide & any swell from the NW to S. Best on smaller clean swells & E wind. Does not hold much swell. Quality; fair / good. 1-6ft. Crowds medium / low. Intermediate.

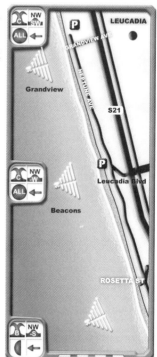

Series of breaks running south from Carlsbad towards Leucadia.

Carlsbad State Beach, off Beach Ave: L & R beach-breaks. Well exposed to summer S swell. Closed out on larger ground swells. Plenty of room. Town beach gets good.

Tamarack Ave: Consistent summertime fat, lined up walls that break over sand and cobblestone. Winter swells are shadowed but do get in if big. Closes out over 8ft. Any tide, likes NE wind. Sections with peeling smooth lined up walls of rights and lefts all the way to sand. Rippable. Consistent. Crowded.

Warm Water Jetties: Jetty beach-breaks at Agua Hedionda Lagoon exit, depending on sand flows. Can get lined up. Scary power plant warms water up. 1-6ft. Crowds OK. Beginner to advanced.

Terra Mar Point. Inconsistent, sometimes fat cobblestone / sand L&R. Swell from NW to S but likes winter NW. Rights can get nice and lined up in winter. Gets crowded with longboards when good. 1-6ft. All levels.

Ponto: Beach-breaks & a good jetty break outside the Lagoon.

OCEANSIDE BEACH

Head into Oceanside on the 1. Park anywhere north of Ash or Pine Streets.

Lengthy beach-break expanse with the pier as its focus. Likes summer south swells and early morning glass-offs. From Ash Street north as far as the harbor. Pier is usually a good bet for the right banks, and gets hollow. 2-6ft. All levels. Crowds but spread out. Parking always a challenge.

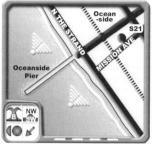

DMJ'S & OCEANSIDE HARBOR

In Oceanside, head to the south side of the harbor on Harbor Drive South, then Pacific Street. Man has once again intervened to give us well-formed peaks. **South Jetty** is a good summer bet, when both sides have lined up hollow lefts and rights on a clean morning before the sea-breeze arrives. Winter swells work too and can toss up long fast rights. **North Jetty** also holds good shape and is best in summer. All levels. Super-crowded but still easy. 2-6ft plus. North of Harbor is **DMJ's**. Long lefts (& some R wedges) on NW swells from 2-15ft. Military access only in Camp Pendleton... Experts.

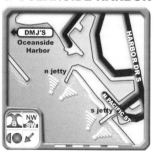

133

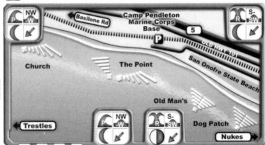

Head to the San Onofre Beach Park off the 5 north of Oceanside. Queues to get in can be very very heavy.

Church: Within sight of Trestles near Basilone Rd. Mellow cobblestone and sand point that works best on winter northwest swells around the 280 degrees mark. Long, usually non-threatening walls at all tides. Whilst there is a crowd here at all times, getting waves isn't hard due to a wide zone and various take-off spots. 3-8ft plus. All levels. Longboards too.

The Point: beginning of a series of spots on San Onofre Beach. A church style right-hander (in winter) and righ/left combo (summer south swells). OK on all tides, and holds 6ft plus, more if swell wraps from north west or west. Mellow spot for all levels. Lefts are shortboard material if tide low, otherwise this wave is quite fat.

Old Man's: Out the back is a sand coated rock reef. Right and left combo, often very long walls. Best on early morning glass any season. Works all year NW - S swells, but summer swells from the south make it a kind of A-frame, and this is it's best season. Fun wave. All levels. Crowds but manageable, and a great vibe. Early morning glass but stays offshore in summer. **Dog Patch**: Just before the scary power plant. Another mellow right left sandy cobblestone peak. Usually very mellow, holding up to about 8ft. All tides. High is fat. Likes summer south swells. **Nukes**: Bang opposite the power plant. One of a few good peaks that work along similar lines to Dog Patch. **Trail 1,2,3,4,5 & 6** are similar spots running east.

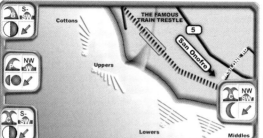

Just north of the San Onofre State Beach, adjacent to the train trestle. One of the world's best surfing arenas. Running continuously from San Mateo Point to San Onofre State Beach.

Cotton's: Lined up left-hander good in big south to southwest swells. Breaks over cobblestone and sand bottom on any tide, but lower is hollower. Holds 2-12ft plus. All levels.

Uppers (Upper Trestles): Superb quality, long (mostly) right-hand cobblestone point wave. Works best on a wrapped northwest to west winter swell at higher tides, when there will be multi-second barrels firing down the beach towards San Mateo Creek. It'll work well on south swell too though. Any tide is OK. 2-10ft plus. All levels. Best in winter...generally. Crowded with mini-tankers.

Lowers: Left and right cobblestone peak. Long rights in winter swells from NW, awesome fast peak left and rights in summer south swells. Generally both lefts and rights have 3 sections, with the first (outside) being more hollow. Rights often longer/lined up, and longer than uppers. Lefts punchy and good channel to paddle back from. Any tide is OK, but Low tide plus summer swell and morning off-shore = hollow green barrels at high speed. 2-15ft. Very crowded. Usually better than Uppers in summer, and vice versa.

Down from here is **Middles:** Mellow right-left summer peak needing northeast winds and any swell. All tides. Low is better as it can be a mush-burger at the best of times. If your surfing isn't working here, get a new board, or a coach.

W2: ORANGE COUNTY

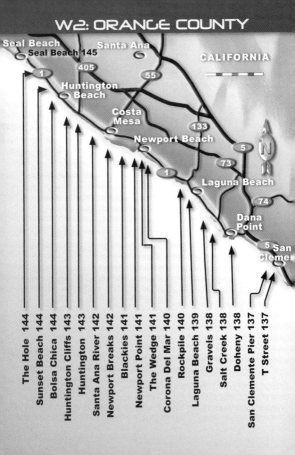

CALIFORNIA

Seal Beach
Seal Beach 145
Santa Ana
Huntington Beach
Costa Mesa
Newport Beach
Laguna Beach
Dana Point
San Clemente

The Hole 144
Sunset Beach 144
Bolsa Chica 144
Huntington Cliffs 143
Huntington 143
Santa Ana River 142
Newport Breaks 142
Blackies 141
Newport Point 141
The Wedge 141
Corona Del Mar 140
Rockpile 140
Laguna Beach 139
Gravels 138
Salt Creek 138
Doheny 138
San Clemente Pier 137
T Street 137

SAN CLEMENTE PIER & T STREET

In San Clemente, head for Trafalgar Street.

T Street: Off Avenida Esplanade by Tragalgar Street. Summer and winter peaks over sand, helped by reef formation off-shore. Lefts and rights depending on swell direction.

The Pier, at the end of Avenida Del Mar: Either side of the pier has lefts

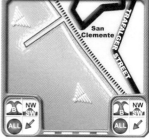

W2

and rights on sand. Tends to work best on 3-5ft swell from northwest through south. Any tide OK depending on size: low closes out. Medium consistent. Beginner plus.

DOHENY

In the shadow of Dana Point Harbor.

Mixed beach-break setup offering protection from the northwesterly winds. Any tide. 2-6ft. Intermediates. An outer bombora works on rare big south swells if over 8ft. It can be a rush to catch this on in any north wind and lower tide. If swell is smaller and from the northwest, **Poche** may be bigger. It's at the

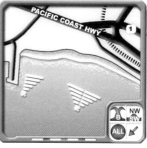

other end of **Capistrano Beach**. There's a crazy but inconsistent reef break on the outside here.

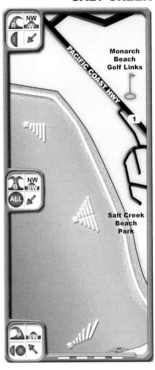



SALT CREEK

Salt Creek Beach Park runs north from Dana Point.

Varied spot for all levels. There's beach / pebble break up and down the park, which offers very hollow lefts and rights on any tide.

At the top end is a pebbly right-hander - **Gravels** that likes winter northwest swells to wrap in. At low tide the wave offers a challenging take-off and race for the shoulder. Advanced. Very crowded into a tight take-off point. 3-8ft plus. Rights and lefts work consistently in the middle of the beach.

The Point: There is a quality left-hand point style wave at the southern end, that works on southeast winds with any swell. Breaks on reef. Summer south to southwest swells create a lined up wave with numerous sections and the odd barrel opportunity. Likes southeast winds. 3-10ft. Advanced. Busy! In fact Salt Creek is one of the most crowded places to surf anywhere.

LAGUNA BEACH

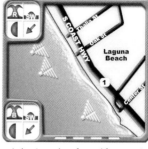

Head into Laguna Beach. North to south from Thalia Street:

Rock peppered beach holding plenty of swell. At the north end there is a pair of quality reefs working on all swells up to 10ft plus. Further south there are mixed beach and reef breaks, all liking northeast winds. You'll find something for just about all tides and swells here, up to 10ft and over. Thalia and Oak Streets host good reefs, and from center street down, there are less rocks in the line-up, and less protection from the sea-breezes.

W2

ROCKPILE

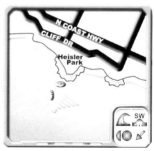

At the north end of Laguna in Heisler Park. Take Cliff Dr off the highway.

Notorious, localized, heavy reef break rights with rocks all over the line-up. Can handle big swells, especially summer southwests, and is protected from northerly winds. Add this to a tight take-off spot and you can imagine what it's like on a howling nor wester on a July weekend (or any day of the week!). Experts only. Paddle-out quietly, alone and in a dark wet suit. Head up the highway towards Abalone Pt and beyond for some crazy reefs visible from El Morro and Emerald Bay.

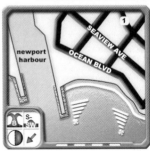

CORONA DEL MAR

Top end of Corona Del Mar Beach.

Worthwhile spot when others are either too big or windy. The jetty here protects from northwest seabreezes, and structures the banks into some quality, sharp sand bank rights. There's a fickle left that breaks on sand but has a boiling rock section at the end. Any tide works but super high can be mush city.

Northwest through east winds can be surfed. So crowded. All levels. 2-6ft but the rights off the jetty can hold 12ft plus. Will take much more if the banks are right. Flat all winter. Down south there are good reef options towards **El Morro**.

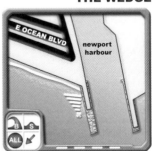

THE WEDGE

Off the west break wall of Newport Harbor.

This rocky jetty is responsible for some of surfing's worst injuries. Mostly a body board spot, mad surfers do come here to risk their lives taking off on the thick, heavy shoredump. It gets it's power from the funneling / rebounding effect of waves that collide with the rock jetty. Not uncommon to see 12 foot waves breaking straight onto the sand. Kind of a Waimea shore-break experience. 1-15ft but has broken the 20ft mark. Experts only. Horrid spot.

140

NEWPORT BEACH

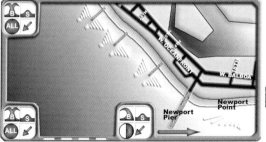

An immensely fertile stretch of sand bottom waves located off jetties at the end of numbered streets. You'll see the streets crossing as you roll up Balboa Boulevard, increasing in number from east to west till you rejoin the Pacific Coast Highway. All these breaks get good in winter, but are known to be well exposed to summer south-oriented swells.

At the end of 18th, east of the pier is a rare left **point** break holding any amount of straight south swell. Only wraps if very south and pretty big. The Pier has some quality, crowded banks too, including **Blackie's** (the next spot up from the pier) and a rare spot of the south end that requires maximum luck to score. Longer lefts and peaky rights are the norm. Park near the restaurant strip behind the pier and walk it.
Rock jetties at the end of various streets vary in quality but can get really good in summer southwest swells from 3-8ft. Some good streets are: **28th, 32nd, 54th, and 56th**, but this is far from the end of the story, and a moveable feast. All are offshore on a northeast wind, or early mornings all year round. Takes swell from northwest through south, and often bigger than anywhere else on summer south swells. Most tides are fine here. There's a jetty about every 4th street so park anywhere and check it! Crowds OK. All levels. 1-8ft plus, with areas around **18th Street** bigger due to an ocean trench. Some jetties also hold more.

141

SANTA ANA RIVER

Between Huntington and Newport. Heading west out of Newport Beach , turn off the PCH before the bridge.

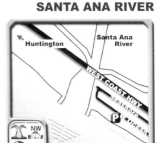

Rivermouth sculpted banks offering quality lefts and rights on swells from northwest through south. 2-8ft++. Pollution is a problem. Crowds acceptable in winter, but horrid when other spots are black-balled in summer. All levels. Huntington Beach runs for miles west of here, so if crowds are up you can stroll up the beach and find a less hectic spot.

Huntington Pier. Jeremy Goring

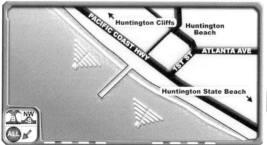

Huntington State Beach, to the east of town, is a good stretch of summer beach-break. Very exposed to the south swells, it gets blown out every afternoon, but on early morning glass at 3-6 feet, it's fantastic.

Huntington Pier is an icon in the surfing world. One of the most photographed spots there is, it epitomizes Southern California's surf scene. Peaky beach-breaks, sunsets, weird people on the beach when you come in. Takes swell from south through nor west, and changes personality accordingly. South of the pier has A-frame peaks, and if swell is south, some lined up lefts to 8ft plus. North side has lefts and rights, but some solid right outside peaks on a winter swell, running under the pier itself. All in all a consistent, quality spot, but no secret - you'll share it with many. All tides although high no good if small. All levels. 1-12ft.

A stroll or quick drive west of the pier can reward with a bunch of beach breaks that spread the crowds out, although hold a bit less swell due to the absence of jetties.

A couple of miles up the PCH is **Huntington Cliffs**: More quality beach-break that gets fast and hollow at lower tide. Southwest swells hit with most power, and the spot holds considerable size compared to some. South swells make it a mellow experience. Needs early morning glass or is a serious mess. Crowds. 2-8ft+. All levels.

BOLSA CHICA & SUNSET BEACH

Off the PCH outside Huntington Harbor.

Sunset is a consistent year round beach-break. Similar to Huntington State Beach. Likes early mornings and a 2-6ft swell from any direction. Can get hollow no matter what tide, but high is a bit of a damper. You have **Bolsa Chica** to the south of here which is similar. It may be a few inches bigger on winter northwest

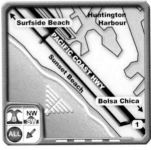

swells, and is less crowded at times but more of an early morning, pre-sea-breeze spot. Less hollow than Sunset.

THE HOLE - SURFSIDE JETTY

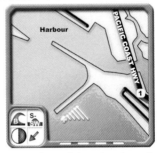

Heading north from Huntington Harbor on the PCH, top end of Surfside Beach.

Right-hand power wave off the jetty in solid west to southwest swells. Refraction causes it to get very heavy and fast, with often gaping barrels. Needs the right conditions, and is protected from afternoon breezes. Lower tides best. Inconsistent. 3-8ft. Advanced plus. Territorial crew. Crowds when on. There are a few well-shaped peaks south from here as far as Anderson Street, worth checking out on summer swells, any tide, and early morning off-shores.

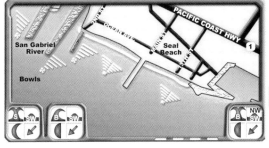

A heap of spots here, along Ocean Avenue and its side streets. Mostly flat during winter, but catches summer south swells, and offers protection from afternoon northwesterlies.

At the west end of Ocean Avenue across 2nd Street, is **Bowls**: a Rivermouth left breaking off the jetty in the middle if the San Gabriel River. Hollow fast to fun waves on any south to southwest swell, so usually a summer spot. 2-6ft. All levels. Stingrays about, so it's also called Stingray Bay. Polluted to dangerous levels. Crowds.

Crabs is a quality right-hand jetty break at the south end of 2nd Street in similar conditions. This will work through the tides and in west to south swell, but straight west or southwest is ideal, coupled with northeast winds early morning. It's fickle.

At the south end of Main Street, the area around **The Pier** is a reasonable beach-break zone on all tides and swells from northwest through south. Consistent. Fat to fun depending on selected bank. Crowd absorber.

There are a couple of heavier set-ups at the east end of the beach, between **10th and Dolphin** streets, which can give out bigger, chunky lefts and rights, especially in lined up winter ground swells if they have plenty of west in them..

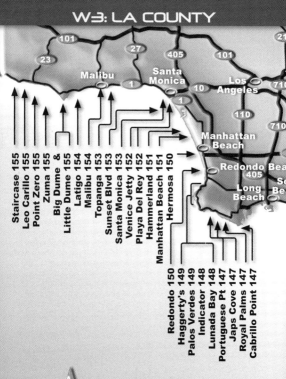

101
23
27
405
101
21

Malibu
Santa Monica
Los Angeles
710

1
10
Manhattan Beach
110
710

1
Redondo Bea
405
Long Beach
Se Bea

Staircase 155
Leo Carillo 155
Point Zero 155
Zuma 155
Big Dume &
Little Dume 155
Latigo 154
Malibu 154
Topanga 153
Sunset Blvd 153
Santa Monica 153
Venice Jetty 152
Playa Del Rey 152
Hammerland 151
Manhattan Beach 151
Hermosa 150

Redondo 150
Haggerty's 149
Palos Verdes 149
Indicator 148
Lunada Bay 148
Portuguese Pt 147
Japs Cove 147
Royal Palms 147
Cabrillo Point 147

CABRILLO POINT

In San Pedro, at the south end of Pacific Avenue to the east of Point Firmin.

The section of real estate between San Pedro and Palos Verdes harbors one of the most heavily localised surfable domains anywhere.

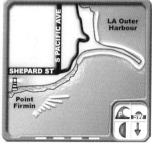

Cabrillo Point is a quirky, out of the way right-hand point break near the lighthouse. Can get very windy here, but on a clean southwest swell of 5ft or more, and early morning glass, there's a nice wrapping wave to be had. Beach-break too but rarely any good shape. Mid tides work pretty well. All levels. Often crowded if it's actually working, but manageable.

3 miles to the west, off Western Ave, is **Royal Palms:** a nice, but very localized, right-hand rocky point. Doesn't handle big swell too well, but quality on a northerly wind and a west to south swell at mid to high tide. Advanced. There's a good jetty peak here too.

Japs Cove is next up, about a mile west around the point. This little beach offers a chain of shallow rock interspersed with sand, throwing up short peaks in any south to west swells. Handles up to about 6 feet and is ultra-exposed to sea-breezes, so best catch it early morning / late winter afternoon. Tight local crew although fickle spot indeed. Advanced. Currents are mad if it gets any size. Do not paddle-out with a gang.

Just about the last stop before Lunada is **Portuguese Point,** at the eastern edge of Palos Verdes. Lefts up to 6 feet in southwest swells. Likes northeast winds and not too much tide. Fickle spot and more heavy locals. Difficult Access. Advanced.

West edge of Palos Verdes, at the north end of Lunada Bay, end of Yarmouth Rd.

On a huge day up to 20 feet of winter northwest or west swell, this is one of the chunkiest, fastest, thick-lipped right-handers anywhere. It has a horrid bunch of locals who will wax your wind-screen if you are very lucky (that was the good old days, today it's just a broken nose). This doesn't mean you can't go and have a look from the top of the bluff. It breaks on an assortment of boulders, some of which are barely below the surface at low to mid tide. 6-20ft plus. Experts only. Know a local or avoid. Actually, just avoid. **The Indicator**, just around the corner off Paseo Del Mar, is a swell-magnet series of left-hand reefs. They take west swells and bend them off 3 defined peaks. All are hardcore, and the outside holds close to 30 feet. When it's on, every hell-man in the county comes out of the woodwork to try and tame

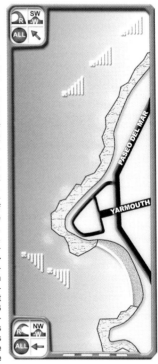

it on 12 foot boards. A spectacle to behold. 6-30ft. Rips. Localized. Pros or Experts. Breaks often, but not often good.

PALOS VERDES COVE

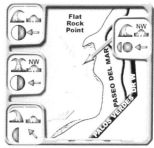

Heading north up Palos Verdes Drive W, take a left on Paseo Del Mar. Walk down cliff path.

From north to south: **Flat Rock Point** is a swell filtering right-hander. Often fat, not always lined up, on N to NW swells. 3-10ft plus. All levels. **North Reef**, just inside, a right hand shallow reef. 2-6ft. All levels. Then **Middles**, a left / right reef combo on all swells, usually pretty fat. 3-15ft. Advanced. At southern end is **Boneyards**: a faster, shallow left-hand reef . 2-10ft. Advanced. Rocky. The whole setup is crowded as. Parking is tough. Many long and short boards, and it can be dog-eat-dog.

HAGGERTY'S

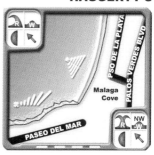

In Malaga Cove, at the north end of Paseo Del Mar in Palos Verdes.

From north to south: **Lower's**: A-frame sandy reef setup on any swell. 3-6ft plus. Advanced. Crowds! Then there's **Haggerty's**: Left-hand reef-point wave, rocky environment but good on all tides. Likes west , southwest or v big south swells. Lined up quality walls, barrels on a southeast wind. Off the map to the south, is **Upper Haggerty's**, taking huge swells, especially wrapping souths or solid winter north wests. 3-15ft. Advanced. Crowds not well absorbed.

REDONDO BREAKWATER

In Redondo, go north past the harbor on North Harbor Drive which joins Hermosa Ave. Left fork into The Strand. Park up.

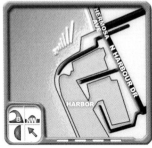

Winter left-hander warps off the wall in northwest swells, and is off-shore in southerly storm fronts. It is a jacking monster, delivering humongous barrels, especially at low tide. Awesome at 4-6ft, but can take 20. Experts only unless small. Crazy crowds when on. There's consistent beach-break running north on smaller days if an easterly is blowing, or early morning glass. To the south there's a series of good jetty /beach-breaks along Redondo Beach on 2-5ft of any swell except due south.

HERMOSA BEACH & PIER

Head into Hermosa and drive up Hermosa Avenue. The pier is level with Pier Ave.

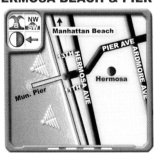

Whilst the beach-breaks along the sea-front at Hermosa vary in quality, they can be hollow and fast when smaller summer southwest swells combine with easterlies in the mornings. Winter swells work too, but are often too juicy to handle on these banks.

The Pier tends to be the focus of both crowds, and some of the better banks around. It's at the west end of Pier Avenue. 2-5ft. All levels. Crowds but many peaks. Fun.

MANHATTAN BEACH

Head up The Strand. The Pier is off 11th Place.

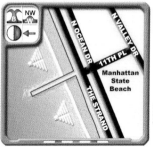

Yet more expanse of beach-break, as usual focussing on and around the pier. Very consistent strip, taking all swell directions from north through south. Good banks pop up at the ends of jetties up and down the beach, and the Pier area tends to be the most crowded. 2-6ft. All levels. Best early mornings. An excellent place to be apres surf, especially if you are fond of the ladies.

NEW JETTY & HAMMERLAND

North of Manhattan Beach, both **Dockweiler State**, and **El Porto** Beaches, have a mixed bag of sand peaks. Between the 2 is **New Jetty.**

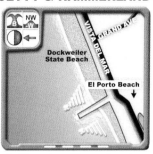

Lefts on the north side in rare S swell and E winds. Rights on the south in NW swell and NE winds. Both break over sand (and a few breakaway boulders) and reel down the line on the lower tides. Winter north wests also refract off the north side and amplify, creating steep, wedge-like, throwing peaks into a channel...ouch! These swells earned the north side the epithet **Hammerland**. Extremely crowded spot if elsewhere is too big or blown out.

PLAYA DEL REY

Heading north up Vista Del Mar from Manhattan Beach, go past Dockweiler Beach, take the left fork (Trolley Place) at Del Rey Lagoon Park, to 64th ave.

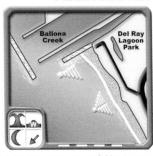

Fun beach-break on small days with northeast breeze. At the north end is the marina jetty, which creates the occasional good bank, protected from northerly winds. 2-5ft. All levels. Crowd relatively OK. A fun little corner to surf. Mostly summer waves from the south. Often smelly, and a horror story after big rains.

VENICE

Arriving in Venice and driving south along Pacific Ave, for the **Breakwater,** turn R at 17th Ave. Or for **Jetty** turn R at 28th, or for **Pier** turn R at Washington intersection.

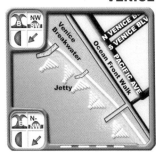

Jetty and breakwater have the best banks on this strip, and turn on and off as swell changes direction. The jetty area has a number of rock walls that protect from nor westers to a degree, so a good afternoon check. The Pier is less consistent on the quality front but can deliver the goods in winter if there's enough size. Northeast winds are best along the whole lot. Any tide.

The Pier is level with Colorado Ave, and there are beach-break set-ups running south from here. Square swells are a bit walled here, but some winter waves get good shape. By the pier there are some right banks and usually a reasonable left-right combo on winter north wests or summer SW. A quality bank can be found off **Crescent Bay Park**, working on smaller swells. Crowded but mellow.

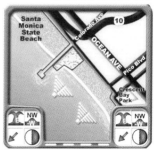

W3

SUNSET BLVD & TOPANGA

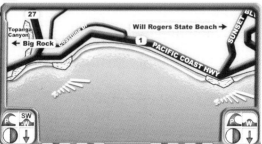

Sunset Boulevard: N from Santa Monica at intersection of Sunset Boulevard and the PCH. Right point break that does a feeble imitation of the classics further north. Cobblestone/sandy reef. Is off-shore in nor westers so a good bet when it's big and blowy elsewhere. Better when bigger. 3-8ft plus. All levels. **Topanga**: West of Sunset Boulevard on the PCH. More rights wrapping around the shoreline. 3-8ft. Intermediate plus.

153

📄 **MALIBU**

Driving into the suburb of Malibu from the south on Pacific Coast Highway, you'll spot it after the pier; park up.

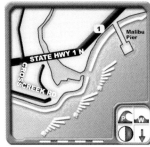

Long, polluted, over-crowded right-hand point on sandy cobblestone floor. It has, like Rincon, 3 main take-off zones that can occasionally link up. All in all it handles 2-12ft and likes big northwest / west swells, or peaky south swell. The latter makes for a hollower faster broken up wave, especially at low tide. Personal taste dictates your preference. Consistent. Crowded, esp summer when its off-shore some afternoons. Dirty. Great fun, or a nightmare come true, depending on your point of view.

📄 **LATIGO**

3 miles west of Malibu on the Pacific Coast Highway, off Latigo Shore Drive.

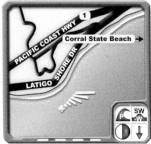

Sheltered right-hand point break that gets the smallest remnants of winter northwest swells and converts them into long, fat, fun walls. A solid southwest pulse will fire it up a bit more but ultimately it's an intermediate break despite the rock bottom. Any tide is OK, low can be faster. 3-8ft. Parking not easy, you may need to hike down from the highway on foot. Offshore in a nor wester, and not too crowded; two major bonuses.

BIG DUME & LITTLE DUME

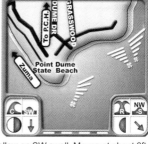

Big Dume: West from Malibu past Escondido. Take left on Wandermere, then R in Dume Rd to end. Rock & cobblestone point, hard fast right barrels on N winds / WSW swells. 6-12ft. Inconsistent. Localized. Awesome. **Little Dume**, the more consistent sister break has a RL reef and R point combo. Heavy local scene here.

A mile further west on the PCH is **Zuma**: 2 mile beach that gets heavy and hollow on SW swell. Maxes at about 6ft, more if swell right. At the far W end of Zuma is a R point (**Trancas**) that works on big west swells to about 8 or 10 feet. Consistent year round. Rocky. Advanced. Crowds OK.

LEO CARILLO

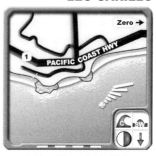

A couple of miles before the State Line off the Pacific Coast Highway, and straddling LA and Ventura counties.

Long, lined up cobblestone right-hander. Likes west swells but works on southwest too. Handles northerly winds and lower tides. 2-6ft. All levels. Not too crowded. To the east is **Point Zero**: fickle right-hander in similar conditions. 3-6ft. All levels. On the west side of the point is **Staircase Beach:** Sand / reef peaks in a pretty setting taking small summer pulses to about 6ft. Northerly is offshore. Any tide.

155

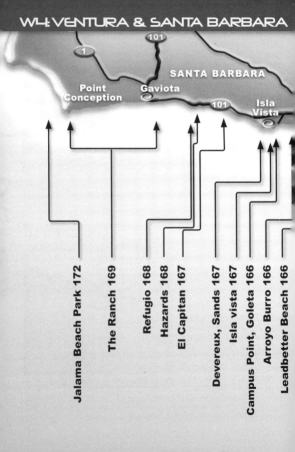

SANTA BARBARA

Point
Conception Gaviota

Isla
Vista

Jalama Beach Park 172

The Ranch 169

Refugio 168

Hazards 168

El Capitan 167

Devereux, Sands 167

Isla vista 167

Campus Point, Goleta 166

Arroyo Burro 166

Leadbetter Beach 166

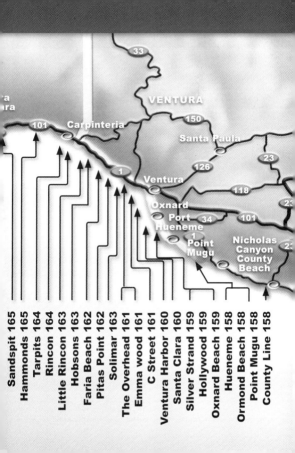

COUNTY LINE

Just north of the county line between LA and Ventura. Off Solromar.

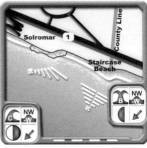

Right-hand cobblestone and boulder point at the top end of the beach. Good in winter northwest to west swells. A fat, fun, but lined up wave. 2-8ft plus. All levels. There are also lefts off this peak, particularly in south to southwest swells, breaking into a rocky zone. It's an acceptable in northwest summer sea-breezes. Beach-breaks all the way down to **The Staircase** in summer swells.

HUENEME & POINT MUGU

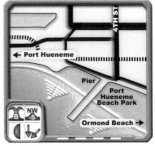

The pier is at the end of 4th street which crosses the 1 in Hueneme. Typical pier-structured waves. In the lee of Point Hueneme, and thus protected from nor westers, but also from winter swells unless pretty big. Peaks here can get hollow though, and in summer it's a focal point for surfers from allover if swell. Crowds. All levels. 2-6ft. South, after ordinary Ormond Beach, is **Point Mugu**. Join the army and find out how good it is...powerful peaks and lined up waves all year, always bigger than elsewhere in summer due to submarine canyon. 2-15ft plus. Military only!

158

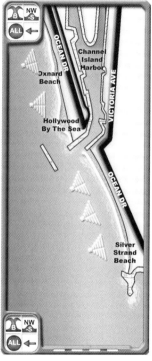

Series of spots around the town of Oxnard, which has a long history with surfing, and a very tight local crew who don't always appreciate uninvited guests.

Oxnard Beach: Consistent year-round heavy beach-break working from 2 to 10ft. Tide not really a problem as varied sea floor. Must have easterly / early morning glass or a total mess. Crowds but space too, All levels except over 5ft.

Hollywood By The Sea. More beach peaks under the shelter of the harbor jetty. In any rare big summer pulses it holds better shape than rest of beach.

Silver Strand: Consistent, often very very hollow beach-break. Gets the brunt of north-oriented winter swells around here, and there are numerous good peaks depending on sand movement. Is blown out all too often so catch it on calm winters day or early summer mornings. Very tight local crew. Show maximum respect. 2-8ft, more on rare days. Advanced. Swell Magnet.

159

SANTA CLARA RIVERMOUTH

North from Oxnard, at the end of McGrath State Beach.

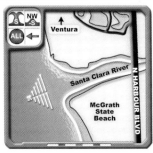

Stunning right and left Rivermouth peaks from 3ft to very big at any time of the year or swell direction except blocked WSW's. Fast barrels rifle down the line for yards and yards, making your best cutbacks redundant. Just pull in and race to the shoulder. Very busy spot popular with Ventura crowds. 3-10ft. Consistent. Intermediate to Advanced. Beach-breaks running south are a good way to avoid crowds in smaller swells.

VENTURA HARBOR

In the southern end of Ventura, south side of the harbor off Spinnaker Drive.

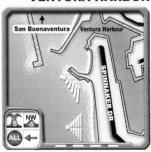

Quality, crowded beach-break pulling straight south summer swells, as well as stronger northwest power, when it will be smaller than anywhere else but usually better shape. Protected from northwest on-shore breezes in the top corner. 2-6ft. All levels. Often firing when other spots are maxed out from the north swells. Show respect. Up north, towards the pier, are a series of jetty breaks, **7 Jetties**, good on any swell and tide, and NE winds. 2 to 10ft. All levels. Crowd spread out.

C STREET

At the west end of Ventura, parking by the County Fairgrounds.

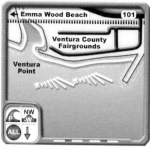

Whilst often fat and bulgingly slow, this is a fantastic long, wrapping right-hander off the parking lot, that peels all the way into the bay towards the pier. Other sections pop up from where it peters out, but you want to walk as far round the cobblestone point as you can and get it from the top. If you were brought up on punchy short beach-breaks, this will be a new experience. 3-15ft. Crowds but plenty of room. Mellow spot.

THE OVERHEAD

In Emma Wood State Beach. If it's working, you'll see it from the overhead bridge on the way out of Ventura towards Solimar.

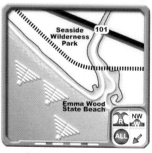

Off-shore reef that breaks with reasonable consistency from 6-20 feet on winter swell. 3 step reef that breaks further out depending on size. When it's good, everyone knows because you can't miss it from the road. Famed status coupled with a concentrated peak, and you have a dog-eat-dog situation. Some elevator drops, left and right. Experts. Beach-break on the inside in all swells (except SW blocked by Channel Islands) and tides.

SOLIMAR

Off southern end of Solimar Beach Drive in Solimar.

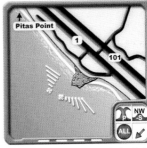

Consistent reef-break peak out the back, on boulders and rock ledge. Lefts and rights on any tide, with northwest swells forming longer rights. Wrapping point under the bluff in similar conditions although goes fat at higher tides or when swell is too north. Can get steep and fast on a solid summer south pulse. Likes northeast winds. Gets horribly crowded but there's a bit of room here. Currents. 3-10ft. Intermediate plus. Way offshore is a deep water reef, long paddle, murky and gets big. Lefts and rights.

PITAS POINT

Off the 1 in Faria.

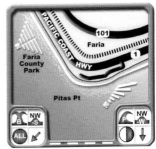

Winding, wrapping, multi-peaked right point. Any tide is good here. Outside point gets very big, over 10 feet, but blows out quickly. The inside sections line up and get extremely ruler-edged. Can be surfed all year, but prefers solid west to northwest winter swells. 3-10ft. All levels. Semi-consistent. If it isn't working here, **Faria Country Park**, running to the north, is very consistent beach-break action on any swell from 1 to 6 feet. Currents can be a bit mad. Crowds not a problem. Cool spot.

HOBSONS

North from Faria Beach off the 1. Hobson County Park.

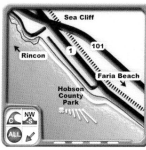

Cobblestone right-handers wrapping in on northwest to west swells. Long lined up quality though not a barrel-fest. Waves here tend to be filtered and slowed up. Several take-off points so crowds not too much of a drama. 3-10ft. All levels. There's a reef way out the back from 6-15ft on west swell, that gets very big and tapers into deep water. One of about 3 good big wave spots between the Overhead and Rincon. Everyone drives past these on the way to Rincon, but few actually surf there. AKA **Tropics** due to palm trees lining bay.

LITTLE RINCON

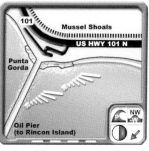

Driving up the 101 towards Carpinteria and Rincon, it's under the pier & easy to spot.

Exactly right: its like Rincon only always smaller. Mellow long, lined up right-handers peel off for a distance, from a take-off spot in the shadow of the pier. If Rincon is 10ft on a northwest winter swell, this'll be 5 feet and simply great fun. Often very fat, it can surprise, when tide is low and swell is west. Fun spot. Intermediates. Crowds vary. 3-8ft but has been surfed way bigger.

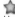

RINCON

Head south from Carpinteria on the 101 and take Bates Road right into parking lot. Walk down path and hobble around point.

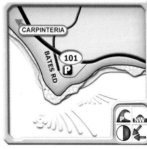

Amazing right-hand point break on large cobblestones. Breaks mostly in 3 sections - the outside peak, the Rivermouth and way inside at the cove. These can connect at times. On lower tides it looks like it is about to close out on you - so long are the walls, yet somehow you just get shacked and keep on going. On a glassy winter's day with 6-8ft swell coming from 280 degrees, you are surfing some of our planet's finest waves. 2-15ft. Crowds but space.

TARPITS

In town at Carpinteria, the birth-place of Wax.

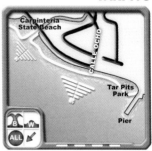

The town beach has a good selection of peaks, notably at the south end, where south swells jack up over a sand covered cobblestone floor. Fun lefts and rights that get hollow early mornings. When it's good, there's a hefty local crew on it. Fickle, as needs straight west, or straight south swell. Worth a check. 2-6ft. All levels. Semi consistent as Channel Islands block southwest swells out.

P

HAMMONDS

Off bottom end of Seaview drive in Montecito, east end of Santa Barbara. You can walk up from Miramar.

Lined up winter right-hander on cobblestone floor, working best on west swells. Known as a west swell spot, but works OK in souths too. Breaks from 3-10ft. Lower tides are faster, with fun waves at high. Likes northerly winds, and is protected from north westerlies, which makes it a crowd puller. All levels. Fickle, but you can drive to **Miramar** east up the coast highway; it's more consistent.

P

SANDSPIT

At the harbor mouth in Santa Barbara, off shoreline Drive. Walk round on the jetty and clamber down. Breaks off sand formation in harbor.

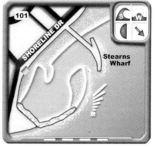

A crazy wedge style wave to check on big west swells. It reels from the harbor wall into the channel. The take-off is incredibly jacking, and it can form some unnatural barrels. It's an experts wave really, and catching it on is a low probability. Low tide or minus is frankly dangerous. Experts. Crowds when on. 3- 6ft plus. If on, you'll see the spectators lining the harbor to behold this sometimes churning, malicious wave.

LEADBETTER BEACH

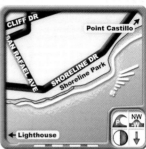

Follow Shoreline Drive west from Santa Barbara harbor, and park near San Rafael Ave.

A relaxed right-hander. Lined up over cobblestones and sand, this is a fat, fun wave. Works in northwest through west swells any size. It's offshore on northwesterly breezes. Crowded with plenty of take-off spots. 3-6ft plus, and can get bigger. Intermediates. If you keep on west along Shoreline Dr, you get to **Arroyo Burro** Beach. Consistent all tide, all swell beach-break for smaller days and northeast breezes or morning glass.

CAMPUS POINT

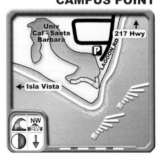

At the southwestern tip of Goleta Beach off the University of California Campus.

Lined up boulder point that generates very long, though fat walls. Inside sections are off-shore in a northwesterly. Winter swells from northwest need to be pretty big to get in, and summer south wests work too. Any tide. All levels. 2-10ft. Plenty of students skipping class when it's on. **Goleta Beach** is often surfable when this is flat. In between the two is **Poles**, which works on big winter NW-W swells, and is pretty forgiving and easy going if the point is over-crowded.

Ⓟ DEVEREUX PT, SANDS & ISLA VISTA

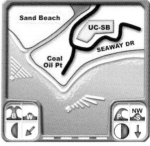

At the eastern end of Sand Beach, Isla Vista.

Devereux Point: Selection of cobblestone right-handers, on Coal Oil Point, pulling more swell than Campus. Quality variable but good on solid west swells. Gets windy, but the inside sections are still semi-offshore in summer sea breezes. Low tide and any north winds can fire up some barrels. Plenty of students. All levels. 3 to 8ft or more if swell is right. To the east is a stretch of summer beach-break - **Isla Vista**: south facing sand/reef peaks taking winter swell from 1 to 6ft. Currents, but can get good. All tides. All levels. Trek north for **Sands**: variable beach-break on W swell.

Ⓟ EL CAPITAN

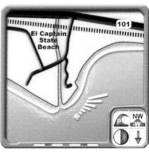

At the south end of El Capitan State Beach, 7 miles east of Gaviota.

The creek waters create sand flow between cobblestone floor, to create a wondrous right-hand barrel machine...if the swell is right. Fickle, lined up, and holding swell to 10 ft or even 15, El Capitan is the top spot for solid west swells with not too much north wrap around the point at low to mid tide and glass / north winds. This is a fast, jacking, hollow spot that can hold perfect shape in huge North Pacific storm pulses.

P

Refugio State Beach is off the 1 about 12 miles east of Gaviota.

Beach-break peaks that are not consistent, but a nice little right point best on lower tides. It doesn't get hollow or that big, but is a fun wave, requiring a big west swell to get in. It can break way out the back, then back off and reform on the inside. Scenic spot. Intermediates. Variable crowds. 3-10ft. Fickle but handles some size. You can head east for **Hazards,** a fun reef break off Beavers Beach.

W4

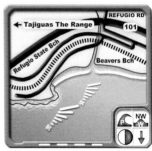

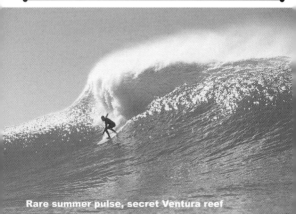

Rare summer pulse, secret Ventura reef

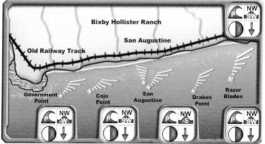

Head to Gaviota on the 101. It is off the private ranches that run for about 15 miles west from here. Sadly you need a boat or friends in high places. The main spots from west to east:

Government Point: Up towards Point Conception. Lined up right-hand walls on cobblestone bottom. The furthest spot from help, but a classic on all tides. Consistent. 3-10ft. All levels except on low tide, when gets steeper / faster / hollow. **Cojo Point**: Consistent right-hand cobblestone break. Takes Northwest through southwest swells, winter and summer. Gets hollow, and low tide with north winds means barrels. 3-12ft. Advanced unless smaller and higher tide. **San Augustine**: Primarily a right point working on any swell. 4-8ft. All levels. Any tide. Peaky lefts on south swells. All levels. **Drake's Point**: Awesome, lined up but whackable right point in winter swells. Can make any surfer look good. Lefts work on summer souths. 3-12ft. Advanced. **Razor Blades**: Right-handers on any tide, northwest to west swells best. Advanced. Low tide is hollow and fast. High tide fun but still lined up. All these spots can get busy despite the remoteness. Generally a heavy WNW swell fires the rights, and SW on lefts. Spots from San Augustine East are blocked from straight south swell. There's about 6 other great peaks here. Many surfers boat in from Gaviota. Best bet is get there early morning. Tough to get here, but unforgettable. We surfed Augies alone on several early mornings last winter.

Background

North of Santa Barbara, the protective cloak of Point Conception is lifted. You are now exposed to gnarly winds, cold, more rain, and uninterrupted winter swell. There are wave options varying from the expansive beach peaks of Morro Rock to the heavily populated line-up at Steamer Lane and the extreme cloud break at Maverick's.

When to go

Winter is markedly cooler here than Southern California, and the coast is frequently lashed by furious northwest winds. There are stretches of south-facing coast that filter swell and provide off-shore grooming at these times. Calm periods punctuate this season, when the open beaches can offer glassy conditions. **Summertime** is punctuated by occasional south swells from the equator, but more notably **late summer / fall** offers a combination of northern low pressure swell and acceptable air & water temperatures - it's the best time.

Hazards

Chilly water. The occasional shark but attacks rare. Most spots are clean and un-polluted. The temperature data is for Santa Cruz, and varies up and down the coast. When weather fronts arrive, winds will go cyclonic and change direction from NW through S.

M	Swell Range		Wind Pattern		Air		Sea	Crowd
	Feet	Dir'	Am	Pm	Lo	Hi		
J	3-15	nw	nw low	nw hi	41	62	52	lo
F	3-15	nw	nw low	nw hi	42	63	52	lo
M	0-6	nw	nw low	nw hi	43	65	56	med
A	0-6	sw-s	nw low	nw hi	45	66	56	med
M	0-4	sw-s	nw low	nw hi	47	69	57	med
J	0-4	sw-s	offshore	onshore	48	72	58	hi
J	0-4	sw-s	offshore	onshore	51	75	59	hi
A	0-4	sw-s	nw med	nw med	51	75	59	hi
S	0-8+	s-nw	nw low	nw low	49	74	58	hi
O	2-8+	nw	nw low	nw low	48	72	58	med
N	3-15+	nw	nw low	nw low	44	65	57	med
D	3-15+	nw	nw low	nw low	41	62	56	lo

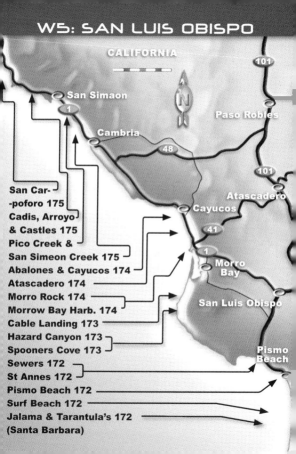

W5: SAN LUIS OBISPO

CALIFORNIA

101

San Simaon

1

Cambria

48

Paso Robles

101

Atascadero

Cayucos

41

1

Morro Bay

San Luis Obispo

Pismo Beach

JALAMA

Actually over in Santa Barbara County, but closer in climate to San Luis breaks. Jalama. Consistent, power beach-break that is all too often windswept. Holds big swells, when it's a tough paddle. Known as a consistent summer south swell magnet, but catches all directions. **Campgrounds, 1st Crack & 2nd Crack** all work over structured sand to 10ft.

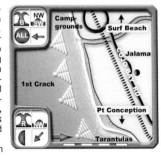

Tarantula's Reef, south on the bend, has short L & long R up to 25ft. Advanced! North up Hwy by Lompoc is **Surf Beach:** Heavy beach-break in SE winds with any swell direction. Gets huge and out of control when Jalama is small. Hard Core.

PISMO BEACH PIER

Head into Pismo to the State Beach.

Peaks all across this long beach, giving consistent surf year round. Works best on summer SW swells of moderate size, early mornings. Any tide is OK with low tending to mess up or close out. 2-6ft plus. All levels, and good for intermediates. Crowds but well absorbed. Heading north past Shell Beach

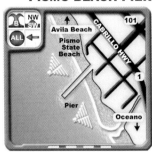

are some fickle reef setups: **Sewers** and **St Annes** are 2 good mid tide spots in either huge NW or solid SW swells. Off-shore in north or northeast winds. Advanced. Pretty crowded if perfect.

HAZARD CANYON & SPOONERS

Southwest from Los Osos in the Montana De Oro State Park.

Hazard Canyon: Hardcore right-hand reef break, both notorious and celebrated. It takes any NW winter swell and throws up gaping barrels over a rock ledge reef. There are currents and an extremely sucky take-off, especially at low tide. It handles up to 6 or 8 feet to perfection. Fairly consistent but not always good. Experts only. Paddle-out in a bright colored wet suit with friends and you could get a bashing from unappreciative locals. A mushier left off the peak helps to absorb crowds. **Spooners Cove** is a longer, left hand reef that handles more swell and works W through NW swells. Big northwest winter swells create an extremely hazardous, wedgy take-off. 4-15ft plus. Big Wave Mecca. Experts+. A paddle-boarder coming past from Cayucos survived this county's only recorded shark attack right here. Just north of the Canyon lies **Cable Landing**: Beach-break working consistently on smaller swells from NE through S. Likely to close out at low tide. Advanced.

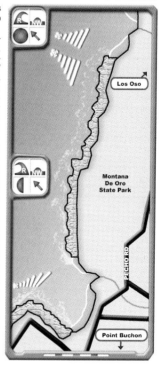

Los Oso

Montana De Oro State Park

PECHO RD

Point Buchon

W5

173

MORRO ROCK

Head south from Cayucos, to Morro Bay.

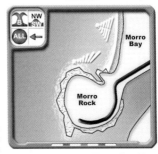

The Rock has several great beach peaks that take NW through S swells all year. Gets hollow when small, and heavy when big, up to 10 feet. Consistent. All levels depending on size. Absorbs crowds well.

North is the **Atascadero Beach Park**, more of the same, but only holds up to 6ft. Holds shape well due to sandy rock bottom. **Morro Bay Harbor** to the south, also has a Rivermouth option with about 5 good wave spots in and around the mouth that will cover you in most wind, tide and swell options.

CAYUCOS

Off N. Ocean Ave. In Cayucos. **The Pier**: Barrelling beach-break working on summer S swells, and off-shore in any N wind. Holds shape up to 5 or 6 feet, on most tides. Dead low can dredge and close out. **Mouse Rock**: Shallow, fast, short right & left reef off the rock way out in deep water on huge NW or S swells. Tow-ins mostly. Also **Abalones**, at the west end of town. Reef rights on gnarly rock bottom. Likes south swell, & closes out at 8ft. Heading south, there are numerous beach-break options too depending on banks, and these are more exposed to NW winds and swells.

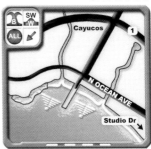

SAN SIMEON CREEK AREA

San Simeon Beach Park is off the 1. Summer peaks on S-SW swells & any tide. 2-5ft. Beginners +. Up north is **Pico Creek**: quality S swell beach-break, with a class left-hander at its N end in west swells at mid tide. 3-6ft. (If too big for Pico, there are some rarely surfed reefs just S). Further north a couple of miles is **Castles**: Consistent reef & beach on winter NW-W swell. SE winds,

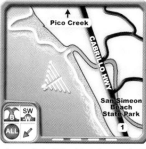

any tide. Big swells work on outer reefs to 15ft+. Next door to the N of this is **Arroyo Laguna**: Fun rivermouth on NE winds, mid tide, any swell. 2-6ft. Sharky. All levels. S of San Simeon before Leffingwell Park is **Exotics**: Fickle big wave left reef, S swell. High tide.

SAN CARPOFORO

Head to San Carpoforo on the 1. The road overlooks the beach north of the creek bridge.

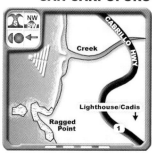

Consistent Rivermouth style peaks left and right in SW through NW swells. Holds some size and whilst often fat, can deliver barrels if the tide is right and light easterlies are blowing. Good summer spot early morning. Sharky. All levels. Parking is lame here,

and the local rancher gets gnarly. Park south and walk up trail. To the south, a few miles after Sierra Nevada Point, is **Cadis**: patchy sand reef under the lighthouse, good on mid-size winter NW swells and south storm winds.

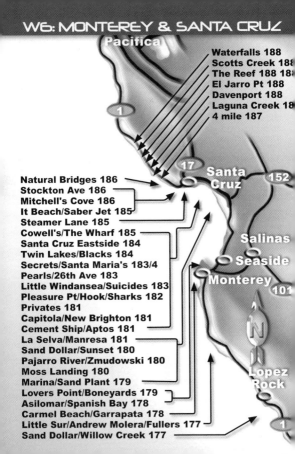

W6: MONTEREY & SANTA CRUZ

Pacifica

Santa Cruz

Salinas

Seaside

Monterey

Lopez Rock

WILLOW CREEK & SAND DOLLAR

Willow Creek: From Lucia, head south on the 1. A few miles down is Plaskett Creek. Right just after this. Rivermouth peaks and a rocky left at the end of the beach. Likes nor east winds and SW to W swells, but takes any. Pretty consistent spot. Crowds OK. All levels. 3-10ft or more. Classic power wave, and it holds some size. Fantastic spot.

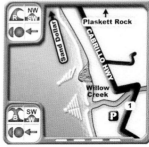

Sand Dollar Beach: Head back up the 1 just past Plaskett Creek. The beach is the where the creek meets the sea. Consistent beach-break that works well on summer south swells and early morning glass. Works well at 3-5ft, but takes more. Scenic, crowds OK, mellow local scene.

W6

ANDREW MOLERA

Turn off the 1 just north of the Big Sur River.

Quality right-hander breaking on bouldery / patchy sand bottom. Depends on bank movement, but likes NW to W swell and any north winds. Semi consistent. Usually has good shape. 3-6ft is best. Intermediates. Sharky. Another fun right is 2 miles north in the **Little Sur Rivermouth**. Similar conditions. A few clicks south is **Fuller's**. Heavy left-hand reef break in Big Sur. Any tide, and wrapping swells out of the southwest are good. Experts. 4-12ft. Extremely tight localized scene.

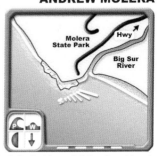

177

CARMEL BEACH

Head for Scenic Road in Carmel, Parking lot.

Summer beach peaks in nor east winds and southwest swell. Messy when tide too low. Consistent in summer, and early mornings can reveal quality hollow stuff. Holds about 6 feet, and the south end takes more, where lefts wrap around the sand / boulder point. All levels. Crowds in summer. **Garrapata Park**, to the south by a mile, is slightly more open to north swells, and good when it's medium sized, low tide, and east winds.

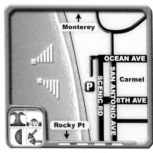

SPANISH BAY & ASILOMAR

At the western edge of Pacific Grove.
Windy spot with beach peaks across, working mostly on winter swells. Off-shore in southeast winds so a good option on medium days with winter storm fronts. When it gets big there are 2 noticeable reefs out the back for the hell-man. All tides OK. All levels. Pretty consistent. **Spanish Bay**, the next beach down is a similar option that handles more size, especially when it's winter monsters and SE winds. There's an outer bombora here too, which has been known to work at 15ft. All levels depending on size.

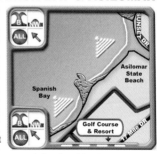

178

LOVER'S POINT

Head into Pacific Grove. Cannot miss it off Del Monte across the trestle.

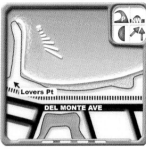

Left-hander breaking on bouldery bottom from a compact takeoff zone. Needs winter swells and any south winds. Tide no problem but low has a few rocks and a suck section. Not always classic but a good bet when its big, and southerly storm fronts are murdering all else. The price is crowds and crowds. There's a channel paddle-out or rock-hop option. 3-12ft. Can hold more. Inconsistent. All levels. On the other side of the point is the horrific **Boneyards**. Right-hand reef setup on NW-SW swells and easterly winds. Gets big! Experts.

MARINA

Off Highway 1 on Reservation Road. Marina State Beach.

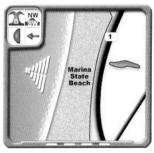

Consistent beach-break that holds swells NW through SW, all year, from 2-8 feet or more. Almost always has a wave, and the peaks can be steep and hollow on a good winter NW swell, east or southeast wind and medium tides. Summer SW swells are great too, especially early morning. All levels. Peaceful. Just south is **Sand Plant,** which is a good option on small summer pulses. Hollow, fast and best in the 2-5ft range on any tide.

Head south on the 1, and turn off for Jetty Road. Follow it round the lagoon and park.

Long, consistent beach-break that is rarely flat and, if not blown out, delivers the goods on a regular basis. There are a number of named peaks, but best bet is turn up and scan the lot before finding your channel. Can hold swells 2-8ft plus, with outer banks dealing with more. The jetties at S end are often a good bet for good shape and handy channels. Most tides are fine here, with higher often better. NW swells peel in and SE winds deliver the off-shore. All year round. All levels. Hassle on occasion, but space.

Zmudowski Beach is just north, as are a host of other variable beach-breaks including **Sunset** and **Sand Dollar**, and the fickle **Pajarro Rivermouth**. If any of these are on you may get to avoid crowds and have some great surf. Right on the other side of the jetties is **Salinas State Beach**. It works in the same conditions as Moss Landing, as well as a rivermouth, and holds 6ft plus. All levels. Medium crowds. Fun.

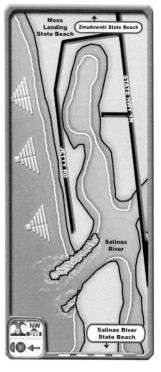

180

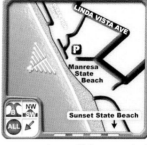

At the bottom end of Ocean View Drive in Manresa Beach.

Heaps of peaks along a summer beach-break, ideal on summer mornings. A very consistent spot, not too sensitive to tides, and offering some punchy, fun little barrels if the winds NE or glass. 1-6ft. Crowds in summer.

You can stroll north to **La Selva Beach** for more of the same, perhaps with less crowds. A cruise up from here, look out for **Aptos**: peaky Rivermouth break on any swell, and **Cement Ship**: structured sandbars around some wreckage at the north end of Aptos. 3-8ft. All levels. NE winds.

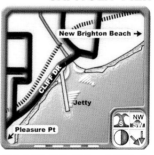

Back on Cliff Drive to the pier at Capitola.

Right / Left sandbar sculpted by Rivermouth. Can form fast walls and barrels for 100's of yards. Likes northerly winds and swell west through south, but only up to 5 ft or so, Semi consistent. Crowds on weekends. All levels. There's also a quality right off the **Jetty** in SW swells and NE winds.

Back toward Santa Cruz, you'll find **Private's**: Mellow right-hander off Opal Cliff Drive. East, you can follow signs to **New Brighton**: Right-hand reef break wrapping in on huge NW swells and NE winds.

SHARKS & THE HOOK

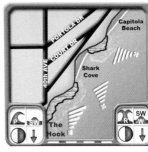

Head east on East Cliff drive. 1st right turn after 40th ave.

The Hook is another classic right reef-point wave. Best on good S, or huge wrapping NW swells and any north winds. It can break from about 3ft upwards, with anything south of a west swell closing it out pretty early but making it fast and hollow (especially at low tide). There's another nice reef further up the cove called **Sharks**, which can have rights and lefts depending on swell direction. On the south side of the cove is a rare reef break that throws up some power rights if swell is heavy south to southwest and the banks are playing ball.

PLEASURE POINT

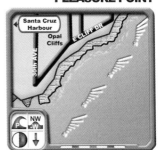

Off East Cliff Drive, at Opal Cliffs Park between 30th and 36th Avenues.

A never-ending series of point style peaks wrapping left around the bluff-lined beach. Breaks on mix of reef and sand, with kelp beds outside that glass it off. From the outside in, there's **Sewer Peak** - big outside rights (and OK lefts if swell is S) to 12ft. First section to get blown out by nor westers. **First & Second Peaks** - crowded, cleaner, lined up, to 12 plus. Finally **Insides** - softer action for intermediates. All take NW swell, with W lining up best, and SW being more peaky & critical. Crowds. All levels.

182

SANTA MARIA'S, PEARLS & SUICIDES

Head to the east side of Santa Cruz on East Cliff Drive. A series of beach-breaks followed by a bit of reef action.

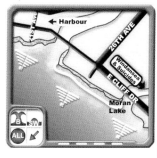

Santa Maria's, at the end of 21st Ave, takes summer swell from south through rare west, and is thus pretty consistent. Left and right beach-break that's pure power in the 4-6ft range at higher tides. Crowded. All levels / advanced if solid.

Next door to the south is **Pearls**, a similar beach-break that works on most tides, with same crowds depending which spot is breaking better. A few streets down is the aptly name **26th Avenue**. Super-crowded summer spot taking south or southwest swells up to 5 ft, on most tides. Likes northeast winds or early morning glass, and is getting more and more of a traffic jam these days. At least this area has many peaks that shift about enough to out-fox the mob.

Little Windansea is just to the southeast of the Moran Lake. A patchy sand / reef setup creating jacking lefts. Needs a rare big south swell, although can work on about 4ft of summer juice if dead low or if sand has built up during preceding storms. In a nor east wind in these conditions, its fast and pretty steep.

South of this setup, at the south end of Rockview Drive (which crosses East Cliff Drive) is the right off Little Windansea: **Suicides**. This is an impressive, fast, sucky little reef-break right-hander that jacks and barrels. On low tide it really can be steep. Needs NW-SW swells and northerly winds.

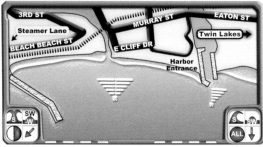

W6

Right in the heart of Santa Cruz.

From west to east, there are a few notable spots. Off East Cliff Drive, you'll see a stretch of beach-break focused around the **Rivermouth.** There can be well shaped banks here, left and right, on most tides. Lower tides and northerly winds can throw up some hollow, lined-up waves if there's enough swell, particularly of the southwest variety. On huge swells, the strip towards the pier gets surfed, as it filters out most of the power.

The **Harbor Breakwall** also hosts some shapely rights, often best at dead low when currents are minimal and the same swell as above is pouring in. This gets super crowded when on and the relatively concentrated takeoff zone is a zoo. All this when it's not strictly legal to surf here. Kirra-style barrels are too tempting though, and the whole county will know about it if any good. 3-8ft, more if direction right. All levels. Fickle as can be. Crowds!

East of this map is **Twin Lakes**: Good beach-break option on northerly winds with SW swells.

East of that, at the end of 13th Ave, is **Blacks**: shapely left-handers near Black Point, working in any tide and liking SW swells and a northeasterly wind. Crowds. All levels.

If huge, the alter-ego of Black's may be working: many names including **Secret's**. Right-hand peeler in large winter swell and northerly wind. Fickle. 3-8ft plus. All levels. Crowds if good.

184

Series of reefs fringing West Cliff Dr. Near the intersection with Pelton Ave in the south-west area of Santa Cruz. From west to east:

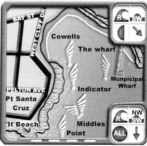

Right next to Lighthouse Point is **It Beach**, a pitching body-board spot with an outside bombora - **Saber Jet**. Rare power lefts at low tide in huge SW swells. 6-12ft.

Steamer Lane Breaks:
The Point, on Lighthouse Point, a mostly high tide right-hand reeling point. Likes south swells and takes the huge northwest winter swells. Has the bonus of being good in northwest winds too. 2-10ft. Advanced. Crowded as can be. **Middles**: a system of ledge reefs (the outer ones extend off the map) producing mostly rights that jack up then taper off from 2 or 3 distinct take-off points. Lefts too depending on swell direction. 3-10ft. Crowds galore. All levels / advanced when swell is up. Inside of all of this in another right-hand point wave that needs a bit more swell to work - **Indicators**. South swells peel in nicely in summer, and the larger winter north wests can also get in but create a pretty fat experience unless huge. You'll find something here on all tides, and all the spots are OK when the howling northwest winds come in. Hyper-crowded spot with a degree of hassle to new-comers, but eye up different peaks and be prepared to paddle over to any take-off spot that's less crowded, and you can get some great waves. 2-10 ft. crowded. Semi consistent.

Cowell's: Mellow right-handers on the inside, breaking on mix of sand and a few rocks. Handles huge west swells and any south. Does not get as big as its counterparts to the south, and thus can be packed with drop-in experts and wave-kayaks. All levels. 3-8ft. Crowds. Inconsistent.

The Wharf, off the end of the pier by Cowell's, is a good bet when it is big, the reefs are crowded, and you need sandbar sanity. 4-10ft plus. All levels. Fickle as can be.

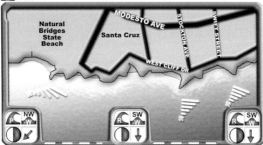

Series of reef breaks on the south-western edge of Santa Cruz. From west to east: **Natural Bridges**: Off the point in Natural Bridges Park, west end of town. Right-hand rock-ledge creates long lined up walls that get v hollow. Off-shore in any east wind and taking Swells SW through NW. Speedy and hollow at low tide, getting more mellow as tide rises. Gets blown out before many other spots in the area though. 4-8ft and handles more on right conditions. Semi consistent. Experts.

Stockton Avenue: At the end of Stockton Ave. A little further into the bay, this right-hand reef break ranges from fun (on a SW to S swell at about 4 ft, on mid tide) to downright jacking (solid 6ft plus swells west through south, low tide). Busy spot with a tight local crew, and so maximum respect is needed. 3-8ft plus. Semi-Consistent. Advanced.

Mitchell's Cove: At the south end of Swift Street. Right-hand rock ledge / point setup working faster and better on low tides and a solid W swell or even huge NW or 5ft+ S. Faces southwest, so winds from north or east areas are best here; too much west and it's a mess. Runs for yards and yards at high speed, making a constant catch-up situation. 3-12ft. Semi-consistent but good days quite rare. Experts. Tight local crew. East on West Cliff Dr, you'll cross **David Way**: Heavy jacking lefts on smaller SW swells. 3-8ft.

186

3 MILE, 4 MILE & 5 MILE

Take the Coast Road north from Santa Cruz. 4 miles on the left there's is small track down under the railway.

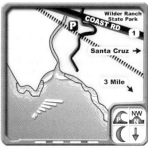

4 Mile: Right-hander wrapping around the point on rock. Likes northwest swells if big enough, and low tide. Hollow spot in southwest swells, and inside peak also works. 2-8ft. Advanced. Uncrowded if lucky. It has a sister break a mile east; **3 Mile**. 3 mile is more consistent but can get messy in winter west winds. And **5 Mile**? Check it west by a mile.

W6

LAGUNA CREEK

Heading north from Santa Cruz on the 1, at the 6 mile mark you'll see Laguna Rd on the right. The track is just before this east of the creek.

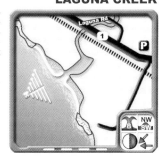

Great summer beach-break across the small cove. Likes south swells and early morning off-shores, and takes a battering from any sea-breeze. Quality varies, and gets lumpy at high tide. A good bet if too small down at 4 Mile, or swell too north for there.

DAVENPORT LANDING

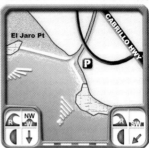

P Heading north from Santa Cruz, after Laguna Creek you'll see a sign on left for Davenport Landing.

2 fun reef options catering for all swell directions. **El Jarro Point** offers a right-hander in most tides on northwest through southwest swells. 3-8ft. Intermediates plus. Crowds. At south end is a left reef for summer south swells and north to east winds. 3-6ft plus. Crowd OK. All levels.

SCOTT'S CREEK

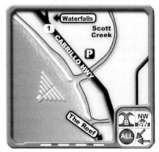

North from Santa Cruz on the 1. 10 miles up is Davenport Landing. There's a track on the left a mile and a half later.

Fun beach-break getting a re-modelling every so often from the creek outflow. Rains make it dirty but good. Likes northeast winds and takes northwest through south swells all year round. Best on medium 4 ft swells on any tide. You can walk up from here to **Waterfalls**: solid right-hand peak with tapering bumpy shoulder in northeast winds and winter swell. Then there's **The Reef** at south end: dredging reef peak on winter swells and east winds.

Central Coast Bomb. Bernie Baker sevenseas@hawaii.rr.com

W7: SAN FRANCISCO AREA

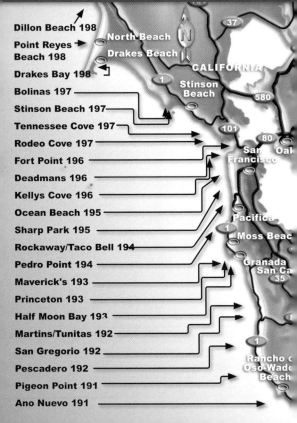

Dillon Beach 198

Point Reyes
Beach 198

Drakes Bay 198

Bolinas 197

Stinson Beach 197

Tennessee Cove 197

Rodeo Cove 197

Fort Point 196

Deadmans 196

Kellys Cove 196

Ocean Beach 195

Sharp Park 195

Rockaway/Taco Bell 194

Pedro Point 194

Maverick's 193

Princeton 193

Half Moon Bay 193

Martins/Tunitas 192

San Gregorio 192

Pescadero 192

Pigeon Point 191

Ano Nuevo 191

North Beach

Drakes Beach

CALIFORNIA

Stinson
Beach

San
Francisco

Pacifica

Moss Beac

Granada
San Ca

Rancho
Oso Wad
Beach

ANO NUEVO

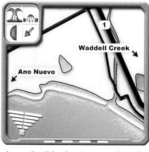

Head into the Ano Nuevo State Park, taking the 1 north from Santa Cruz. On the East side of Point Ano Nuevo, side road.

Powerful patchy sand / reef setup with wedgy rights and the odd left. Steep, very jacking take-offs and immediate barrel section. Likes any northerly wind and any southerly swell. Huge NW storm swell can get in but currents are crazy. Likes higher tides, and the lower the tide, the more sectiony the wave / more heavy the consequences. 3-8ft. Advanced. Sharky. Crowds. Summertime, inconsistent in winter.

W7

PIGEON POINT

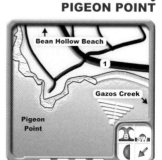

Driving south on the 1 from Pescadero, about 10 miles down, just after Bolsa Point.

Series of LR reefs that are in the lee of northwest storm winds. Pretty rare to catch it on, and very sharky. For this reason it is uncrowded. 4-8ft. Experts. Not safe. Fickle!

Head south on the 1 for about 5 miles to **Gazos Creek**. Summer beach-break peaks for smaller days, on all tides and easterly winds. 3-8ft. All levels. **Bean Hollow**, north on the 1, is a pretty consistent beach-break option.

PESCADERO

Pescadero State Beach at the Pescadero Intersection, signs off the 1.

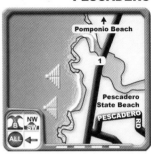

Consistent peaks across a pretty beach. Likes smaller swells from any direction and easterly winds. Breaks on sand with rocks in the line-up. Easy paddle-out in the channels. The Cove, at the south end, is a good spot in south winds and W to NW swell. Ideal in winter. All tides. Both spots 2-6ft plus. All levels. Sharks. North by a few miles up the 1, is **Pomponio Beach**; a consistent though wind affected beach-break good for small days in a morning off-shore, swells NW through S. No crowds to speak of there.

TUNITAS CREEK

From San Gregorio, Head up the 1. Tunitas Creek Road intersection, left to beach.

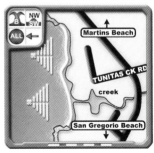

Rivermouth lefts and rights on all swells and low to mid tide. Peaky hollow sections that can be fast, but closed out when big. 2-6ft. All levels. Sharks. AKA "Don't eat us creek". South down the 1, is **San Gregorio** State Beach, working in similar conditions and giving some similar sandy barrels if wind off-shore and tide middle. If driving north, you can check **Martin's,** 2 miles up; a varied beach-break that catches SW-NW swells but gets wind-swept.

PRINCETON JETTY & HALF MOON BAY

Take the 1 to south side of Princeton.

Half Moon Bay is a varied beach-break; southern half is wind-blown but consistent. Northern sector misses the NW swells but can get hollow and fast on higher tides & SW swell. You are in town parking is a bit of a hassle. 2-6ft. All levels. **Princeton** has a crowded, wedgy little wave off the jetty on a sandy bottom that holds its shape

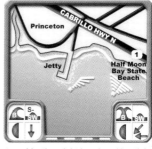

thanks to the man-made structure. Mostly a right-hander with a tight take-off spot making sure you stay low in the pecking order. Breaks into a good channel close to the beach and filters big NW swells into fast, performance peaks in NE - E wind. 3-8ft. All levels.

MAVERICK'S

Princeton. Hairy paddle out from south side of Pillar Point. Current sucks you south of the peak and you have to scrabble. Some go by boat from harbor.

Way out to sea, Maverick's bowls up almost cartoon-like over a deep ledge reef in a minimum 10ft of swell. It forms impossibly steep, concave drops, and for this reason really needs to be surfed on the glassiest, cleanest of days. It does fade into a channel, but controlling

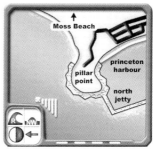

the drop well enough to set a rail and get there is why experts / total hell-men only need apply. 10-35ft. Tight crew of tough guys. Fall / Winter. Supreme danger. Spectators only.

PEDRO POINT

Head south from Pacifica on the 1. Take Shoreside Drive to shelter Cove.

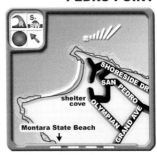

Left-hand reef break for days when all else is maxed out. 6 feet to monster-sized, if swell is long-period, and wind is south to east. When it's big, better surf it at high tide. It's a sectiony old bastard at the best of times, with unpredictability added to the harsh drop. A perfect environment for hyper-active danger-men - and it isn't too busy here. 6-20ft+ Expert only. Currents. If small, **Shelter Cove** has fun beach peaks protected from south winds, or **Montara** is about 10 miles south, and a consistent beach-break on E winds and 3-8ft swell.

TACO BELL BEACH & ROCKAWAY

Head S through Pacifica. Rockaway comes up first, then Taco Bell is at Lindamar beach round the point.

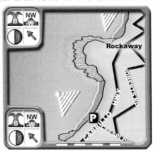

Rockaway: Beach-break (mainly) favouring southerly winds and solid winter ground-swell. It handles size but gets messy. On a good day(6-8ft of NW swell at low to mid tide and SE wind) barrels everywhere. **Taco Bell**: More beach-break in the same conditions, but a mellow option. OK on all tides, with a few rocks in some sections. All levels. Crowds of beginners. 3-8ft. Outer bommie handles more if clean and off-shore.

SHARP PARK

Pacifica's town beach.

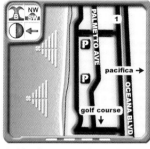

Expansive beach-break that is often wind-swept, massive and impossible to actually surf. Deep water right up to the shore allows un-diluted power. On a clean day it holds any swell thanks to some sand-holding embedded reef and a pier. If 8ft and under, on a middling tide with easterly winds, there is potential for some gaping green barrels, and some almighty floggings on the bank. Plenty of room for all, but still localized. 3-10ft. All levels. A perfect spot on an off-shore summer morning at 4ft.

W7

OCEAN BEACH

San Francisco's town beach, in the Sunset District.

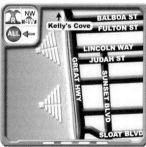

Superb quality, sometimes heavy, sucking, dredging beach-break with fangs. This is a truly excellent spot, but it regularly dishes out floggings & broken boards. On a 4-12ft(& holds up to 20) day with clean ground-swell from almost any direction, one or more of the banks will deliver vertical take-offs, wide barrels, and crazed races for the shoulder. Crowded near parking lots. Constant duck-diving. Ruthless currents. Dead sharks can wash up on the beach. All this against the latte-sipping backdrop of California's most sophisticated city.

195

DEADMANS

At the north end of town, in the park off Camino Del Mar.

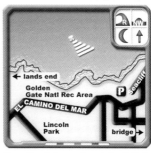

Reef-break extreme-ism meets the city. Inconsistent wrapping left-handers boil up over a rock ledge in winter NW swells. Can handle quite a bit of size but refracts it down, and likes southerly winds. Gets good when Ocean Beach is starting to close out. Currents. Crowds. Very moody fellow-surfers. Too near to town. Drive round to the northern tip of Ocean Beach for **Kelly's Cove**, which throws up nice hollow beach-break waves on swells south through nor west, and north to east winds. Super-crowded. Consistent. Less wind-affected in summer northwesterlies.

FORT POINT

Under the Golden Gate Bridge on the leeward side.

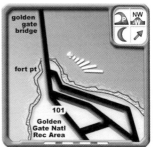

Long lined up left-hander. Not a barrel-hunter's paradise, but when all else is over-sized, provides clean-faced waves. Can form quality walls wrapping around the rock and wall shoreline. It's fat, dirty, with sweeping currents at times, and crowds of beginners, but what the heck.

4-10ft. All levels. Offshore from here are the fabled **Nomansland** and **Potato Patch peaks**; a probably unrideable big wave arena, breaking to unimaginably big size in ridiculous currents.

RODEO COVE

Coming from the bridge, 101 North, then Bunker Rd into Golden Gate State Rec Area. Mitchell Rd to end. Fort Cronkhite.

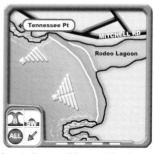

Southwest facing bay taking summer swells and offering protection from northerly winds. Varied beach-break peaks sculpted by Rivermouth. 2-6ft. Sharky as a shark-fin soup. Close to the epicenter of the "Red Triangle", which stretches from Santa Cruz to Oregon. If the creek has been let out, beware. All levels. Crowds. Beauty spot, best in summer.

STINSON BEACH

Coming N from the Golden Gate, take the 1 into Tamalpais State Park. Take any left off Calle Del Arroyo. Calle Del Onda is often a good bet.

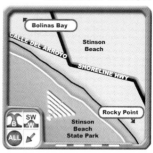

Good summer spot, taking southwest swells and offering protection from nor west winds. Stinson likes small swells up to 5ft, and most tides seem to be OK. All levels. Usual shark advisory applies. **Bolinas** up north is better, but sharky (about 1 body-boarder gets eaten per year) and it has a protective local community. Head south on Shoreline Hwy and via Muir Beach Junction to **Muir Beach** if heavy NW winds and solid NW swell - protected beach-break.

DRAKES BAY

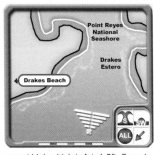

Point Reyes Nat Seashore. Sir Francis Drake Blvd south then Drakes Beach Rd. Long walk, long paddle. Superb Rivermouth lefts and rights at Drakes Estero on summer south swells and any N winds. 2-6ft plus. All levels. Sharks. Back on the 1 south, peel off at Horseshoe Hill Rd to **Bolinas**: Beach-breaks holding good shape on S swell due to rock pile jetties. Protected from any N winds and OK on most tides except high which is fat. 1-5ft. Crowds. All levels. To your north, and if it is too small here and wind is south, **Point Reyes Beach** is a consistent beach-break, blown out by north winds. SE is dead off-shore. 1-5ft. All levels. Uncrowded.

DILLON BEACH

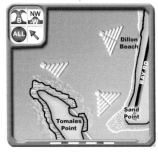

Runs along western edge of Point Reyes National Seashore. Signs to South Beach. Beach-break peaks working in NW - W swells and southeast to south winds. Quality varies but on smaller swells can be hollow and fast. Rarely very lined up but usually fun. Rivermouth left at the south end is a reeling hollow speed-run in big W or moderate NW swells and SE winds. Most tides will give you a wave somewhere here, and the Rivermouth is best at on-high or on-low due to tidal rips. Rare left off the point. Shark breeding ground. All levels. 2-6ft, more on some swells.

Background
Cold. Unforgiving. Huge. Sharky. Windy. Beautiful. The frontiers of surfing have been pushed back a long way, but not this far.

When to go
The counties north of San Francisco collect swells from just about anywhere in the Pacific, and they tend to hit uninterrupted. Trouble is winter storm winds lash the coast at the same times, or summer on-shore breezes. This means that it is often choppy, wet, cold and unsurfably big. You are also in the "Red Triangle", named for the blood of Great White shark victims that has spilled here on occasion. The odds are lower than a car crash, but thanks to Jaws 1 2 & 3 that is little consolation. There are, however, little gems across this stretch, and many go unridden except by a tight local crew of un-sung hell-men. These guys are to be respected not only because they may be mad to surf some of the monsters here, but because they live here to avoid the overpopulation of the southern coastline.

Hazards
Cold water. Currents. Difficult paddle-outs. Sharks. Loneliness. Temperatures below are at Fort Bragg, and vary slightly up and down the coast. Prevailing winds are northwest, and often strong, with storms creating high south winds. Local deep-sea upwellings can create very varied, unpredictable water temps.

M	Swell Range		Wind Pattern		Air		Sea	Crowd
	Feet	Dir'	Am	Pm	Lo	Hi	50	lo
J	4-20	nw	nw low+	nw hi	43	54	50	lo
F	3-15	nw	nw low+	nw hi	43	54	51	lo
M	0-6	nw	nw low+	nw med	44	56	53	med
A	0-6	sw-s	nw low	nw med	46	57	55	med
M	0-6	sw-s	nw low	nw med	46	60	55	med
J	0-6	sw-s	nw low	nw med	47	63	56	med
J	0-6	sw-s	nw low	nw med	49	63	57	hi
A	0-6	sw-s	nw low	nw med	52	65	58	hi
S	0-8	s-nw	nw low+	nw med	49	63	57	med
O	4-20	w-nw	nw low+	nw hi	45	60	56	lo
N	2-20	nw	nw low+	nw hi	44	58	52	lo
D	3-20	nw	nw low+	nw hi	43	55	51	lo

Piercy

Westport 205
Chadbourne Gulch 205
Cleone 205
Mackerricher 205
Caspar Creek 204
Mendocino 204
Manchester 204
Arena cove 204
Moat Creek 204
Blackpoint Bch 203
Horseshoe Cove 203
Timber Cove 202
The Fort 202
Russian Rivermouth 201
Salmon Creek 201
Doran Beach 201

Westport
Mendocino
National
Forest

CALIFORNIA

Mendocino

1

Elk

128
Boonville

101

Point
Arena

Gualala

1

Bod
B.

Head north out of bodega bay to Salmon Creek, and west on Bean Ave to Beach parking lot.

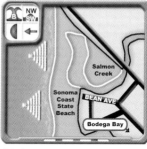

Extended beach-break open to any swell from NE through S. It is therefore, one of the most consistent bets around. Of course prevailing NW winds blow it off but early morning calm or light easterlies are the go. Often too big to paddle-out in winter, but holds 2- 12ft plus. If the swell is in the south, or absolutely massive, and winds are NW - check **Doran Beach**, south on other side of Bodega Bay. There's some mellow beach-break that's off-shore in any northerly winds, any tide.

RUSSIAN RIVERMOUTH

From Bridgehaven head north across river. You will come to the beach after a few miles.

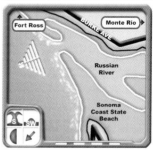

Rivermouth banks that can be sculpted perfection. Likes little summer swells from the southwest, and unreliable early morning easterly winds or glass, but offers acceptable faces if the winds are in the north too. Rights and lefts, and the choice is determined by the river herself. Sharky spot meaning care should be exercised - although there have been few rationales explaining how care will stop a 14ft Great White from ripping your hand off. All levels. 2-8ft plus. Consistent.

THE FORT

Head up the 1 to Fort Ross State Park. Shoreline Highway takes you in, then a stroll.

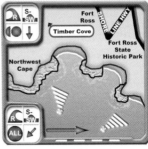

A pair of reef-breaks that are a good option on nasty northwest wind days, as nicely sheltered. There's a flat reef / boulder left-hander that's pretty gnarly with heavy take-offs and unpredictable sections. When it lines up, and the wind is north with higher tides and a solid 5-6 ft swell, it's awesome. There's a right which peels off the eastern end of the same patchy ledge reef system. It works in similar conditions but likes more of a west swell. 3-8ft+. Advanced. Variable crowds. Pretty spot.

TIMBER COVE

North on the 1 from Fort Ross State Park, into Timber Cove.

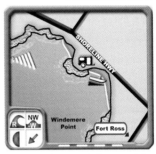

Right-hand reef break that likes northerly winds and northwest to west swells. Any tide will do except dead high, which can fatten it off completely. Rocky little spot, but pretty. Handles a fair bit of swell, and a good bet in huge winter NW swells, as it filters these into manageable sizes and shapes. 2-8ft. Inconsistent. Advanced. Scary paddle-out. Close-out sections on the boulder reef. Peaky little waves in a summer south swell.

HORSESHOE COVE

Off the 1 north after Horse-shoe Point. Access via Shoreline Highway to the camp-ground.

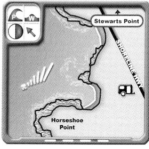

Left-hand point break in the cove. Some lined up walls that can be pretty hollow on lower tides and southerly winds. Higher tides make a fat, fun carving wall that wraps in for a long way. Likes winter swells. Bouldery spot and close-outs can have con-sequences. 4-8ft plus. Crowded when on. Inconsistent although often has something rideable. All levels. Reports of nastiness among other surfers...what's new?

W8

BLACKPOINT BEACH

Head past Black Point on the 1. Black Point Beach is sign posted via Black Point Road.

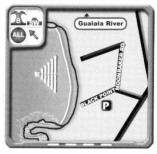

Good bet spot when all else is too small. Beach-break peaks that work on NW - SW swells and any wind with east. Offers protection from winter south-erly winds too. Any tide will do here, with different banks working at different depths. Maxes out pretty easily at about 5-6ft unless you are lucky enough to catch it on a rare big south swell, which can create nice lefts in the S corner. Consistent. 2-6ft. All levels. Uncrowded.

203

Arena Cove off the 1 south of Arena.

Awesome right ledge reef-break off Point Arena. Handles just about any size. Jacking outside peak that drops off and often steps / double sucks, followed by a tapering shoulder. Likes big NW-W swells, & NE winds. Also a mushy fun left inside the cove by the pier, and a very rare barrelling left out the back off the south point. 4-18ft+. Rocky spot. Sharks. Crowded. Major abalone spot. Advanced to pro. 1/2 mile south is **Moat Creek**; a fairly consistent beach-break with some reef options on SW swells and NE winds. Just N is **Manchester**, which has some consistent beach peaks in southerly winds.

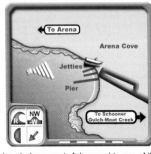

Just west of the town of Mendocino, Gulch Rd to the Rivermouth.

Classic Rivermouth stuff. Extensive sand flats slow the thing down into gentle sandbar action, but high tide and easterly winds can be great, with barrelling peaks across the bay. Pretty consistent, taking any available swell direction. Maxes out at around 6 feet. Crowds well absorbed in different areas. All levels. Consistent. Shark sightings reported. When this is maxed out, **Caspar Creek** just after Point Cabrillo is a good bet; consistent beach-break good on all tides and E winds.

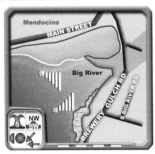

VIRGIN CREEK

At the north end of fort Bragg off shoreline highway then Virgin Creek.

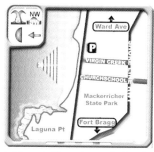

Right and left beach-break peaks that vary with swell direction, but are very consistent year-round. Likes east winds and middle tides. Low can close out a bit, and high gets super mushy. Best on smaller swells and maxes out over 6ft. All levels. Crowded as can be. There are some good options north from here to Wesport. **Cleone** has a nice beach-break that's consistent and good in SE winds. Also after **Inglenook** heading N, are a couple of quality coves off the 101 that you can scan from the car and jump in if its going off.

WESTPORT & CHADBOURNE GULCH

Head south out of Westport on the Shoreline Highway, before Bruhel Point.

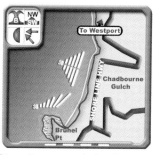

Quality beach-break good on most tides and southeast winds. Maxes out at about 6ft although any solid southwest swell will wrap around Bruhel Point and generate some good left-handers. Needs east to southeast winds or morning glass (rare!). Spread out so crowds OK. A few sharks get spotted. North of town, there are peaky beach-breaks in the Westport Union State Beach area, in similar conditions but maybe less crowded.

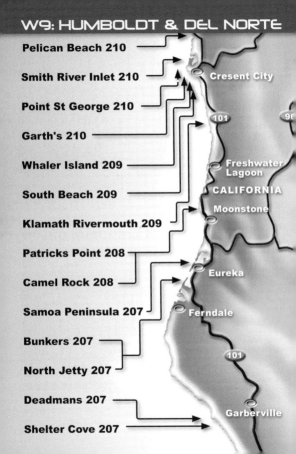

W9: HUMBOLDT & DEL NORTE

Pelican Beach 210

Smith River Inlet 210

Cresent City

Point St George 210

Garth's 210

101

Whaler Island 209

Freshwater Lagoon

South Beach 209

CALIFORNIA

Klamath Rivermouth 209

Moonstone

Patricks Point 208

Camel Rock 208

Eureka

Samoa Peninsula 207

Ferndale

Bunkers 207

North Jetty 207

101

Deadmans 207

Garberville

Shelter Cove 207

SHELTER COVE

Head north from Westport and west to Shelter Cove. There's a pretty 3/4 mile walk down to the first peak by the boat ramp.

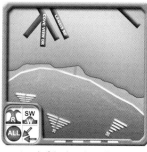

A great selection of reef options that work well when wind is north and swell is either raging NW monsters or solid SW-W. **Deadmans**, the most notorious, is a pretty consistent left in summer with some rights (the rights can take over in winter), up at the west end of the bay. It works on most tides and takes up to about 10ft. There are other options with varying degrees of wind protection as you head down the beach. Filters the winter swells to nice waves in the 4-8ft range.

HUMBOLDT HARBOR & NORTH JETTY

From Eureka, head over the bridges northwest past Samoa and the airport. Sandbars at Humboldt Harbor jetty form superb L & Rs. Heavy current along N side of N jetty sweeps you out to the north jetty peak (or past it to the scary **Sunset** peak). 3-12ft, but 20 ft faces possible. Also hollow power peak between the jetties, in the **heavy** tidal currents of the harbor (only surf dead low tide). 3-15ft +. Experts only. Crowds. Current. Sharks & boats. Frightening. Extremely serious wave. **Bunkers** just north is consistent beach-break with quality on lower tides and all swells. The **Samoa Peninsula** stretches several miles N.

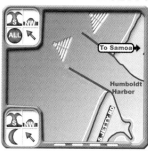

CAMEL ROCK

Head up the 1 past Moonstone, to Westhaven turnoff.

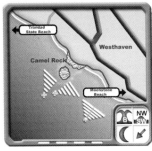

The rock off Houda Point attracts sand formations that give life to a sometimes wedgeing, bending right that wraps into the cove, as well as lefts. Consistent spot working on all tides if the sand is there. Can be off the menu for long periods though. On a light northeast wind and lower tide, it can throw up the odd barrel and some longer walls. Gets very crowded as near town and a pretty summer spot. Mellow. 3-6ft. All levels. **Moonstone**, running south, offers easy going beach peaks out of the NW wind on S swell. Shark migration zone.

PATRICKS POINT

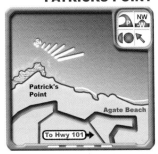

Head north from Trinidad on the 1. 5 miles up there is a left turn to the point. It may not be Desert Point, but its a super lined up left-hander that can handle any swell size, particularly winter north wests with winds in the south quadrant. Rocky entry and exit, but further down the line it's sand on the bottom, and the walls are there to be whacked - unless your talking of a 10-15ft day, which it handles with ease. Good winter spot. Crowds OK as wide arena. Brutal currents. Deep water; whales pass by. 3-25ft. Advanced. If wind swings north check **College Cove** to the south.

KLAMATH RIVERMOUTH

Head to Requa on the D7 off the 1. Patrick Murphy Drive gets you to the north side.

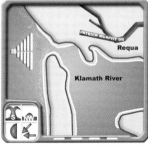

Fast, excellent barrelling Rivermouth banks, predominantly right, in any swell. Can close out some days on 5ft, but often holds closer to 10. On a solid fall 6ft swell from the NW, reeling long walls and barrels down the line. Super-Sharky. Advanced. There's a nice beach-break about 8 miles north up the 1 visible from the road, if smaller and you would like to live rather than get eaten by a shark; you'll see a steep incline and rocky stacks in the ocean. The road bends and you stop after the bridge and hike it down.

SOUTH BEACH & WHALER ISLAND

South end of Crescent City, well signed.

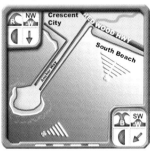

South Beach: good stretch of well-surfed beach-break protected from nor west winds, but smacked by winter souths. Plenty of peaks and the numbers are well absorbed. 2-6ft. All levels. Whaler Island: Chunky reef-break that breaks on the same ledge that they used to build the break walls. Tight take-off zone means plenty of opportunity to meet the many local residents, who may not be pleased to meet you. 4-8ft plus. Advanced. Varying quality. **Pebble Beach**, up north at the west end of town, is a good beach in S swell & N winds.

209

POINT ST GEORGE

Head north out of Crescent City to North Pebble Drive.

Quality point break requiring huge paddling effort. Fickle spot that works best on huge winter swells. When on, long walls usually brushed by accompanying stormy south winds. Likes northwest swell and southeast winds, and will work on most any tide. There are inside reforms worth a look, and these can be quality.

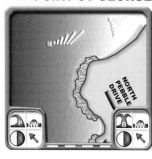

Garth's. To the north, is another fatter right reef worth a look if this is maxed out. North of here, you are back in largely beach-break territory.

Smith River Inlet has some interesting sharky set-ups where the highway meets the road. Then **Pelican State Beach** is a consistent beach strip that is often windy or just too darn big; cannot handle much over 5ft.

Agoura Hills
I G Boardstore, 5653 Kanan Rd, 818-707-1944
Val Surf, 5312 Derry Ave, 818-707-4579
Aliso Viejo - Laguna Surf, 26601 Aliso Creek Rd, 949-360-6495
Atascadero - Surf & St, 8645 El Camino Real, 805-466-9283
Pac Coast, 8645 El Camino Real, 805-466-9283
Bakersfield - Wavelengths Surf, 3501 California Ave, 661-322-7873
Bodega Bay - Northern Light Surf, 17191 Bodega Hwy, 707-876-3032
Surf Shack, 1400 Hwy 1, 707-875-3944
Bolinas - Bolinas Surf Shop, 52 Wharf Rd, 415-868-1935
Brea - Beach Access, 1006 Brea Mall, 714-257-0590
Burbank - Fastlane, 3501 Burbank Blvd, 818-840-0997
Camarillo -Revolution Surf Co, 1775 East Daily Drive, 805-383-1288
Cambria - Westside Surf & Skate, 800 Main St, 805-924-1803
Capitola - Arrow Surf & Sport, 312 Capitola Ave, 831-475-8960
Cardiff By The Sea - Raw Skin, 1359 Rubenstein Ave, 760-943-9317
Carlsbad - Back Yard Boards, 2221 Las Palmas Drive, 760-931-6910
Carve Board Sports, 2722 Loker Ave West, 760-930-9767
Oceancalls Surf Co, 300 Carlsbad Village Drive, 760-434-4840
Offshore Surf Shop, 3179 Carlsbad Blvd, 760-729-4934
Pacific Sunwear, 5610 Paseo Del Norte, 760-476-0500
Rip Curl, 2105 Rutherford Rd, 760-603-6700
Rusty Whitlock Surf Shop, 325 Oak Ave, 760-729-2062
Salty Sister Surf Shop, 2796 Carlsbad Blvd, 760-434-1122
Witt's Carlsbad Pipelines, 2975 Carlsbad Blvd, 760-729-4423
Carpinteria - A-Frame Surf, 3785 Santa Claus Lane, 805-684-8803
Blue Pacific, 905 Linden Ave, 805-566-4990
Cayucos -Cayucos Surf Co, 95 Cayucos Drive, 805-995-1000
Good Clean Fun Surf and Sport, 136 Ocean Front Ave, 805-995-1993
Cerritos - Nui Eke Surf, 20140 South State Rd, 562-860-7873
Chatsworth - Safari Surf & Sport, 20936 Devonshire St, 818-349-9283
Chino - Jer's Board Shop, 14500 Pipeline Ave, 909-606-4707
Chula Vista - Surf Shack, 345 3rd Ave, 619-476-4400
South Bay Surf & Skate, 523 Telegraph Canyon Rd, 619-482-7873
Corona Del Mar - Becker Surf & Sport, 3140 East Coast Hwy, 949-720-0533
Coronado - Little Sam's, 1343 Orange Ave, 619-435-4068
Dana Point - Alternative Surf, 34085 Pacific Coast Hwy, 949-488-9568
Girl In The Curl, 34116 Pacific Coast Hwy, 949-661-4475
Infinity Board Shop, 24382 Del Prado, 949-661-9299 / 6699
K'Nini Surfboards, 34085 Pacific Coast Hwy, 949-496-0074

Killer Dana Surf Shop, 24621 Del Prado, 949-489-8380
Sea Jane Surf, 34318 Pacific Coast Hwy, 949-443-2305
El Cajon - Rider's House Boardshop, 2864 Fletcher Parkway, 619-462-6160
Sun Diego Surf Skate Snow, 477 Parkway Plaza, 619-441-5213
Encinitas - 101 Board Sports, 828 North Coast Hwy, 760-942-2088
Hansens, 1105 S Hwy 101, 760-753-6595
Board Exchange, 466 North Coast Hwy 101, 760-632-1998
Boardroom, 1105 South Coast Hwy 101, 760-753-6595
California Surfing Products, 1105 South Coast Hwy 101, 760-753-2100
Cannibal Bros Surf & Sail, 823 North Vulcan Ave, 760-753-4749
Encinitas Surfboards, 107 North Coast Hwy 101, 760-753-0506
K-5 Surf & Sport, 1465 Encinitas Blvd, 760-436-4584 / 6613
Leucadia Surfboards, 1354 North Coast Hwy 101, 760-632-9700
Longboard Grotto Surf Shop, 978 North Coast Hwy 101, 760-634-1920
Performance Board Center, 1650 North Coast Hwy 101, 760-635-0146
Water Girl, 642 South Coast Hwy 101, 760-436-2408
Escondido - Active Ride Shop, 1266 Auto Park Way, 760-839-6941
Legend Surfboards, 2120 Mission Rd, Unit P2, 714-396-7873
Ocean Snow Boardshop, 1016 West Valley Parkway, 760-747-7873
Sun Diego Surf Skate Snow, 200 E Via Rancho Prkwy, 760-743-4133
Fairfax - Fat Kat Surf, 1906 Sir Francis Drake Blvd, 415-453-9167
Fair Oaks - Surf & Skate, 12417 Fair Oaks Blvd, 916-927-2005
Foothill Ranch - Laguna Surf, 26771 Portola Parkway, 949-588-0499
Fort Bragg - Gone Surfing, 330 North Franklin St, 707-961-0889
Fountain Valley - Axis Board Shop, 9092 Talbort Ave, 714-962-7393
Fullerton - Carve, 305 North Harbor Blvd, 714-446-0666
Union St Surf & Skate, 318 North Euclid St, 714-871-7724
Garberville - Tsunami Surf & Sport, 445 Conger St, 707-923-1965
Gardena - Legend Surfboards, 1266 West 134th St
Point Southside, 1513 West 162nd St, 310-515-1237
Saltys Sports, 18204 South Western Ave
Spyder Surfboards, 17000 South Vermont Ave, 310-323-3472
Goleta - Blue Shade Surfboards, 5668 Calle Real, 805-683-4450
Isla Vista Surf Co, 901 Embarcadero Del Nort, 805-968-1145
Surf Country, 5668 Calle Real, 805-683-4450
Granada Hills - 118 Board Shop, 11118 Balboa Blvd, 818-831-1358
Half Moon Bay - Clark Surfboards, 151 Harvard Ave, 650-728-0503
Coastside Surf & Skate, 535 Main St, 650-726-6422
Cowboy Surf Shop, 2830 Cabrillo Hwy North, 650-726-6968
Half Moon Bay Boardshop, 3032 Cabrillo Hwy North, 650-726-1476

CALIFORNIA SURF SUPPLIES

Maverick's Surfshop, 151 Harvard Ave, 650-728-0503
Healdsburg - North Coast Boardshop, 429 Healdsburg Ave, 707-473-9800
Hermosa Beach - Becker Surfboards, 301 Pier Ave
E T Surfboards, 904 Aviation Blvd, 310-379-7660
Just Long-boards, 914 Aviation Blvd
Olympus Boards, 1117 Aviation Blvd
Spiderboards, 2461 Pacific Coast Hwy, 310-374-8276
Spyder II, 65 Pier Ave
Surf Company, 337 Longfellow Ave
Huntington Beach
Sports chalet, 16242 beach blvd, 714- 848-0988
5th St Surf Shop, 224 9th St, 714-969-8930
Beachcombers Surf & Skate, 207 Main St, 714-960-0031
Huntington Surf & Sport, 126 Main St, 714-374-6266
Huntington Surf & Sport, 300 Pacific Coast Hwy, 714-841-4000
Huntington Surf & Sport, 3801 Warner Ave, 714-846-0181
Jacks Garage Surf Boards, 101 Main St, 714-536-1610 / 2563 / 4516
Quiksilver Boardriders Club - 300 Pacific Coast Hwy, 714-377-9191
Michael Surf & Sport, 414 Pacific Coast Hwy, 714-960-0880
Robert August Surf Boards, 300 Pacific Coast Hwy, 714-960-2266
Rockin Figs Surf Headquarters, 316 Main St, 714-536-1058
Sakal Surfboards, 201 Main St, 714-536-0505
Touch Of East, 414 Pacific Coast Hwy, 714-960-0880
Imperial Beach - Salt Water Magic, 226 Palm Ave, 619-423-7874
Surf Hut, 710 Seacoast Drive, 619-575-7873
Irvine
Boardriders Club, Irvine Spectrum, 71 Fortune Dr, 949 753-5031
Laguna Beach - Costa Azul Surf Co, 689 S Coast Hwy, 949-497-1423
Hobie Sports, 294 Forest Ave, 949-497-3304
Laguna Surf & Sport, 1088 South Coast Hwy, 949-497-7000
Quiksilver Boardriders, 255 Forest Ave, 949-376-0245
Second Reef, 1020 South Coast Hwy, 949-497-6742
Toes On the Nose Surf Shop, 903 South Coast Hwy, 949-497-3292
Laguna Hills - Jays Boardshop, 26538 Moulton Pkwy, 949-425-1680
Laguna Niguel - 1 W S Boardshop, 32411 Goldern Lantern, 949-443-9179
La Jolla - World core, 7863 Girard Avenue, 858-456-6699
La jolla surf, 2132 Avenida de la playa, 858-456-2777
Lakewood - Gold Coast Surf, 6410 Del Amo Blvd, 562-429-2757
La Mirada - Beach Bums, 15717 e imperial hwy, 562-943-3848

CALIFORNIA SURF SUPPLIES

Lompoc - The Surf Connection, 664 North High St, 805-736-1730
Long Beach - Gold Coast Surf, 5909 East Spring St, 562-420-7902
Los Angeles - Quiksilver Boardriders, The Grove, 6301 W 3rd street
Los Gatos - NC Board Shop, 440 North Santa Cruz Ave, 408-354-7873
Malibu - Becker Surf & Sport, 23755 Malibu Rd
Clout Rideshop, 29575 Pacific Coast Hwy, 310-457-1511
Malibu Surf Co, 22935 Pacific Coast Hwy, 310-456-6302
Malibu Surf Co, 22967 Pacific Coast Hwy, 310-314-0234
Stewart Surfboards, 18820 Pacific Coast Hwy, 310-317-8688
Manhattan Beach - Frohoff Beach Hse, 1151 Manhattan Ave, 310-546-2264
Ocean Gear, 920 Manhattan Ave, 310-798-7896
Ski Surf Shop, 1765 Artesia Blvd
Surf Concepts, 2001 North Sepulveda Blvd
Mill Valley - Marin Surf Sport, 254 Shoreline Hwy, 415-381-9284
O'Neill Surfshop, 247 Shoreline Hwy, 415-383-2058
Mission Viejo - Beach Access, 27000 Crown Valley Pk, 949-347-0077
Becker Surf & Sport, 28251 Marguerite Parkway, 949-364-2665
Gold Coast Surf & Sport, 27230 La Paz Rd, 949-855-7873
MAKO Surf Skate & Snow, 27741 Crown Valley Pkwy, 949-367-1300
Monterey -On The Beach, 693 Lighthouse Ave, 831-646-9283
Sunshine Freestyle Sports, 443 Lighthouse Ave, 831-375-5015
Montrose - Ocean View Board Spts, 3706 Ocean View Blvd, 818-541-9127
Moorpark - Transition Boards, 476 W Los Angeles Av, 805-531-5490
Morro Bay - Liquid Soul, 701 Embarcadero, 805-772-3245
Morro Bay Surf Company, 2830 Main St, 805-772-2678
TKD Surf Shop, 571 Embracadero, 805-772-1211
Unsound Surf Shop, 245 Morrow Bay Blvd, 805-771-9660
Newport Beach - 15th St Surf Shop, 103 East 15th St, 949-673-5810
Frog House, 6908 West Coast Hwy, 949-642-5690
QS youth, 259 Newport Center Drive 949-718-9792
Green Room Surf Shop, 6480 West Coast Hwy, 949-548-9944
Jacks Surf Boards, 2727 Newport Blvd, 949-673-2300
Main St Surf Shop, 105 Main St, 949-673-4412
Newport Beach Surf Co, 2224 Newport Blvd, 949-723-0635
PJS Surfrider, 2122 West Oceanfront, 949-673-1389
Russell Surf Boards, 2280 Newport Blvd, 949-673-5871
Surf Boards by Small Faces, 6908 West Coast Hwy, 949-642-5690
Surfside Sports, 112 23rd St, 949-675-2855

CALIFORNIA SURF SUPPLIES

North Hills - Valley Skate And Surf, 16914 Parthenia St, 818-892-5566
Oceanside - A-Axis, 3375 Mission Ave, 760-433-5887
Beach Culture, 401 Mission Ave, 760-967-6677
Earth and Ocean Sports, 576 Airport Rd, 760-828-4300
Ezera, 389 Via El Centro, 760-721-5044
Morning Glass Surf Co, 3205 Production Ave, 760-721-3018
Oceanside Surf & Sport, 205 North Coast Hwy, 760-757-5274
Surf Ride, 1909 South Coast Hwy
The Beach Co, 1129 South Coast Hwy, 760-722-2578
X-Axis, 3375 Mission Ave, 760-433-5887
Ojai - Beached, 11195 North Ventura Ave, 805-649-2811
Orange - Ron Jon Surf Shop, 20 City Blvd West, 714-939-9822
Sunny smith, 1814 tustin Ave. 714-998-5522
Oxnard - Momentum Surf Co, 1005 South Harbor Blvd, 805-985-4929
Pier Pressure, 3611 West 5th St, 805-984-6414
Pacifica - Neptune Surfboards, 1080 Palmetto Ave, 650-355-8281
Nor-Cal Surf Shop, 5460 Cabrillo Hwy, 650-7389283
Sunlight Surfshop, 575 Crespi Drive, 650-359-0353 / 5471
Pasadena - Epic Sports, 380 East Colorado Blvd, 626-356-3742
Quiksilver Boardriders Club, 380 East Colorado Blvd, 626-405-0067
Paso Robles - Alliance Board Company, 1233 Park St, 805-238-2600
Kahunas Surf Skate & Snow, 817 12th St, 805-238-3214
Petaluma - High Tide Surf Shop, 9 4th St, 707-763-3860
Pismo Beach - Moondoggies Beach Club, 781 Dolliver St, 805-773-1995
Panchos Surf Shop, 181 Pomeroy Ave, 805-773-7100
Pismo Surf & Sport, 231 Pomeroy Ave, 805-773-0134
Shell Beach Surf Shop, 2665 Shell Beach Rd, 805-773-1855
Port Hueneme - Anacapa Surf N Sport, 260 South Surfside Dr,8054882702
Redondo Beach - Boardriders, 1700 South Cataline Ave, 310-316-9101
C H P Surf, 1613 South Pacific Coast Hwy, 310-540-1214
Dive 'n Surf, 504 North BRdway, 310-372-8423
Secret Spot, 1205 South Pacific Coast Hwy
Soul Performance, 2215 Artesia Blvd, 310-370-1428
Surf Concepts, 1876 South Pacific Coast Hwy, 310-540-4606
The Shred Shack,800 South Pacific Coast Hwy, 310-792-5434
The Shred Shack, 505 North Lucia Ave, 310-792-5435
Riverside - Beach Access Girls, 2284 Galleria At Tyler, 909-785-7680
Rohnert Park - Gone Surfing 1451 Southwest Blvd, 707-665-0100

CALIFORNIA SURF SUPPLIES

Rolling Hills East - Peninsula Surf, 627 Silver Spur Rd
Sacramento - Wavelengths Surf Shop, 2100 Arden Way, 916-564-7433
San Clemente - California Surfari, 302 North El Camino Real, 949-481-6275
Fluid Surf And Sport, 638 Camino de Los Mares, 949-487-9283
Herbie Fletcher Surf Shop, 1755 North El Camino Real, 949-492-5721
Rip Curl, 3801 South El Camino Real, 949-498-4920
Rocky Surf & Sport, 100 South El Camino Real, 949-361-2946
San Clemente Surf Co, 1755 North El Camino Real, 949-492-5721
Stewart Surfboards, 2102 South El Camino Real, 949-492-1085
SZ Surf Designs, 124 Calle De Los Molinos, 949-369-5449
T St Surf Shop, 802 South El Camino Real, 949-361-1804
Trestles Surf Outlet, 3011 South El Camino Real, 949-498-7474
San Diego - Beach Culture, 3545 Del Mar Heights Rd, 858-259-7873
Bob's Mission Surf, 4320 Mission Blvd, 858-483-8837
Emerald city 3126 Mission Blvd Ste. #E 619 488-9224
Clairemont Surf Shop, 6393 Balboa Ave, 858-292-1153
Epic Surf Snow Skate, 8991 Mira Mesa Blvd, 858-635-5877
K-5 Boardrider Shop, 11955 Carmel Mountain Rd, 858-673-7333
Ocean Beach Surf Shop, 4885 Newpost Ave, 619-225-0674
San Diego Surf Skate Snow, 200 E Via Rancho Pkwy, 760-743-4133
South Coast Longboards, 5037 Newport Ave, 619-223-8808
South Coast Surf Shops, 740 Felspar St, 858-483-7660
South Coast Surf Shops, 5023 Newport Ave, 619-223-7017
Southcoast Wahines, 4500 Ocean Blvd, 858-273-7600
Surf Club Surf Shop, 952 Garnet Ave, 858-483-4854
Wavelines, 11658 Carmel Mountain Rd, 858-675-9696
San Francisco - Aquaholics, 2830 Sloat Blvd, 415-242-9283
Big Yank Board Sports, 710 La Playa St, 415-666-1616
City Front Boardsports, 2936 Lyon St, 415-929-7873
Madsurfer, 2037 48th Ave, 415-759-1525
S F Surf Shop, 3809 Noriega Ave, 415-661-7873
Wise Surfboards, 800 Great Hwy, 415-750-9473
San Juan Capistrano - Capistrano Surf & Sport, 31888 Del Obispo St, 949-234-0320
Doheny Board Center, 33955 Doheny Park Rd, 949-487-3231
San Luis Obispo - Baja Bobs, 2899 McMillan Ave, 805-543-2396
Copelands, PO box 1348, 805 5430660
Central Coast Surfboards, 736 Higuera, 805-541-1129
Surf Sisters, 785 Marsh St, 805-546-0705

CALIFORNIA SURF SUPPLIES

San Marcos
Energy Board Works, 1370 Armolite Drive, 760-736-4370
Rancho Boardride Co, 339 South Rancho Sante Fe Rd, 760-744-4500
Utility Board Shop, 339 South Rancho Sante Fe Rd, 760-744-4500
San Pedro - A Secret Spot About Surfing, 1322 West 26th St
San Pedro Surf Shop, 2234 South Pacific Ave
Santa Ana - Pure Energy Safe And Skate, 2781 West Macarthur Blvd, 714-545-1261
Santa Barbara - Beach House Surf Shop, 10 State St, 805-963-1281
Channel Islands, 29 State Street 805-966-7213
Morningstar Board Shop, 179 South Turnpike Rd, 805-967-8288
Santa Clemente - B C Surf Shop, 222 North El Camino Real, 949-498-9085
Cole Surf Boards, 129 Calle De Los Molinos, 949-940-9044
Santa Cruz - Arrow Surf & Sport, 2322 Mission St, 831-423-8286
ASD Longboard Heaven, 546 Palm St, 831-458-2151
Cybershapes, 1334 Brommer St, 831-475-9022
JD Rocket Surfboards, 402 Ingalls St, 831-427-2421
Longboard Heaven, 2548 Portola Drive, 831-462-5770
M 10 Surfboards, 402 Ingalls St, 831-427-2591
Natural Curves Surf Boards, 4340 Gladys Ave, 831-476-2772
O'Neill Downtown, 110 Cooper St, 831-469-4377
O'Neill Surf Shop, 1115 41st Ave, 831-475-4151
O'Neill Boardwalk, Beach Street, 831-459-9230
O'Neill Beach, 2222 East Cliff, 831 476 5200
Pacific Wave, 1502 Pacific Ave, 831-458-9283
Paradise Surf Shop, 3961 Portola Drive, 831-462-3880
Santa Cruz Style, 3912 Portola Drive, Suite 1, 831-475-4556
Shoreline Surf Shop, 125 Beach St, 831-458-1380
Stretch Boards, 205 Capitola Rd Extension, 831-479-7309
Surf House, 883 41st Ave, 831-476-9344
Santa Maria - One Way Board Shop, 4869 South Bradley Rd, 805-938-7858
Santa Monica - Island Surf Shop, 2934 Wilshire Blvd, 310-315-7244
Horizons West Surf-N-Wear, 2011 Main St
Islands Surf Shop, 2934 Wilshire Blvd, 310-315-7244
Z J Boarding House, 2619 Main St, 310-392-5646
Santa Rosa - Brotherhood Board Shop, 1216 Mendocino Ave, 707-546-0660
Scotts Valley - Momentum Boards, 220 Mt Hermon Rd, 831-438-9283

CALIFORNIA SURF SUPPLIES

Seal Beach - Alternative Surf, 330 Main St, 562-431-1010
Drop Surf Shop, 905 Ocean Ave, 562-430-7090
Harbor Surf Boards, 329 Main St, 562-430-5614
Simi Valley - IG Boarding Shop, 1407 East Los Angeles Ave, 805-582-1492
Surfin west, 1727 Los Angeles Avenue 805-526-8801
Solano Beach - Five-Forty, 858-481-5404
Mitch's Surf Shop North, 363 North Hwy 101, 858-481-1354
Solana Beach Surf Center, 363 North Hwy 101
Surf Ride Board Shop, 325 North Hwy 101, 858-509-8868
Stinson Beach - Off the Beach, 15 Calle Del Mar, 415-868-9445
Sunnyvale - NC Boardshop, 769 East El Camino Real, 408-739-7166
Sunset Beach - Bruce Jones Surfbds,16927 Pacific Cst Hwy, 562-592-2314
Bruno Surf, 16601 Pacific Coast Hwy, 562-592-4454
Temecula - Just Surfing, 27576 Commerce Center Drive, 909-694-9243
Thousand Oaks - IG Boarding, 5784 Lindero Canyon Rd, 818-707-1944
Torrance - Becker Surf & Sport, 2750 Oregon Court, 310-320-6032
SNT Enchant Board Sports, 2130 Redondo Beach Blvd
Vanguard Surf & Skate, 5205 Pacific Coast Hwy
Ukiah - Ronnies Basics, 1395 North State St, 707-462-0535
Universal City - Quiksilver Boardriders, Universal City Walk, 1000 Universal City Drive #v11 818-760-6650
Valencia - Val Surf, 23460 Cinema Drive, 661-222-7288
Valley Village - Val Surf & Sport, 4810 Whitsett Ave, 818-769-3060 / 6977
Venice - Venice Surf & Skate, 1515 Pacific Ave, 310-392-2179
Ocean echo, 23 Washington Blvd, 310-823-5850
Ventura - Bottoms Surf Company, 7961 Hermosa St, 805-647-6840
Ventura Surf Shop, 88 East Thompson Blvd, 805-643-1062
Walden Surfboards, 1760 North Venture Ave, 805-652-1279
Waveline Ventura Surf Shop, 154 East Thompson Blvd, 805-652-2201
Watsonville - La Selva Beach Surf Shop, 308 Playa Blvd, 831-684-0774
Woodland Hills - Val Surf & Sport, 22864 Ventura Blvd, 818-225-8177
Yucaipa - Icon Boardshop, 34451 Yucaipi Blvd, 909-790-3031

Background

Water temperatures close to freezing. Unfettered monster swells. Wild weather. Remote rugged locations. Huge distances. The top corner of the west coast can challenge you more than anywhere else on the planet. There are some splendid point waves like Seaside Point, and remote big-wave spots like Cape Lookout. You'll share them with some tight local crews.

When to go

Winter water temperatures are frightening, and North Pacific storms batter the coast with cutting south winds and rain. Often the challenge is to find somewhere small enough to surf. Summer is pretty consistent though, and the scenery at its most beautiful. The best time to score is undoubtedly early fall, when weather can break and water temps are survivable, yet north to west swells can roll in. Also, wind patterns are changeable at this time, and light easterlies are common in the mornings.

Hazards

Cold water. Currents. Difficult paddle-outs. Remote locations far from help. Temperatures below are at Aberdeen, and vary slightly up and down the coast.

M	Swell Range		Wind Pattern		Air		Sea	Crowd
	Feet	Dir'	Am	Pm	Lo	Hi		
J	4-18	nw	s med+	s hi+	34	45	48	lo
F	3-15	nw	s med+	s hi+	34	47	50	lo
M	0-6	nw	s med+	s hi	38	56	51	lo
A	0-6	w-s	nw low	nw med	39	48	52	lo
M	0-6	w-s	nw low	nw med	50	66	53	lo
J	0-6	w-s	nw low	nw med	50	70	54	lo
J	0-6	w-s	nw low	nw med	54	75	55	lo
A	0-6	w-s	nw low	nw med	55	73	55	lo
S	2-10	w-nw	e low	nw med	50	68	55	lo
O	4-20	w-nw	e low+	nw med	47	60	54	lo
N	2-20	nw	e-s med	e-s hi	44	50	51	lo
D	3-20	nw	s med+	s hi	37	46	50	lo

WIO: OREGON

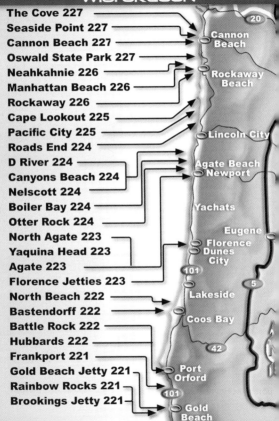

The Cove 227
Seaside Point 227
Cannon Beach 227
Oswald State Park 227
Neahkahnie 226
Manhattan Beach 226
Rockaway 226
Cape Lookout 225
Pacific City 225
Roads End 224
D River 224
Canyons Beach 224
Nelscott 224
Boiler Bay 224
Otter Rock 224
North Agate 223
Yaquina Head 223
Agate 223
Florence Jetties 223
North Beach 222
Bastendorff 222
Battle Rock 222
Hubbards 222
Frankport 221
Gold Beach Jetty 221
Rainbow Rocks 221
Brookings Jetty 221

Cannon Beach
Rockaway Beach
Lincoln City
Agate Beach
Newport
Yachats
Eugene
Florence
Dunes City
Lakeside
Coos Bay
Port Orford
Gold Beach

20
101
5
101
42

BROOKINGS JETTY

Head into Brookings on the Oregon Coast Highway. South side of the river.

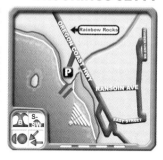

A mild, fun beach-break that offers left and right peaks on swells W through S. Slight protection from winter N winds too. Likes higher tides, when it is fun and maybe a little fat. Lower tides OK on smaller swells, but can turn the whole thing into a close-out. River run-off so marine life has been spotted. 3-6ft. Fun little town, so relatively crowded if good. Intermediates and Beginners level. If small here and winds from E, check **Rainbow Rocks** up north for good beach-break in similar swells.

GOLD BEACH SOUTH JETTY

Head to Gold Beach on the 101. Long stretch of beach off Oceanside Dr.

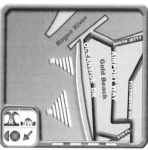

Multiple beach-break peaks taking swell from all directions. Winter NW winds rip it up, but N end does offer protection and often better banks by the jetty. Low tide adds to the close-out effect when any solid swell comes in square-on. 2-6ft. Currents. Sharks. Seals. If a howling southerly is messing this up, head north up the 101, half way to Port Orford, for **Frankport**. Quality left point / A-frame beach combo on W-NW swells and all tides. Needs fair bit of juice, but great in S to E winds.

PORT ORFORD

Head into Port Orford on the 101. 6th Street to the beach.

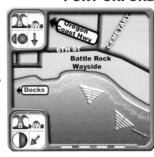

There's a couple of options here depending on the winds. North end is **Battle Rock**, a punchy though inconsistent beach-break protected from those strong NW winds. Best on higher tides but often dumping. If wind is in the East, **Hubbards** is a good bet, at the exit of Hubbard Creek. The sand / cobblestone bottom flows into good shapes here and quick-fire barrels are a possibility on lower tides and a good SW swell. It can work on winter NW swells too, but gets blown out often then.

COOS BAY

Head S from North Bend onto the Cape Arago Highway, then Bastendorff Rd.

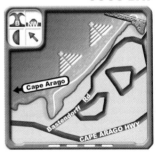

Coos Bay has several options, and **Bastendorff** is the most well-surfed. Beach-break peaks good on swells W through NW, and protected from southerly winds. 2-6ft. Pollution. Weekend crowds. Some quality reef options in the Cape Arago direction when swell bigger; you may spot them from the beach. Other side of the river is **North Beach**, which is good in similar conditions, and ripped up on any NW or W winds.

FLORENCE SOUTH JETTY

In Florence, head up Jetty Rd to Vista Country Park (North Jetty) or south across river to Oregon Dunes Nat Park (South Jetty).

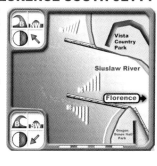

South Jetty: Beach has peaky lefts and a nice R in the top corner if winds in the N quadrant. Summer S swells. 2-6ft+. Jetty holds more. Intermediates. Weekend crowd. Inside the river is occasional Left peeling off wall. 2-6ft. NW swells with S-E wind. Sharky. Currents. **North Jetty**: Peeling rights when swell in north and wind in the south. Prefers lower to mid tides and E wind. 3-6ft. Tight local crew. Intermediates.

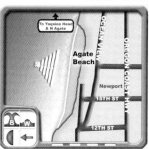

Head into Newport. North end of town is **Agate Beach**. Lengthy strip of beach-break options working consistently in swells NW through SW. Gets pretty fat on the higher tides, and wind affected. North end of beach gives protection from north winds, and holds up to 6ft plus. Crowds always well absorbed. All Levels. The northern headland, **Yaquina Head** hosts a gnarly offshore reef that holds up to 12ft+ of winter storm swell. Maximum current and sketchy paddle-out / in though, requiring fancy footwork to navigate the rocks. Experts only. Further N, **North Agate** is a good option in S winds, mid tide and W-NW swell.

Lincoln City is off the 101, and is Home to a series of cliff-lined beaches. From North to South:

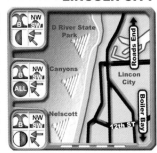

Roads End Beach: north of the town. Mixed beach-breaks good on all swells with E winds a must. 2-6ft. Intermediates. Un-crowd-ed. On huge days there are 2 L and R reef options from 5-10ft plus on middle tides and E winds.

D River State Park: River-mouth sand bars that can shape up extremely well to take swells SW through NW, all year round. Best on lower tides although banks can conspire to confound this theory. E winds a must. 2-6ft. Inter-mediate.

Canyons Beach Park: South of town. Beach-break that holds sol-id swell and good shape due to rock formations that structure the sand. Can hold power swells from SW through NW. 3-10ft. Inter-mediates or Experts when bigger.

Nelscott: South of Canyons. Similar style of beach-break with out-side reef option on all swells. Handles the big stuff but pretty fickle and known to disappoint. Lower tides better, East winds.

South Across Siletz Bay is a reef break shrouded in mystery, and definitely for experts. **Boiler Bay** hosts a monster right (folklore is rife about the left) that can take well over 12ft. Likes a lower tide but if big, any will do. Faces north, thus protected from southerly winter winds.

Motoring it back towards Lincoln City, you get to **Otter Rock**: beau-tiful mellow spot good in summer S swells and NE wind. Has heaps of peaks, friendly rips, and relaxed setups for all levels.

PACIFIC CITY

Head N out of Pacific City to Cape Kiwanda Rd.

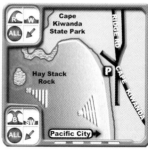

At the top end of the beach is a right hand reef break that can take solid NW or W swells. 4-12ft. Advanced. Uncrowded unless real good. The beach has varying sand peaks left and right. The further north, the more protected from both N winds, and any N to NW swell; so on winter days there is a compromise between cleanness and size. All tides. All levels. The town beach just south also has some nice peaks although these have less wind protection and a few more in the water. 2- 8ft. All tides. All levels.

CAPE LOOKOUT

North from Pacific City on the 101. Follow signs after Sandbake.

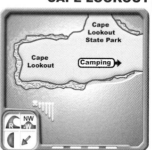

Long lined up reef break in the southern lee of the Cape. This is a remote spot capable of dealing with most any size of northwest or west swell. The result is beautiful point-style walls that can reel across into the channel and offer some barrel time it the wind plays ball (light northeast is best). 4-12ft+. Inconsistent. Long Trek. Experts. Remote. Heavy local crew. The beach that runs south has some quality peaks too over sand. These all enjoy some protection from north winds. All levels. Scenic.

 # ROCKAWAY & MANHATTAN BEACH

Take the 101 north from Bay City. Half way to Manzanita.

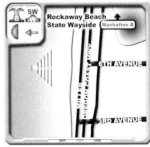

Huge expanse of exposed beach-break for miles. This is summer surfing, when the chance of an early morning land breeze based easterly can combine with smaller SW - W swells. It closes out at about 5ft, and lower tides can exacerbate the problem. Crowds however, are not a problem as so many peaks. 2-5ft. Consistent. All levels. Many options around.

 # NEAHKAHNIE

At the north end of the town of Manzanita.

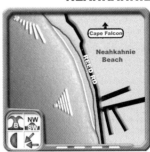

More beach-break peaks that work on any small swell, and easterly winds. Neahkahnie Beach bends round to face southwest, and some reef right-handers work off the corner, handling more swell, particularly of the W-NW refracted variety. This section likes middle tides (lower tides are rocky) and northeast breezes. The whole strip is better early morning in summer, and between fronts in winter. Consistent. Frustratingly windy, but when on you'll be rewarded with uncrowded fun waves.

CANNON BEACH

Heading north on the 101, just about the last beach town before the highway bends inland around Tillamook Head.

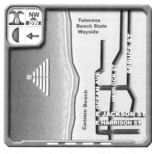

Consistent beach-break for smaller days. Any swells accepted but square wests or anything over 6ft closes out. Any tide, as different sandbars will fire at various depths. One of Oregon's more crowded summertime spots. Check it early morning before the winds, or between winter fronts. All levels from beginner upwards. Crowds. For an escape, head south into **Oswald State Park**. Small pretty protected cove for nice low tide beach-breaks in northeast winds and SW - W swells & lower tides.

SEASIDE POINT

South from the town of Seaside onto Tillamook Head. Hike it down the trail & across the rocks.

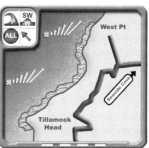

Long, lined up bouldery left-hand point break that does the business in SW-NW swells and SE winds. Winter spot protected from S wind. Wrapping, warping walls into the boulders in **First Point**, and heavy jacking monsters on the outside at **2nd Point.**
Fast barrels. 3-15ft+. Heavy local scene so if you want to risk it, be extremely careful. **The Cove** a few clicks north inside the bend is home to hollow sand lefts on SW-NW swells and ESE winds. 3-8ft. Crowds. Intermediates. Awesome long walls.

227

WII: WASHINGTON

Vancouver Island

Neah Bay

14

101

The Strait 230

Rialto 230

First Beach 230

Point Grenville 229

Taholah

WASHINGTON

Sunset Beach 229

Pacific Beach 229

Ocean Shores

8

Roosevelt Beach 229

Westport

12

Damon Point 229

101

Westport Jetty 229

Long Beach

30

Warrenton

WESTPORT

Head north from Westport to Westhaven State Park.

The area's best shape-holder is **The Jetty,** off the southern break wall of the harbor. The south side of this produces good rights and the odd left, on any swell and winds E through NE. Peaks down the beach are pretty consistent. North side of the break wall at **The Cove** is protected from southerly winds, but

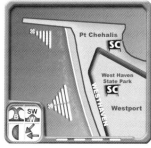

has currents. **Damon Point** , inside north jetty, gets good shape in solid SW swell and N winds. **Long Beach Peninsula**, south from here across Willapa Bay, varied beach peaks, often blown out / too big. 2-8ft. All levels. Moderate crowds at the jetty in summer.

POINT GRENVILLE

Head up the 109 from East Hoquiam, almost to the end of the line. On the way you will pass **Roosevelt Beach, Sunset and Pacific Beach.** If lucky stop here. If not, and winds are N to NW, continue to Point Grenville.

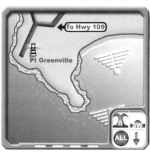

South facing point offers 2 rare but good reefs that are sheltered from NW winds, and filter out the huge winter N swells. There's also some quality beach peaks with varying exposure to swells. Most require an element of S swell. Any tide. Beach access not always granted, which leads to lonely surfs if you are allowed.

ⓟ FIRST BEACH, RIALTO & THE STRAIT

From the 101, take 110 to La Push.

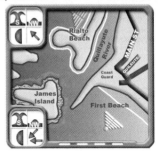

First Beach: Shingly sand beach with various mid tide banks. Needs SW swell and NE-E winds, so best in summer.

Further north, **Rialto Beach** works well on winter NW swells with winds in the south. Sand peaks left and right.

Some remote mysto spots are dotted along the trails between here and Canada. The challenge is threefold: find a spot, during off-shore conditions, and actually get permission to surf it: much of this is Indian reservation with permit requirements. One of the most interesting of these is right inside **Cape Flattery**, where heavy fast lefts refract in on the south side of the cape and get protection from north winds. It's in the reservation thus permit required. 3-10ft. Advanced.

On humungous NW swells with southerly winter winds, waves break up and down **The Strait** in some of the coldest waters imaginable. Neah Bay hosts a couple of quality lined up lefts, but waves can break much further inland if it is massive; a bizarre sight indeed. The most consistent is **Dump Site**, at **Neah Bay**. Then there's **Clallam Bay**, with a lined up, soft left-hander. Right inshore at Lyre Park is **Twin Rivers**, yet another long fat left. Further investigation on massive ground swells will yield more.

If this is not mad or cold enough for you, there's the ferry over to Canada, and **Vancouver Island**. Jordan River, Long Beach, Eagle Reef, and many many reef, Rivermouth and beach-breaks.

PACIFIC NORTH-WEST SURF SUPPLIES

OREGON
Brookings - Sessions Surf Co, 880 Chetco Avenue, 541-412-0810
Cannon Beach - Cleanline Surf Co, 171 Sunset Boulevard, 503-436-9726
Coos Bay - Rocky Point Surf & Sport, 222 South Broadway, 541-266-9020
Eugene - Boardsports, 265 East 13th Avenue, 541-484-2588
Florence - Cort Gion Surfboards, 87637 Hwy 101, 541-997-2007
Grants Pass
Extreme Board Shop, 1661 Northeast 7th St, 541-474-7464
Nob Surfboards, 567 Hidden Valley Road, 541-476-7926
Langlois - Big Air Wind & Surf Shop, 48435 Hwy 101, 541-348-2213
Lincoln City
Lincoln City Surf Shop, 4792 Southeast Hwy 101, 541-996-7433
Oregon Surf Shop, 4993 Southwest Hwy 101, 541-996-3957
Safari Town Surf Shop, 3026 Northeast Hwy 101, 541-996-6335
Newport - Ocean Pulse Surfboards, 429 Southwest Coast Hwy, 541-265-7745
Pacific City - South County Surf, 33310 Cape Kiwanda Drive, 503-965-7505
Portland
All Surf Industry, 532 Southeast Clay St, 503-239-8973
Gorge Performance, 7400 Southwest Macadam, 503-246-6646
Seaside
Cleanline Surf Co, 719 1st Avenue, 503-728-7888

WASHINGTON
Auburn - Outhouse, 510 East Main St, 253-931-3898
Issquali - Extremely Board, 1145 Northwest Gilman Boulevard, 425-391-4572
Kirkland - Perfect Wave, 8209 124th Avenue Northeast, 425-827-5323
Ocean Shores - North Coast Surf, 773 Point Brown Avenue Northwest, 360-289-0651
Port Angeles - North by Northwest Surf Co, 902 South Lincoln St, 360-452-5144
Renton - Gravity Sports, 126 Rainier Avenue South, 425-255-1874
Seattle
Cheka-Looka Surf Shop, 2948 Eastlake Avenue East, 206-726-7878
Urban Surf, 2100 North Northlake Way, 206-545-9463

Hatteras. Bernie Baker sevenseas@hawaii.rr.com

Background

An immensely varied, contorted coastline offers every possible angle to Atlantic swells, creating the widest range of wave set-ups. Whilst the East Coast is often accused of being puny in the juice department, the sea-bed off New England is deep, and funnels available swell without sapping it's power. Yes it is freezing up here, but the waves are great, and can be powerful. The diversity in coast angle makes surf prediction as much a matter of geometry as meteorology: The northern coast of Maine for example, may miss NE swells that smash into Cape Cod, but it gets the lion's share of opportunistic hurricane pulses.

When to go

Fall is best. Low pressure systems spinning off Greenland kick up a good supply of swell from September and through winter. Fall heralds the beginning of this, as well as the last half of hurricane season, which sends long period south swells up. It is downright beautiful then, and the water temperature is less of a punch in the ribs. Summer is inconsistent but often great, and winter is occasionally power-packed but always severe (think 5 - 7 mm rubber). Winds vary massively up the coast, depending on low pressure systems.

Hazards

Cold water. Currents. Icebergs. Temperatures below are at Portland, and vary up and down the coast. Summer crowds. Expensive parking.

M	Swell Range		Wind Pattern		Air		Sea	Crowd
	Feet	Dir'	Am	Pm	Lo	Hi		
J	2-12	ne	nw	nw	16	24	33	lo
F	3-10	ne	w	w	19	32	34	lo
M	0-6	ne	w	w	32	50	40	lo
A	0-6	s	w	w	40	60	45	lo
M	0-4	s	w	w	58	68	50	med
J	0-4	s	w	w	65	86	56	hi
J	0-4	s	w	w	70	90	62	hi
A	0-6	s	w	w	58	70	68	hi
S	2-8	s-ne	w	w	50	65	65	med
O	3-12	ne	nw	nw	45	58	58	lo
N	3-12	ne	nw	nw	35	45	52	lo
D	3-12	ne	nw	nw	20	30	40	lo

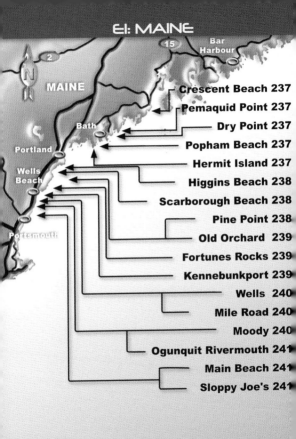

EI: MAINE

MAINE

Bar Harbour

Bath

Portland

Wells Beach

Portsmouth

Northern and Central Maine

A wild and beautiful surfscape that does not open it's treasure chest easily. The top half of the state has a convoluted coastline that benefits surf travellers by presenting every angle possible to the winds and swell, yet frustrates with it's inaccessibility. Here you can be within a mile of all-time surf without any chance of spotting it, so hidden is the coast and so basic the roads. Epic adventure indeed.

Crescent Beach

From Rockland, take 73 south past Knox airport. At the airport there's a left to Crescent Beach, then right on Crescent Beach Rd.

One of the most accessible spots, a few clicks south from Rockland. All-tide power beach-break sheltered from north winds and swells. Likes SE swell, but straight E is blocked. One of the more consistent options in the area. 2-6ft. All levels. Mysto reef break past southern end worth a check if big.

Pemaquid Point

From Rockland, take the 1 south. Turn off left to Bristol. From Bristol take 130 south to New Harbor and continue past, to end of Point Terrace. Rugged bouldery point break producing quality rights. Likes swells south through east, and any northerly wind. Inconsistent. 3-10ft. Advanced. Currents.

Dry Point

Take the same turn off the 1 as above. Go to South Bristol on the 129 and follow road to the end. Half a mile walk. Left hand boulder point break, that lines up nicely on southerly swells from 3-6ft plus plus. Best at higher tides and often sectiony and harsh. Northeast winds off-shore. Experts.

Popham Beach

From Bath, take the 209 south. Peel off at Ashdale on Main Rd. Left on Popham Road. Follow to the end. Consistent crowd pleaser of a beach-break. Likes NW winds and any swell south through east. Lined up peaks on all tides. 2-8ft. All levels.

Hermit Island

As above, but stay on Main Rd till Small Point.

Inconsistent but quality beach-break on Hermit Island, a good option when elsewhere is huge and blown out. Protected from all north winds, and working on any tide. Southern shore of the peninsula has other options across towards Popham if it's flat here.

HIGGINS & SCARBOROUGH BEACH

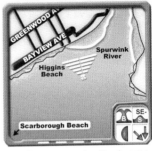

Head S on Hwy 1 from Portland. L on 207 through Scarborough to the beach or L on 77 to Higgins Beach.

Inconsistent beach-breaks breaking on sand bottom (rocky at S end). Average size and quality, unless you get a big SE-E swell in fall or winter time. It might be cold, but this spot handles size - it is not unknown for double overhead to dump here. Huge tides and strong currents. Watch the pop-up rocks. Needs a reasonable NW to hold the face up. Mellow local crew. All standards (unless big, when it is a good surfers break). **Scarborough** tends to be similar to Higgins but usually bigger & more consistent.

PINE POINT

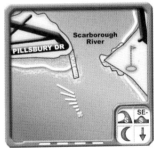

Head S past Scarborough on 1 Hwy from Portland. Turn L on Hwy 9 to the beach. Follow the rd E to the end of Pillsbury Dr.

Unlike the more consistent OOB pier to the S, pine point is a fickle, but good quality L breaking off the S Jetty of the Scarborough River. Needs a winter SE hurricane swell to really crank, and low incoming tide. Normally starts working as the beaches around are maxing out. Long L needing a straight northerly for offshore. Great wave for improvers learning to ride point waves (assuming they can handle the cold.)

OLD ORCHARD & FORTUNES ROCKS

Follow the same directions for Pine Point. Instead of turning L to the point, go R on Hwy 9 to the town beach pier.

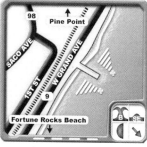

There are quality banks along this beach, usually around the pier, in SE or E swells. Quality is dependent on the sand banks that shift up and down the beach, but the pier tends to hold them together. In late summer, on a south swell you could find yourself alone on a quality, clean overhead peak here if you're lucky. Head S on the 9 then Hwy 208 to **Fortunes Rocks Beach** for a short, dumping shore-break at high tide only. Many back-yard waves in this area - exploration zone.

KENNEBUNKPORT

Head S from Portland on State Hwy 95. Take the Kennebunkport turnoff, then Kennebunk Beach Rd to the beach.

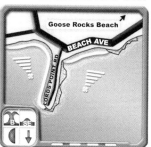

In a big NE winter swell with NE winds, this S facing beach can produce thick-lipped, double overhead plus beasts. Big drops, steep faces and heavy hold-downs are the order of the day when it goes off. Add the very strong currents and on its day, you have an advanced to expert break for the slightly psychotic. There's a very good, fast break at **Gooch's Beach,** just N in winter S swells and a NE wind. Further NE, try **Goose Rocks Beach** N on Hwy 9 to avoid the crowds.

E1

WELLS BEACH

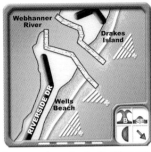

Head S from Portland on State Hwy 95. Turn L on Hwy 98 to Wells Beach. Turn L on Atlantic Av to the end and S Jetty.

Wells Beach has some pretty consistent beach-break action on south through east swells at middle tides. The jetties get fun, and the Webhanner River south jetty holds a lined up left if the tide is pretty low. On spring tides at full flow there'll be a churning sweep to contend with. Often gets crowded with a solid local crew. Head S down the beach as far as **Mile Road**, particularly in a S-SE swell on incoming tide for un-crowded peaky beach-breaks for all standards.

MOODY

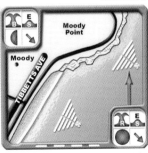

Take the same turning off State Hwy as for Wells Beach. Turn R on Hwy 1 then turn L on Furbush Rd to Ocean Av.

At the N end of the beach, a rocky reef close to shore produces jacking, intense L&Rs in biggest SE storm swells and off-shore NE winds. Pretty high volume of water churns here, so watch the dump. In smaller conditions in straight N winds and at mid tide, head down the beach for peaky beach-breaks on sand bottom. Mellow locals, freezing water and few crowds make this worth the stop-off.

OGUNQUIT RIVERMOUTH

Continue S on Hwy 1 from the Moody Beach turnoff into Ogunquit. Turn L on Beach St or take Shore Rd to Israel Head for the Point. This famous but very fickle R breaks off Lobster Rocks into the Rivermouth. Needs low incoming tides and a W wind to crank. In best conditions, a fast overhead, glassy barrel. It's pretty rare though. There's also major rips and currents to contend

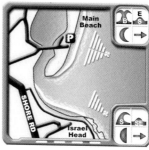

with, and it can't handle too much size. Intermediate to advanced spot. **Main Beach** offers uncrowded options on all swells and all except highest tides. Watch out for big rips. Heading north, the patient explorer may discover some quality slab reefs.

SLOPPY JOE'S

Head S on Hwy 1 from Ogunquit. Take the 1a (Main St) to York Beach and Short Sands. Turn R on Broadway for Long Beach.

Sloppy Joe's, at Long Sands, offers L&R peaks up to 6ft. Best in winter storm E swells and NW winds, but takes S through E swells. All levels. Rarely crowded. North of the Cape, **Short Sands** is a

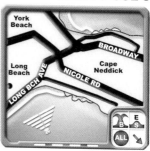

fickle beach option in big NE swells with a S-SE wind. The L is a thick-lipped, powerful barrelling beast over sand bottom. A few drinks bought in a local pub may lead to the revelation of some heavily guarded local jewels near here.

E2: NEW HAMPSHIRE & MASSACHUSSETS

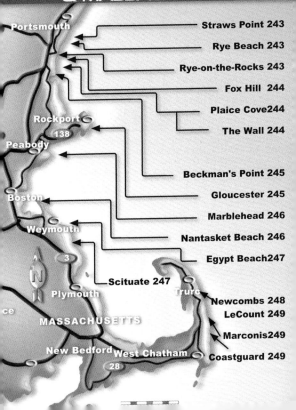

Portsmouth

Rockport
138

Peabody

Boston

Weymouth

3

Plymouth

Truro

MASSACHUSETTS

New Bedford West Chatham
28

STRAWS POINT & RYE BEACH

Take Hwy 1a S from Portsmouth. Into Jenness Beach, where it becomes Ocean Blvd. L on Old Beach Rd to Straws Pt.

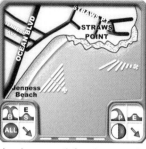

Straws Point: left-hand reef-point that can toss up lined up and hollow waves at lower tides, and some short rights. Likes straight east swell and northwest winds. 3-6ft, more if a huge NE swell is wrapping. Advanced, although mellower at high tide. Beach-breaks run south from here, gentlemen's waves on sand. Best conditions are on E swells at mid tide. Does get overhead here, when you'll find the paddle-out is a bit of a mission. Never too crowded. All surfing standards.

RYE-ON-THE-ROCKS

Take Hwy 1a S from Portsmouth through Jenness Beach into Rye Beach. It is off the point by Church road.

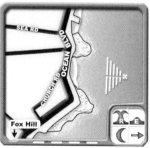

Great spot for all standards of surfer in easterly swells. Low tide is best, with steep take-off and square lined up lefts and tapering walls, point style. These lefts like east to northeast swells and west winds. Rocks are close to the surface and all around. At high it's fat and mushy, and rights start to pop up, particularly if there's more south in the swell. Crowded, but a mellow scene if you are low-key. All levels. 3-15ft.

FOX HILL POINT

Head S on Hwy 1a from Rye Beach along the coast to the point.

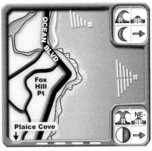

Bit of a mythical spot, meaning that when it's on, the world will be out in the surf. It handles huge SE swells at low tide, and produces a real quality, barrelling right-hander over rock and sand bottom. Steep, big takeoff and juicy, walling barrels to follow. On more of a ENE swell, peaky lefts also break well. The rights on the inside and further north also line up, especially in SE swells and similar tides. Advanced surfers. Crowds. 3-12ft plus. Head further S for beach-break options at **Plaice Cove.**

THE WALL

Head S on State Hwy 95 from Portsmouth. Turn off on Hwy 101 to Hampton. L on 1a for The Wall, R for Hampton Beach. **The Wall**: L and R beach-break of repute, on most tides and swells. Consistently bigger than most breaks in this area, but heavy if big. Great Boar's Head hosts an off-shore left and right reef, holding size on most swell directions & west winds. The

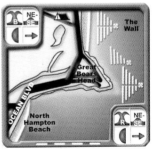

inside tosses up lined up rights. Advanced spot, sketchy entry and exit over boulders, almost never worth the hike. If you catch it on, your presence may not be appreciated. 3-15ft. Fickle.

BECKMAN'S POINT

Head S from Hwy 101 junction in Hampton on Hwy 1a over Hampton Inlet bridge. L on River St to the beach.

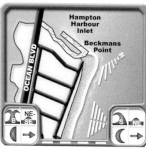

Lined up left-hand sand-spit fed by the harbor tidal system. On a low to mid tide and north-north-east swell, grinding shallow barrels are possible. Down the beach are OK banks at **Seabrook**, and they work in any swell northeast through southeast. 3-4ft is best but it handles more to a degree. When swell is up, and tide in full flow, there's considerable current. 2-6ft. All levels. A long way from anywhere, so don't upset the locals!

GLOUCESTER

Head N on Hwy 95 from Boston. Take 128 to Gloucester then 127a (Thatcher Rd) to Rockport and Long Beach.

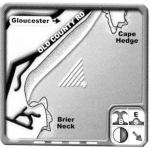

This beach, just S of Cape Ann gets all the swell the Atlantic can pump its way. Consistency depends on banks, but in good conditions (higher tides when it's big as there are a few rocks), you'll catch powerful challenging L&Rs. Paddle-out is heavy so make use of the channel near the rocks. Crowds. Intermediate plus break depending on conditions. Try S of Gloucester on coast road for less consistent but good beachies when winds are north tide is higher and swell is from the south. Fewer crowds.

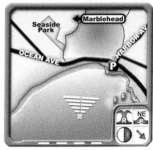

Take 114 into Marblehead. Right on Ocean Avenue. Keep on till you see Devereux Beach and parking lot in front of you.

High quality L&R reef break over rock bottom, best at low tide in big winter NE swells. The drop takes you fast into a long, thick, peeling wall of juice. On its day, an uncrowded adrenaline rush. Watch the currents on big days. One of the only spots that's offshore in those horrid northeast winds. Advanced. Great wave. Heavy in the water though. Beach-break here too. Head to **Lynn** for **Nahant Beach** on the N side of the harbor in NE swells (protected from southerlies).

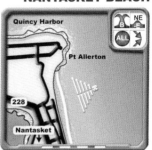

Head S round Boston Harbor through Quincy to Nantasket. Take 228 to Hull and look for the Red Parrot Inn.

Cape Cod stands in the way of any southerly swells so it needs a solid NE or E to crank. L&R beach-breaks up and down this long beach. You'll find something for everyone here, but whatever happens, its inconsistent due to shifting banks and tide windows. Keep an eye on the currents – you don't want to find yourself in the shipping lane!

EGYPT BEACH

Take the 3 from Boston to Quincy. Head through Weymouth to Scituate. Follow Hatherly Rd to Seaside Rd and the beach.

Suffers the same problems with E-SE swells as Nantasket i.e. Cape Cod. However, this does help by blocking the currents. Reasonable NE ground-swell at mid tide will produce a great long-boarders wave breaking on sand bottom.

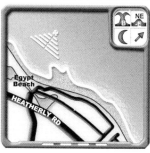

Long mellow rides are the order of the day up to 6ft. Off the beaten track, so crowds are not normally a problem. There are beach and patchy reef-break options on both sides of **Scituate Harbor** for investigative surfing.

PEGGOTY

Take the 3 from Boston to Quincy. Head through Weymouth to Scituate. Follow Front St to the south side of harbor.

Super-slow left-hand point break. It's a good point break for long-boarders at mid tide, but gets fat and mushy at high tide. Best to catch it at low tide when it's a bit more interesting, although it never really squares up. An E swell

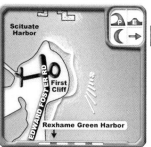

with a bit of N in it is probably optimum. Mellow spot for intermediates. Gets crowded. Head S on the coast rd for **Green Harbor,** where the jetty works in a northeasterly on bigger swells. **Gurnet Point** area has good spots to check.

Take State Hwy 495 to Cape Cod. Follow Hwy 6 to Wellfleet, and cruise up or down Ocean View Drive.

Cape Cod is open to all the swell the Atlantic can muster, but has considerable tidal range and very little coastal structure. This promotes shifting, unpredictable banks and current. The same 4ft swell can create perfection on one strip and fat mushburgers on the next, and this can be reversed a week later, all on the same tides - a lottery. Rule of thumb is lower tides, with 2-6ft swell from either the north or south, preferably at an angle, and westerly winds. Any tide can work here though; it simply depends on where the banks are on that day. Some consistently good beaches include **Head of the Meadow, Highland Beach, Longnook, Ballston, Newcomb Hollow, Cahoon Hollow and Le Count Hollow**. As you head north, south swells start to lose their impact

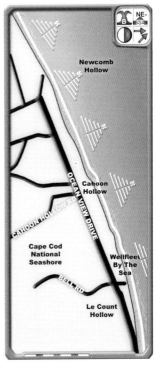

as the coast starts to orient more towards the northeast. 2-10ft. Variable crowds. Currents and rips. All levels.

MARCONIS BEACH

Take State Hwy 495 to Cape Cod. Follow Hwy 6 to Wellfleet Harbor, then R on Marconi Beach Rd.

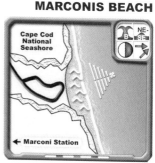

In a substantial swell and light westerly, Marconis can serve up hollow, pounding L&R beach-breaks over a shifting sand bottom. You can arrive to find 6 feet close-outs one day, and 10 ft perfection the next, such is the movement of the banks. Ideally, an angled swell from either southeast or north will peel along the scalloped sand. Advanced surfers only when it's pumping here, because paddle-out hard, and sweeping currents. Summer crowds, winter OK. The good surfer will get plenty of waves.

COASTGUARD & NAUSET BEACH

Take State Hwy 495 to Cape Cod. Follow Hwy 6 through East Orleans. Turn R on Doane Rd to Ocean View Dr.

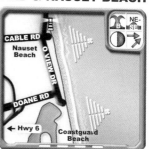

Probably the most consistent surf Cape Cod has to offer. Offshore in W wind, and handling most swells, although Rs in SE and Ls in NE ground-swells, and lower tides is the general rule. Again, sandbar dependent. Coast guards can be a really heavy, hollow and thumping experience in best conditions. Something for everyone - you'll find them all here too, particularly in summer!

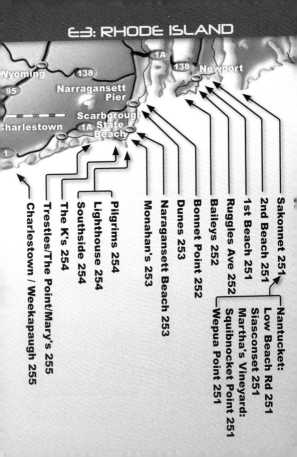

E3: RHODE ISLAND

Wyoming 138

95

1A 138 Newport

Narragansett Pier

Scarborough

Charlestown 1A State Beach

1

Charlestown / Weekapaugh 255

Trestles/The Point/Mary's 255

The K's 254

Southside 254

Lighthouse 254

Pilgrims 254

Monahan's 253

Narragansett Beach 253

Dunes 253

Bonnet Point 252

Baileys 252

Ruggles Ave 252

1st Beach 251

2nd Beach 251

Sakonnet 251

Nantucket:
Low Beach Rd 251
Siasconset 251
Martha's Vineyard:
Squibnocket Point 251
Wepua Point 251

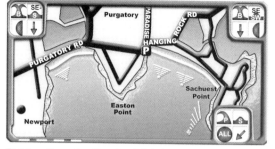

East from Newport on Purgatory Rd. 1st beach comes up first. Second comes up after Paradise Rd intersection, where there's a parking lot and a good channel. First Beach tends to be smaller than Second and closes out earlier. Both offer small beach-break options on a gentle sloping sand bottom. At the E end of Second, there's a hollow, sizey L breaking off **Sachuest Point** over sand and rock bottom. Very crowded in summer, and worsening each year. Parking expensive. Novice surfers upwards.

Heading up north and east across the Sakonnet River, you come to **Sakonnet Point**. There's a left point break here as well as some quality reef action.

Further east from these breaks, you are starting to fall under the swell shadow of Martha's Vineyard and only straight south swells can really do any damage. The Point at the town of **Salters Point** is a lined up reef-bottom left in any northerly wind and a middle tide. AKA Peggarty's. The ferry to **Martha's Vineyard** accesses some quality breaks, many on restricted/military areas. The funny little **Squibnocket Point** hosts a quality reef break holding up to 10 ft of SW to SE swell. **Gay Head** can line up Kirra style, & there's a range of shifting beach-breaks all the way across the south coast as far as **Wepua Point**. Surfing here requires good connections or a boat, but there are some consistent beach-break peaks in SW-E swells and north winds. The exclusive and preppy island of **Nantucket** also has consistent beach-breaks, at **Low Beach Rd** &**Siasconset**.

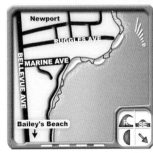

From Newport, take Bellevue Av S towards Bailey's Beach. Turn L on Ruggles Av.

A series of power-packed reefs hold as much swell as anywhere on the northeast coast. The ideal set-up is a hurricane S-SE swell, lower tides and a northwesterly, combining to produce big, cranking R hand point-reef beasts over rocky reef bottom. Long, critical sections follow a bit of a heart-stopping drop. Bring your biggest board if there's swell. There are numerous reef peaks adjacent. A magnet for surfers within a wide radius, so crowded. Scenic New England vibe. Rocks on the way out. Advanced break.

Just south is **Bailey's Beach**. A crowd avoiding option, but in the lee of Lands End, making it most inconsistent. Straight south swells get in and it will work on any tide provided swell is pumping. Lefts and rights, all levels. 3-6ft.

Heading across the bridge to Jamestown, then south through the Fort Getty Park is **Beaver Tail Point**. Rare mysto reef set-up that needs straight south swell to work. When it fires, it sets up a jacking left / right peak over a bouldery rock bottom, then a tapering wall. Not a good option at low tide if it's big, but 4-5ft is perfection on light north winds. Not worth the trip unless you've done the math, as a mission to get to, and you'll probably find it switched off. Western shores of the national park have a couple of occasionally great but fickle secret spots in any east wind, if accompanied by very big south swells. Inconsistent, wild and rugged. If you catch it on, go and buy a lottery ticket immediately

Heading west again on the 138, then south towards Matunuck, is the left-hand classic, **Bonnet Point**. On major south swells, the rock-bottom wave peels into the bay, giving off-shore walls in north to northeast winds on any tide.

Hwy 1 to Narragansett. Follow signs to Hwy 1a (Beach St) to the Pier.

Narragansett Town Beach is the only real option in this area when the swell is small – particularly in summer. Westerlies are offshore, so expect Newport surfers in their droves. Also open to the full swell pattern from S through SW. All this adds up to crowded beach-breaks. Shifting peaks mean variable quality, but if the banks get right it can get really good. West winds. Beginners plus. Any tide but low can close out. Consistent. South on the 1a is **Monahan's Dock**, a rocky pier at the end of the seawall. A short, powerful, board-snapping L&R (the R is better) on uneven rocky bottom. Heavy crowds with heavy attitude. Advanced surfers only. There are other options in the area though. Heading north out of town to the Rivermouth, may be a fast left-hand sandbar on the north side of the channel. It holds size, and lines up perfectly on a solid south swell and north / northeast winds. Fickle but good. All levels.

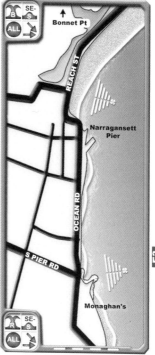

E3

From Providence, head S on Hwy 1 to Naragansett. Turn off on Hwy 108 (Ocean Rd) to Point Judith, then Follett St to the Lighthouse.

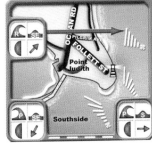

On the north side of the point, **Pilgrims**, at the end of Pilgrim Avenue, is a very popular right reef setup, with lined up walls good in southeast swell and southwest winds. Intermediates. 2-10ft plus if conditions right. Further peaks up north in similar conditions.

Lighthouse, just south, off the east tip of the point is a typical quality R point set-up – big steep drop, then quickly into critical bowl sections. Handles the biggest swells, up to 15 feet plus on south or southeast swells and any west winds. Crowds in summer or when good. Shuts down on straight east swells.

Southside is a left-hand point, offshore in N winds producing 2-300m rides in big conditions. It gets good on a solid south-southeast swell, but super-crowded. Any tide. 2-15ft. Advanced. Crowds when on.

Inside the harbor break wall further west off the map, **The Ks** are a pair of L&R reefs breaking on rock – fat easy walls on all tides. Extremely inconsistent but acceptable when it is huge elsewhere, or straight south swell is poking in between the break-walls. All levels. Fat waves. Solid local crew surf it when on, and are welcoming. Show consideration and humor and more local secret spots may be revealed to you.

Icy RI perfection

TRESTLES & THE POINT

From Providence, head S on Hwy 1 through Naragansett. Turn L on the signs to Jerusalem then Matunuck.

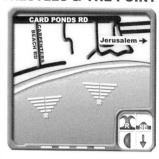

The are numerous boulder reefs here, producing high-quality, powerful waves. **Trestles** is a superb quality left and right reef break. Best in SE swells and northerly winds. More easterly swells line up the lefts better, more south and the rights can be longer but mellower. Any tide is good though it's more a fun, easy wave at higher tides and hollower, faster and even shutting down on a few barely submerged rocks at low. Any wind NE through NW is great. Crowds in summer. All levels. 3-10ft plus.

The Point, paddling distance to the west, is similar to Trestles and works on similar directions. Takes 3-10 feet. All levels except bigger days and lower tides when it's advanced. Gets crowded as hell if going off.

Right next door to the west is **Mary's:** another fun reef / boulder option if the above is too crowded. Mostly lefts on a middle tide and northwest winds. Solid east-southeast ground-swell lines it up nicely. Usually smaller than the others, and slow!
Further west are some out of the way beach-breaks, particularly in the Charlestown district: Fast Rivermouth and beach-break peaks on any swell south through east, at the southwest end of West Beach Road. North winds best, any tide. Fickle. All levels. 3-8ft plus.

Weekapaugh Beach at the bottom of Weekapaugh Rd: More peaky beach-breaks and a river inlet protected from northeasterly breezes, all tides. South swell best. All levels. Semi consistent. 3-6ft.

NE SURF SUPPLIES

Maine
Ogunquit - Liquid Dreams Surf Shop, 365 Main St, 207-641-2545
Portland - Ride 207, 671 Forest Ave, 207-775-1115
Wells - Wheels & Waves, Route 1, 207-646-5774
York
Liquid Dreams Surf Shop, 1717 Long Beach Ave, 207-352-2545
Zapstix, 38 Woodbridge Rd, 207-351-3366

New Hampshire
Hampton - Cinnamon Rainbows Surf Co, 931 Ocean Boulevard, 603-929-7467
North Hampton
Pioneers Board Shop, 62 Lafayette Road, 603-964-7714

Massachusetts
Marblehead - The Brick House, 14 School St, 781-929-9678
Nantucket - Indian Summer 6 broad St., 508-228-3632
Orleans
Nauset Sports Rt. 6 Orleans, 508-255-4742
The Pump House, 508-240-2226
Provincetown
Board Stiff, 286 Commercial Street, 508 487-2406
Scituate - Nor'easter, 105 Front St., 781-544-9283

Rhode Island
Middletown
Elemental Surf & Skate, 89 Aquidneck Avenue, 401-846-2280
Island Sports, 86 Aquidneck Avenue, 401-846-4421
Narragansett - Warm Winds Ltd. 26 Kingstown Rd 401 789-9040
Tiverton - Boardworks, 1741 Main Road, 401-624-1416
Westerly
Ride-A-Wave Surf Shop, 401-596-7722
7 Ply, 38 High Street, 401-348-0656

CENTRAL EAST COAST

Background
Much of this coast is a series of long beaches, often interrupted only by piers, inlets and jetties. These structures are in many places the focus of any quality waves, as they help sculpt an otherwise feature-less sea bottom into good contours. Whilst the continental shelf is fairly extended here, sapping swell energy, the window for that swell is wide. Waves arrive from north through south, and that means consistency. Long Island is sheltered from north swell directions, but it's eastern edge makes up for this by poking out from the continental shelf. This shallow ledge becomes an issue further south.

When to go
The summer period is to be avoided. The colder months receive the large portion of swell, leaving the scraps to be fought over by the masses in the summer holiday period. There are some heavy population centres along this coastline, and this means solitude is not often an option. Fall benefits from warmer water, North Atlantic storm swells, and opportunistic hurricane pulses.

Hazards
Pollution, Crowds. Temperatures below are at Middletown, and vary slightly up and down the coast.

M	Swell Range		Wind Pattern		Air		Sea	Crowd
	Feet	Dir'	Am	Pm	Lo	Hi		
J	2-8	ne	sw low	sw mid	22	36	34	lo
F	2-8	ne	sw low	sw mid	25	41	38	lo
M	0-5	ne	sw low	sw mid	30	50	40	med
A	0-5	ne	sw low	sw mid	35	56	44	hi
M	0-5	s-e	offshore	onshore	50	63	50	hi
J	0-3	s-e	offshore	onshore	55	76	55	hi
J	0-3	s-e	offshore	onshore	64	85	60	hi
A	0-5	s-e	offshore	onshore	60	80	68	hi
S	0-8	s-ne	offshore	sw mid	55	72	60	hi
O	2-10	ne	sw low	sw mid	48	62	52	med
N	2-10	ne	sw low	sw mid	40	50	48	lo
D	3-8	ne	nw low	sw mid	32	44	44	lo

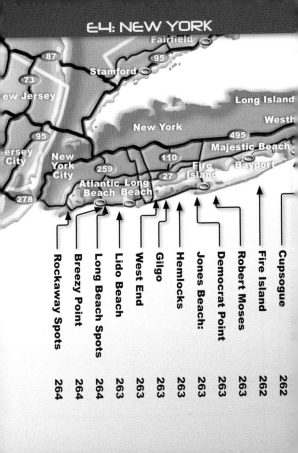

Fairfield

Stamford

New Jersey

ew Jersey

Jersey City

New York City

Long Island

Westh

New York

495

Majestic Beach

Bayport

Fire Island

Atlantic Beach Long Beach

Location	Page
Rockaway Spots	264
Breezy Point	264
Long Beach Spots	264
Lido Beach	263
West End	263
Gilgo	263
Hemlocks	263
Jones Beach:	263
Democrat Point	263
Robert Moses	263
Fire Island	262
Cupsogue	262

Southhampton
**on
ch**
89

Montauk
Point

East
Hampton

27

Main Beach 261

Indian Wells 261

Hither Hills 261

Johnsons 261

Atlantic Terrace 260

Kamikaze 260

Ditch Plains 260

Trailers 260

Cavett Cove 260

Turtles 260

Light Keeper's 260

LIGHTKEEPER'S & TURTLE COVE

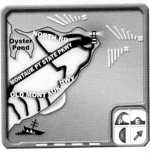

From New York, head E on State Hwy 495 to Holbrook. Take Hwy 19 to Hwy 27 and continue E as far as you can go. On the N side of the Point in a big E swell, **Light Keeper's** is a fast R reef break over rock and sand bottom & stands up well in stronger SW or W winds and solid ESE swells. Watch out for heavy currents dragging you W. Intermediates. Limited access. **Turtle Cove,** a beautiful, classic R point break over rocky and sand bottom. A serious wave, handling the biggest swells and getting double overhead plus. Some lefts. Rocky. Advanced. If big, head W for **Cavett Cove:** Reef L&R on big SE swells to 10ft. Mid Tide. Advanced.

MONTAUK

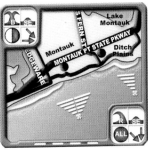

Heading further southwest, into the Montauk area, **Ditch Plains** is the longboard option – a consistent gentle L on lower tides and any swell. Crazy crowds. There's a bit of a secret spot E too: the mysto **Trailers**; LR reef 3-6ft on E-S swell or huge NE. Just west is **Kamikaze**, a fun beach-break on any swell especially south. If you want a barrel and it's summertime, head west into town for **The Terrace**, a sand-covered L&R reef, full of kids and locals. Off Atlantic Terrace. Worlds largest ever Great White shark caught off Montauk.

E4

EAST HAMPTON MAIN BEACH

From New York, head E on State Hwy 495 to Holbrook. Take Hwy 19 to Hwy 27 then East Hampton.

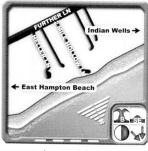

Typical east coast beach jetty set-up. L&R beachbreaks up and down the beach – good consistent peaks, working best on SW swells, but handles swell with E in it. Gets overhead here. Very good chance you're going to get barrelled. Crowded, particularly in summer. Surprising power always catches the unwary. There are good low tide beach options east from here at **Indian Wells** and **Hither Hills State Beach**. At the far end of Hither Hills is **Johnson's Reef**: patchy reef lefts and rights on summer pulses.

SHINNCOCK INLET

From New York, head E on State Hwy 495 to Holbrook. Take Hwy 19 to Hwy 27 then turn at Southampton or Hampton Bays to Hampton Beach.

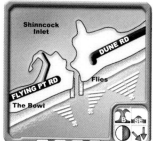

A shocker to get access to (permits, locals, parking etc), the E jetty has a nice R peeling down it, called **Flies**. S-SE swells produce the goods. When the swells too big and this spot maxes out, head to the west jetty for **The Bowl** – if you are very luck you'll witness a big wave (up to 10ft) in huge S swell on sand bottom. The name tells you what to expect. Expert surfers only.

CUPSOGUE & K ROAD

From NYC, E on State Hwy 495 to Holbrook. Take Hwy 19 to Hwy 27 then the 80 at Shirley to Westhampton into the beach park.

Jetty beach-breaks all over the place on sand bottom in the Cupsogue Beach Park. Most of the peaks can handle Westerlies, as there's protection provided by the inlet jetty. As with everywhere in these parts, crowds, parking and access can be a problem. Head further E by 4WD for consistent sandbar peaks at **K Road.** Be nice to the locals if you can find it – try not to look like a kook!

FIRE ISLAND

From NYC, go E on State Hwy 495 to Holbrook. Take Hwy 19 to Hwy 27 then S on 46 through Shirley to the island. 4WD essential or get the ferry.

An island paradise less than an hour from NYC. Sandbar beach-breaks up and down a long stretch of coast for explorers to discover. Shifting sandbars work in most prevailing conditions, but they're fickle and there can be some quite serious rips and currents.

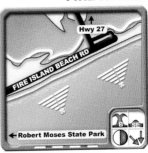

ROBERT MOSES STATE PARK

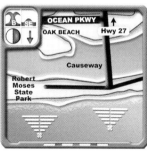

From NYC, go E on State Hwy 495 to Holbrook. Take Hwy 57 through West Babylon to the island. 4WD recommended. At the W end of Fire Island. Lots of shifting sandbar peaks, less crowded and open to more swell on the E side of the park. You can find hollow little peaks on the right day; big dumping punch. Same issues with currents as before. Novice upwards. At the western end is **Democrat Point**: summer left-hand point on rare big S swell to fire up. 3-8ft. All tides all levels. Check out **Jones Beach State Park**; low tide summer S swell beach-breaks include **Hemlocks** & **Gilgo Town Beach**, & the jacking left-hand patch reef **Westend.**

LIDO BEACH

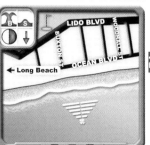

In NYC, head S through Queens to Hwy 27. Head E then take 144 to Long Beach. Follow Lido Blvd E to Ocean Blvd.

A city beach gem, Lido's main break is a pumping L&R sandbar peak that can handle overhead and has a reputation of breaking boards with regular monotony. Needs S swells and N wind to fire. Understandably, the paddle-out is a mission when it's big. Also, it's a deeper water break than most so watch the currents. Intermediate break, but there's other peaks up the beach for less advanced surfers.

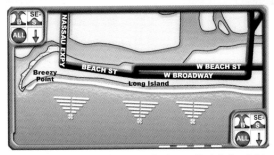

In NYC, head S through Queens to Rockaway Blvd. Follow it S to Long Island. There's a train or subway option too. One of the madder places to surf on this planet - so close to such a buzzing city, yet some great waves. Good spots include: **Lincoln** and **Lauralton** in the E – jetty beach-breaks facing S, breaking on sand bottom but with debris and pilings hazards. Best in July-November hurricane season, although swells can die very quickly whenever. Try 30th-40th **Streets** for more jetty beach-breaks – peaky, fun, unsafe.

ROCKAWAY

Directions as for Long Beach. Head W to the area of 92nd Street. Probably the best-known break on Long Island – only half an hour from the city center on the train. Primarily a jetty L with a steep takeoff and fast sections in big E swells on sand. Consistent, so crowds & hassle. All levels. Hardcore atmosphere. Head E to the community at **Breezy Point.** Nice peaky (private) L&Rs.

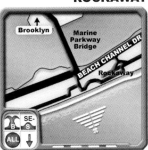

E4

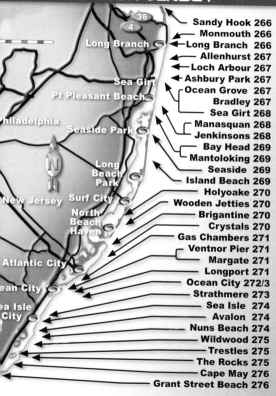

36
4

Long Branch

Sea Girt

Pt Pleasant Beach

Philadelphia

Seaside Park

N

Long Beach Park

New Jersey

Surf City

North Beach Haven

Atlantic City

Ocean City

Sea Isle City

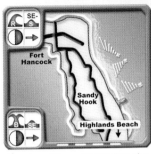

From NYC, head S on State Hwy 95 or the 9. Take the 36 to Atlantic Highlands. Follow Hartshorne Dr to Sandy Hook. In the Gateway National Rec, you'll find a pretty rare occurrence in these parts: a R point break called **The Cove**. Produces a classic, long R breaking over sand bottom in big S-SE swells. Tends to get a bit fat at high tide – best on low incoming. Easy to forget you're in Jersey when it's going off here. Intermediate plus. Can be crowded and there's quite a local scene. Show respect and you'll be fine. Check **1st Parking Lot** for nice, smaller jetty L&Rs when there's a pumping swell. All standards of surfers.

MONMOUTH BEACH

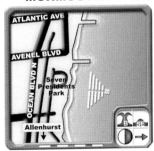

From NYC, head S on State Hwy 95 or the 9. Take the 36 (Ocean Blvd N) to Monmouth Beach.

Right out in front of Presidents St Park, a L&R punchy, hollow beach-break is consistently good. There are a few other breaks (mainly jetties) up and down this stretch but the sandbars can be fickle.

Have a look S down the 36 at **Long Branch**. It's a bit of a forgotten spot these days but the banks can have their moments. Works on SE swells, east winds and any tide.

266

THE COVE & ALLENHURST

Take State Hwy 195 from State Hwy 95. At the end take the 138 to Belmar, then N on 71 to Allenhurst. R on Spier Av to Boardwalk.

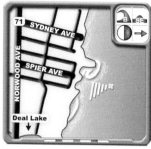

A good L breaks over sand bottom off the jetty. Works best with a straight E swell in hurricane season, on a low-mid tide. Fast, bowling sections that shoulder out if you make the first bit. Shallow at low tide so not really a beginners break (you'll find there's no room for you, unless you know what you're doing anyways). watch out for the currents and closeout sets when it's big.' Head south to **Loch Arbour, Ashbury Park** or **Ocean Grove** if it's too crowded.

BRADLEY TO BELMAR

Take State Hwy 195 from State Hwy 95. At the end take 138 to Belmar. Go N on 71. Take 5th to Belmar & N on Ocean Av to Bradley.

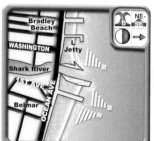

Bradley Beach has a selection of inconsistent jetty options. Shifting sandbars are a problem. There's an **L Jetty** on the N side of Shark River Inlet that produces good Rs on sand bottom that get hollow at low tide in bigger SE swells. On the S side is **Belmar Pier**, for similar breaks when there's N in the swell. Pretty inconsistent. All standards.

MANASQUAN

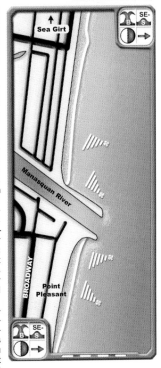

Take State Hwy 195 from State Hwy 95. At the end take Hwy 34 to Manasquan. Cross the bridge to Jenk's or go L to the beach and take 3rd Av to Manasquan.

In a massive SE swell (it can hold up to 20ft) and a low incoming tide, **Manasquan** is one of the premier spots on the coast. It's a wedgy, long L&R with serious power and gnarly barrels, breaking on sand off the jetty (where there's a helpful rip). Further N is the **Sea Girt** area with an array of beach & crowded jetty breaks. Good on low-mid tides. S of the Inlet is **Jenkinsons** at Pt Pleasant, in NE swells at lower tides for a wedgy, dumping L. You'll know it if you get held down! If the crowds are heavy, there's plenty of smaller options up and down the beach.

There are acres of unmanned peaks down towards Bay Head, that warrant investigation. Peaks move all the time, so if you find a good bank, keep it quiet and get onto it. Best breaks tend to be off crowded jetties. Low-mid tide & SE swells normally turn it on. Gets surprisingly hollow and powerful in places.

268

From Manasquan, take Hwy 35 S to Bay Head and head for Bridge Av. Continue S for Mantoloking.

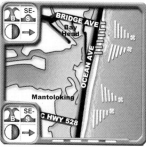

Bay Head is a great place to get barrelled – it needs a good SE swell and mid-high tide to turn on mainly R hollow, spitting pipes of pleasure. Gets overhead in bigger storm swells. The jetties tend to hold the banks together, even during hurricane season, when the banks can get wiped away in a flash. All standards. Just S is **Mantoloking**, for smaller beachbreaks. Sandbars here lack the consistency of its better-known relatives to the N. All standards.

From Manasquan, take Hwy 35 S to Seaside Heights, or take the 37 from Garden State Parkway.

Home to the famous Casino Pier – a focal point of Jersey surfing. This is barrel-central. There's L&R options both sides of the pier. At low tide, N of the pier can handle bigger swells to produce long, hollow, thick-lipped barrels. In higher tides there's a bowl-

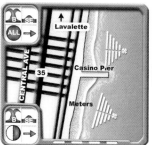

ing R in a NE swell. In best conditions it's double overhead here. Summer crowds are nearly unbearable. If you're going crazy, take a 4WD and head S into the relative nirvana of **Island Beach State Park** to relax and find yourself an uncrowded peak.

E5

HOLYOAKE & WOODEN JETTY

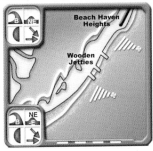

Take the 72 from Garden State Hwy onto Long Beach Island. Head R down to Beach Haven Heights and then into Holgate Reserve. 4WD recommended. A long, bowling L breaks off the Beach Haven Jetty at **Holyoake Av**. Best in NE-E swells. Watch out for the intense takeoff that catches many unaware. Watch out for the strong current – always worth seeing how the locals deal with it. When it's smaller there's a sandbar L&R down the beach. **Wooden Jetty** has a reasonable L that handles big NE swells and breaks on sand bottom at low-mid incoming. If you miss the city vibe, head back to **7-11** and its back to reality.

BRIGANTINE

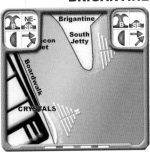

From Philadelphia, take the 30 to Atlantic City. Head N on 87 and cross the bridge to Brigantine.

From the Jetty to the beach area just N you'll find shifting L&R beach-breaks. The Rs tend to stack up better & get pretty zippy and hollow. When the swell has some S in it and tides are mid-high, the rides can be long, but this is not an overhead spot. if its macking and 6ft plus, head S into Atlantic City. **Crystals** over the bridge at N Maine Av. handles W to N swells and delivers power.

GAS CHAMBERS

At the end of Atlantic City Expressway (Hwy 30), turn R on Pacific Av, then L on S Ocean Av to States Av.

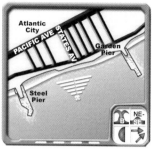

Named for its barrel potential, this area of beach has a submarine trough promoting a bit more power than elsewhere. The area works on any swell, but it's best on a square-on southeast pulse. There's a groyne, which spins off Ls to the S and Rs to the N.

Stand by for the hold down if you get it wrong! These can at best be challenging, double overhead, hollow slabs. There's also a long, bowling L&R further S. The currents are serious if a rare big swell hits. 2-10 ft. Advanced surfers when it's big.

VENTNOR PIER & MARGATE

From Atlantic City, head S on Atlantic Av to Ventnor. Margate is further on.

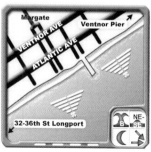

Similar quality beach-breaks are found at these 2 piers – fun Rs and Ls on both sides of the piers. Both have consistent banks, work better at low tide, and get very crowded in summer. Margate maxes out pretty easily, Ventnor can get slightly bigger. Both require beach tags. All standards. There are other options at **32nd St** and **36th St, Longport**.

E5

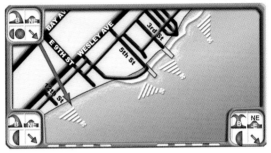

From Pleasantville take the 9 S till you get to the bridge. Follow it to Ocean City. Turn into Wesley Av, then L on 5th St to the beach.

It will come as no surprise that Ocean City surfing focuses on the many jetties and rockpiles, where shifting sands are held in place to give a semblance of good shape. Rule of thumb is that in a big south swell, north sides of jetties deliver long rights, with wedgy lefts on the south sides, often swarming with bodyboards. In winter northeast storm pulses there can be some quality lefts and wedgy rights.

From the north, there are jetty breaks off **1st St & 3rd Sts**, which have a good history. Best at mid-high tide. These spots handle good size too. It's fall surfing here, as no daytime summer surfing.

5th St offers a L off the jetty of equal quality, in NE swells. The famous **7th-8th St** gives you year-round surfing – with hollow L&Rs off the jetty – the big L can be a double overhead, spitting beast.

12th, 15th and 30th all have a good reputation. In reality, it pays to park in the middle and check a few different spots.

OCEAN CITY 55TH STREET PIER

From Pleasantville take the 9 S till you get to the bridge. Follow it to Ocean City. Take Central Av as far as 55th St.

The old pier here picks up sand washed out from the inlet to build up excellent banks, resulting in good, hollow L&Rs on most S-E swells. Consistent, if not as big as the northern neighbor spots. The bonus is that crowds are not normally as big as it is that bit further out.

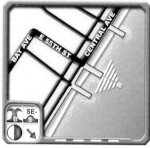

STRATHMERE

Head S from Atlantic City on Hwy 9 or Garden State Parkway. Turn L at Oceanview to Sea Isle City. Take Hwy 636 N to Sumner Ave in Strathmere.

This is a great little spot that offers uncrowded, small beach-breaks that are longboard heaven in all S-E swells and at mid-high tide. Don't expect power, but just enjoy the scene. Unbelievably mellow line-up. Very good novice spot.

E5

SEA ISLE

Head S from Atlantic City on Hwy 9 or Garden State Parkway. Turn L at Oceanview to Sea Isle City. Take Hwy 636 N to 36th.

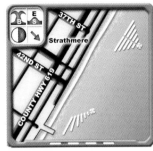

Wave rich area. SE-E swells produce primarily Ls off the various jetties, breaking on sand bottom. **36th-37th St** turns on mid-low tide barrels on consistent sandbars. Beach tags are needed. There are normally very consistent banks off the next 10 streets south. Head to **47th St Jetty** for long Ls on a more northeast swell and lower tides. All standards of surfers will have a good time in this area.

AVALON

Head S from Atlantic City on Hwy 9 or Garden State Parkway. Turn L at signs to Avalon. Turn off Atlantic Av to the beach.

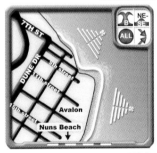

A good NE swell will deliver quality L&Rs over consistent sandbars. 9th to 15th streets good. The beach angles enough to handle a SW wind too. Clean peaks, best in the 4-5ft size range. Attracts the crowds due to its proximity to the town. Beach tags needed too.

Localism, but hey, you're used to it! Other options S include **30th St Pier** for nice Ls and all day summer surfing and **Nun's Beach / 114th St** for novices on the N side of the jetty in NE swells.

WILDWOOD 2ND TO 10TH STREETS

Head S from Atlantic City on Hwy 9 or Garden State Parkway. Turn L at Rio Grande on 47 to Wildwood. Take Dune Dr N.

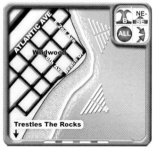

Not the spot for double overhead, but good smaller L&Rs breaking on sand bottom, in a pretty mellow environment. Mid-tide is perfect for long-boarders; high tide gets a bit hollower. The breaks at the S end can be surfed all day in summer. All standards of surfer will enjoy this place, and there are plenty of angles, meaning you can find an off-shore spot in north through south west winds.

TRESTLES & THE ROCKS

Head S from Atlantic City on Hwy 9 or Garden State Parkway as far S as you can get. Take the 109 E, then walk or take a boat.

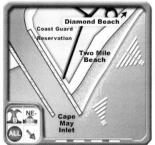

Inaccessible spot near Cape May Inlet – it's a long walk or a boat ride in, and when you get there the Coastguard are not exactly stoked to see you. Still, adventurers amongst us will find a way. **Trestles** is a series of L&R peaks off the wooden jetties. The sandbanks held together well by the jetties to create power. **The Rocks** is a quality L&R off the rock jetty over sand. Handles all swells and gets wedgy / hollow in best conditions. Good luck! A bit easier to get to is **Diamond Beach**.

CAPE MAY

Head S from Atlantic City on Hwy 9 or Garden State Parkway as far S as you can get. Take Hwy 653 to Beach Av & turn R.

A very popular spot, where you'll find good Ls breaking off the jetty on sand bottom. Needs shoulder high-plus S-SE swells to fire. As with most of the Cape May spots, it is offshore in N winds, so it can get crowded when other spots are onshore. Beach

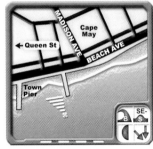

tags are required. A bit inconsistent due to sand replenishment programs. All standards.

GRANT STREET BEACH

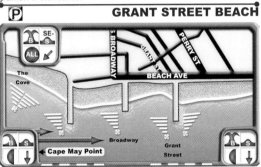

Head S from Atlantic City on Hwy 9 as far S as you can get. Take Hwy 653 to Beach Av & turn R to end. **Grant St** likes big S swell. Ls get long, and the Rs are hollow & fast. **Broadway Beach** is a quality L jetty break, with other peaky beach-break options up and down the beach. Big NE swells fire. Crowds . **The Cove** at **2ⁿᵈ Av Jetty** is a good learner wave. All these spots require beach tags.

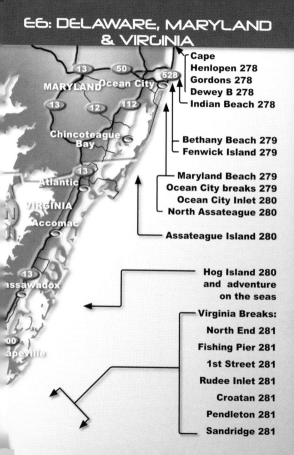

E6: DELAWARE, MARYLAND & VIRGINIA

MARYLAND

Ocean City

Chincoteague Bay

Atlantic

VIRGINIA

Accomac

assawadox

apeville

Cape Henlopen 278
Gordons 278
Dewey B 278
Indian Beach 278

Bethany Beach 279
Fenwick Island 279

Maryland Beach 279
Ocean City breaks 279
Ocean City Inlet 280
North Assateague 280

Assateague Island 280

Hog Island 280 and adventure on the seas

Virginia Breaks:

North End 281

Fishing Pier 281

1st Street 281

Rudee Inlet 281

Croatan 281

Pendleton 281

Sandridge 281

CAPE HENLOPEN & GORDON'S POND

From Dover, head S on Hwy 113. Take Hwy 9 turn-off to Quakertown then Lewes. Head E on 19 to the Naval Base at Cape Henlopen.

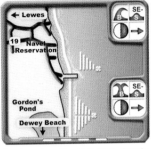

Consistent, long Rs break off the jetty (AKA Naval Jetties) over a good sandbar. Best in hurricane S-SE swells, when it can handle 6ft. Probably most hollow at low tide, although hazardous, so this is really only a good surfers spot. Other hassles include the rips when it's storm time. Rarely crowded. Check out **Gordon's Pond** for a less-crowded summer beach-break option in a S swell or **Dewey** Beach further south, for more crowds.

INDIAN BEACH - NORTH JETTY

From Dover, head S on Hwy 113. Take Hwy 9 turn-off to Quakertown. Join Hwy 1 and head S into Seashore State Park to the river. South end of Indian Beach.

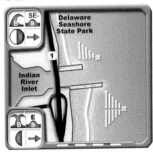

North Jetty is the home of ESA Comps in these parts and is unrestricted. A long, mellow R over sand can get quite hollow in hurricane S swells although it's likely to close out. Very crowded. **South Jetty** is a very heavy, steep L&R, producing fast, thick barrels. Due to sand replenishment, it has got even steeper and therefore, is full of bodyboarders. Lots of broken bodies. No day surfing in summer.

BETHANY BEACH

From Dover, head S on Hwy 113. Take Hwy 9 turn-off to Quakertown. Join Hwy 1 and head S to Bethany. Turn L to Atlantic Av.

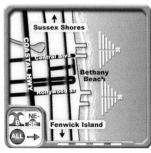

Standard east coast jetty break set-up, over sand bottom. The jetties tend to hold the banks together well so the surf's pretty consistent when the swells up. Best in hurricane S swells so it's a fall break, and often flat in summer. You will, if you're lucky, get barrelled here. Crowds when it's on. Head S for **Fenwick Island** for small, consistent uncrowded breaks. Alternatively, **Sussex Shores** runs north toward the south jetty of Indian River, for exploration.

OCEAN CITY BEACH

A large number of options in Ocean City, where sand gets moved by both nature and man to make for unpredictable banks.

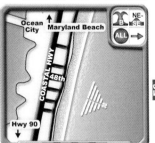

Some spots that have been consistent over time are **80th Street Jetty**, which can hold up good banks. Also **48th St**, where a jetty holds some shape on lower tides & south swells. There are several jetties from here south to about **24th**, which hold some of the best shape in town. These jetties continue all the way down past the Boardwalk to the inlet. **Maryland Beach**, just north, is worth a check for less crowds.

OCEAN CITY INLET

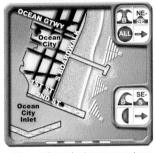

Head into Ocean City from Hwy 113 on Hwy 50. Turn R in Philly Av, then L down to Broadwalk for the Pier or L on 1st for the Inlet.

Crowded, consistent area – always working when the rest of town is flat or shapeless. Rs peel off the **North Jetty** to form hollow steep waves on sand bottom in most swells. In a NE swell, you may find a L S of the jetty on the prominent sandbars, but its a heavy paddle-out through strong currents so experts only. At **The Pier**, there are Ls & Rs either side, breaking on sand bottom. Good in NE or SE swells. Intermediate-plus spot.

ASSATEAGUE ISLAND

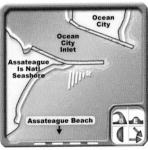

Head into Ocean City from Hwy 113 on Hwy 50. Turn R in Philly Av, then L on 1st for the Inlet. Paddle. Gnarly L breaks off the S side of the S jetty on sand. Needs mid-high incoming tides to crank. Its not a common site, but when on, it's a short intense ride. Small take-off zone and difficult currents. **Assateague Island**'s southern park hosts some fun waves. Trek down from the inlet or drive around on the 611. It's beautiful and uncrowded. **Hog Island** (By boat from Nassawadox) has an off-shore shoal that delivers long rights in a major hurricane swell and nor'west winds.

RUDEE INLET & CROATAN BEACH

From Virginia Beach, take Hwy 58 E till you get to Hwy 60. Head S as far as you can to 1st St.

North End: the north end of town off Atlantic Ave. Many peaks on S swell and SW wind, all tides but low can be better. **Fishing Pier**: Park near corner of Atlantic and 14th. Banks held together well to produce L & R beach-breaks, good on low tide and SW

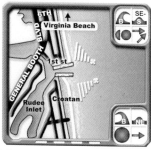

winds. Crowded! **Rudee Inlet**: Quality right off north jetty (1st Street) and waves between the breakwalls on solid SE swells and W winds. **Croatan Beach**: Good jetty lefts in solid winter NE swell and WNW winds. More banks down the beach on most tides.

CAMP PENDLETON & SANDRIDGE

From Virginia Beach, head S on Hwy 60 to Hwy 149. Take 149 S then L on Sandbridge Rd to the beach. Head N on Sandpiper.

A good fun L&R breaks on an outer sandbar in big S-E swells. Normally best in summer when the crowds appear from 1st Street. However, it's a mellow environment and the surfing is for all standards. The

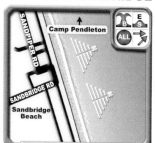

world's biggest parking lot ensures you'll never be alone out there. Try **Sandbridge Beach** itself for small, fun peaks in similar conditions with less crowds.

MID EAST COAST SURF SUPPLIES

NEW YORK STATE

Amagansett - Amagansett Beach Co, Montauk Hwy, 631-267-6325

Equilibrium Surf Shop, 160 Main St, 631-267-6289

Atlantic Beach - Atlantic Beach, 1848 Park St, 516-371-2903

Breezy Point - Breezy Point Surf Shop, 61 Point Breeze Ave, 718-634-8830

Centre Moriches - Inlet Surf Shop, 327 Main St, 631-878-8700

East Hampton - Espo's Surf & Sport, Main St, 631-329-9100

Khanh Sports, 60 Park Place, 631-324-0703

East Northport - Xtreme Surf & Sport, 1931 Jericho Turnpike, 631-462-9283

Huntington - Surf Shop, 276 Main St, 631-424-7873

Levittown - Emilios Ski & Surf Shops, 2726 Hampstead Turnpike, 516-796-1565

Long Beach
All Seasons Surf, 70 West Park Ave, 516-431-5431

Long Beach Surf Shop, 651 East Park Ave, 516-897-7873

Unsound Surf, 359 East Park Ave, 516-889-1112

Massapequa - District Board Shop, 4221 Merrick Rd, 516-797-5216

Montauk - Air & Speed Board Shop, 7 The Plaza, 631-668-0356

Plaza Surf & Sports, Montauk Hwy, 631-668-9300

Rockaway Park - Rockaway Beach Surf Shop, 177 Beach 116th St, 718-474-9345

Shirley - Woody's Surf Shop, 44 Surrey Circle, 631-281-0008

Southampton - Flying Point Surfing, 69 Main St, 631-321-7753

Offshore Surf & Sport, 46 Jobs Lane, 631-287-2979

Sunrise to Sunset Surf, 21 Windmill Lane, 631-283-2929

Wainscott - Main Beach Surf, 27 Montauk Hwy, 631-537-2716

NEW JERSEY

Allenhurst - Spellbinders Surf , 318 Main St, 732-531-7873

Avalon - Avalon Surf, 2249 Dune Drive, 609-967-7115

Boarding House, 2409 Dune Drive, 609-967-9283

Wetsuit World, 2743 Dune Drive, 609-368-1500

Barnegat - Tiki Surf Shop, 538 Main St, 609-607-1098

Beach Haven - Brighton Beach Surf Shop, 8511 Long Beach Boulevard, 609-492-0342

MID EAST COAST SURF SUPPLIES

Farias' Surf & Sport, 823 North Bay Ave, 609-492-0201
Ron Jon Surf Shop, 201 West 9th St, 609-494-8844
Surf Unlimited, 19th and Boulevard, 609-494-3555
Belmar - Eastern Lines Surf, 1605 Ocean Ave, 732-681-6405
Brick - No Flat Earth, 990 Cedarbridge Ave, 732-262-8404
Brigantine - Primal Surf, 3106 Revere Boulevard, 609-264-9900
Cape May - Summer Sun, 315 Washington St, 609-884-3423
Pete Smith's Surf Shop, 421 Washington St, 609-884-1010
Yo Dude Surf And Skate, 4 Clermont Drive, 609-624-9040
Haddonfield - Threds & Sleds Surf Skate & Snowboard Shop, 33 East King's Hwy, 856-429-3555
Lavellette - East Lines, 907 Grand Central Ave, 732-830-5424
Ocean Hut Surf Shop, 3111 Route 35 North, 732-793-3400
Little Silver - Brave New World Surf & Snow, 61 Oceanport Ave, 732-842-6767
Manasquan - Inlet-Outlet Surf Shop Surf Report, 146 Main St, 732-223-5842
Margate City - Heritage Surf & Sport, 9223 Ventnor Ave, 609-823-3331
Marlton - Bad Boy Club Surf-Skate-Snow, 888 State Hwy No 73, 856-988-0997
Moorestown - Pete Smith's Surf Shop, 96th & 3rd Ave, 609-368-7263
Ocean City - 7th Street Surf, 652 Asbury Ave, 609-398-7070
Aquasport, 744 West Ave, 609-398-6390
Heritage Surf & Sport, 744 West Ave, 609-398-6390
Surfers Supplies, 3101 Asbury Ave, 609-399-8399
Point Pleasant Beach - Baja East Surf Shop, 2600 Bridge Ave, 732-892-9400
Beach House Classic Boardshop, 517 Main Ave, 732-714-8566
Brave New World Surf, 1208 Richmond Ave, 732-899-8220
Red Bank - Jack's Surf, 30 BRd St, 732-530-3353
Rio Grande - Woody's Surf & Skate, 1304 State Hwy No 47 South, 609-886-9100
Sea Isle City - Heritage Surf, 3700 Landis Ave, 609-263-3033
Seaside Park - Right Coast Surf, 214 SE Cntl Ave, 732-854-9300
Silver Apple Surf Shop, 1815 Boardwalk, 732-830-8941
Ship Bottom - Surf Shack, 2919 Long Beach Blvd, 609-494-4017

Spring Lake - Board Room, 1206 Third Ave, 732-449-4455
Stone Harbor - Sun Catcher, 95th and 2nd Ave, 609-368-3488
Toms River - Cosmic Surf Shop, 1407 Route 37 E, 732-270-0647
Wavejammer, 1490 Route 37 East, 732-929-8656
Wildwood - Kona Sports Ctre,103 E Rio Grande, 609-522-7899
Ocean Outfitters, 6101 New Jersey Ave, 609-729-7400
Wild Ocean Surf Shop, 215 East Fern Rd, 609-729-0004

DELAWARE

Newark - Campus Surf, 127 East Main St, 302-368-2677
Rehoboth Beach - Dewey Beach Surf & Sport, New Orleans St
& Ocean, 302-227-8288
Selbyville - Tiger Surf Racks, Route 54, 302-436-7796

MARYLAND

Annopolis - East of Maui Surf Shop, 2303 Forest, 410-573-9463
Evolve Board Shop, 179 Main St, 410-267-0800
Bethesda - Evolve Board Shop, 4856 Bethesda, 301-654-1510
North Beach - Surf Side South, 7149 Lake Shore Dr, 410-257-0052
Ocean City - Chauncey's Surf, 2908 Coastal Hwy, 410-289-7405
Silver Spring - Shredders, 2655 University Bvd W, 301-949-6963
Towson - Wavedancer Surf Shops, Towson Town Ct, 410-583-5635

VIRGINIA

Chantilly - East Coast Board Company, 13824 Metrotech Dr,
703-378-7873
Chincoteague Island - BBSS, 6324 Maddox Blvd, 757-336-3271
Fairfax - East Coast Surf Shop, 10358 Lee Hwy, 703-352-4600
Fairfax Surf Shop, 3936 Old Lee Hwy, 703-273-0015
Newport News - 17th St Surf Shop, 12233 Jefferson Ave, 757-249-0416
Norfolk - Surf City Squeeze, 300 Monticello Ave, 757-625-3445
Poquoson - Virginia Sports, 895 Yorktown Rd, 757-868-5580
Reston - Single Surf, 11425 Isaac Newton Sq S, 703-707-2215
Virginia Beach - Seasoned Surfboards, 1244 Jensen Drive, 757-425-6025
Wave Riding Vehicles, 1900 Cypress Ave, 757-422-8823

Background

The peakiest beach-breaks anywhere. That's North Carolina and the Outer Banks. Open to the widest swell window in the USA, it takes winter north swells, and late summer hurricane power from the southerly quadrants. The enormous movement of sand due to storms and ocean currents makes it hard to predict which spots will work at a given time, but piers and jetties tend to trap banks and focus peaks. Further south, the land angle and the widening continental shelf start to limit options, in particular across Georgia.

When to go

There can be surf all year round, with late summer and fall providing the best chance of scoring swells from the odd hurricane, and autumnal North Atlantic storms that start from the vernal equinox in mid September. Summer is undoubtedly the least generous season for surf, with lack of north swells, and onshore afternoons prevailing.

Hazards

Crowds, some hassle near urban centres. Occasional shark sightings. Fishermen and their ire. Parking hassles. Surfing is restricted to areas and times of day in many parts of the Carolinas, and regularly forbidden within range of piers. Times, application and enforcement of these ridiculous rules vary.

M	Swell Range		Wind Pattern		Air		Sea	Crowd
	Feet	Dir'	Am	Pm	Lo	Hi		
J	2-8	ne	ne	ne	42	60	48	lo
F	2-8	ne	ne	ne	48	65	52	lo
M	0-5	ne	ne	ne	53	70	55	med
A	0-5	ne	se	ne	54	75	60	hi
M	0-5	s-e	se	ne	60	80	70	hi
J	0-3	s-e	offshore	onshore	66	85	75	hi
J	0-3	s-e	offshore	onshore	73	90	76	hi
A	0-5	s-e	offshore	onshore	70	85	79	hi
S	0-8	s-ne	offshore	onshore	66	80	69	hi
O	0-5	ne	ne	ne	63	75	65	med
N	2-10	ne	ne	ne	53	70	59	lo
D	3-8	ne	ne	ne	46	65	54	lo

158

95

17 158

Southern
Shores

64

Wanchese

NORTH CAROLINA 264

Swan
Quarter

17

70

Sealevel

Surf City

Wilmington

Corolla 287
Swan Beach 287
Duck Pier 287
Pine Island 287
Kitty Hawk 287
Laundromats 287
Avalon 288
Kill Devil Hills 288
Nags Head 289
Jenette's 289
Pea Island 289
The Pier 291
Rodanthe 290
Waves 291
Salvo 291
Avon Pier 292
Lighthouse 292
Frisco 294
Okacroke 294
Atlantic Beach 294
Bogue Banks 293
Topsail Island 293
Figure 8 Island 293
Shell Island 293
Columbia Street 293
Wrightsville 294
Masonboro Inlet 294
Carolina Beach 294
Pelican Watch 294
Fort Fisher 294

KITTY HAWK PIER

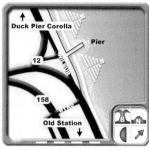

From Virginia Beach, take Hwy 17 S to Elizabeth City. Hwy 158 to Outer Banks. It's the first pier you see. Quality L&R barrels working on any swell. Steep and hollow is the order of the day in lighter E winds and big 12ft plus swells. Inside breaks for less experienced surfers at higher tides. Head N (pref 4WD) for a variety of less crowded options. Shifting sandbars make it hard to predict quality. Options include: **Swan Beach** for powerful beachies in NE swells; sandbars at **Corolla Light** and **Coral Lane** (Corolla) in SE swells; or **Duck Pier** and **Pine Island** for good smaller swell beachbreaks with fewer crowds due to difficulty of access.

LAUNDROMATS

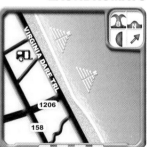

From Kitty Hawk head S. Turn L on Lillian St at Kitty Hawk trailer park. Park at the bath house.

A variety of outside sandbars up and down this long beach offer the possibility of hollow, peaky L&Rs for all standards, breaking on sand bottom. In bigger NE swells, some of the banks will hold double overhead, although they can get trashed easily by the storms, and so are fickle. You'll always catch something here though. The shore-break is dominated by kids and improvers. Pretty mellow environment if you follow the rules.

AVALON

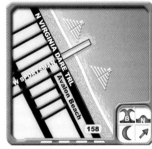

From Kitty Hawk Pier, take the State Hwy 12 or the 158 to Avalon. Turn L on W Avalon Dr to the pier.

L&Rs off the pier over sand bottom on an incoming tide. The southside of the pier is normally more consistent and hollow, particularly at low tide in NE swells. Tends to get crowded with town grommets, old locals and travellers alike. Good vibe though. Park just S of the pier in the big parking lots.

KILL DEVIL HILLS

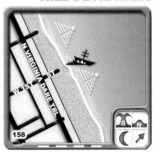

Head S from Avalon on State Hwy 12 to Croatan Shores. Turn L on 1st St at Milepost 7 to the beach.

Solid and consistent L&Rs over sandbars in all tides (the L peak between 2nd and 3rd goes off in big conditions). Hollow and sucky in lower tides, getting a bit fatter as the tide rises. Holds 10ft plus swells – best in NEs. Heavy paddle-out in bigger conditions. The bars are good so there's plenty of local action and an ESA comp to boot. The place to hang out.

NAGS HEAD PIER

Continue S on State Hwy 12 until you reach Jockeys Ridge State Park. Can't miss the pier.

This is the 'Police Station' of local folklore. Another sandbar L&R which is rumored to get really good if the bars stack up, producing surprisingly powerful and peaky waves. The problem is that it hasn't fired for quite a time so it tends to be quiet. All surfing standards. Head S for **Jennette's Pier** if it's crowded in bigger NE swells.

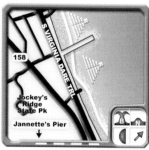

PEA ISLAND

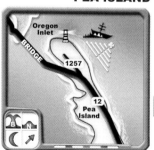

Head S through Whalebone to Oregon Inlet and onto Pea Island. Walk over the dunes straight out from the Coast Guard Station .

This spot is a real swell magnet, handling 15ft. Big pitching Ls and shorter hollow, bowling Rs break off a sand-covered shipwreck (known as 'The Boiler'). Hollower at low tide. Best in NE storm swells, although the paddle can be a mission. Pretty inconsistent of late. Watch out for strong currents. Hell men only when (if) it's firing.

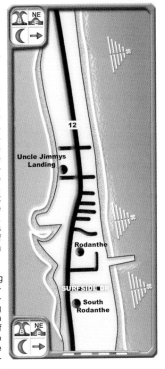

Head S from the coast guard station on Pea Island for 20 mins to Rodanthe. Peaks up and down this long stretch, with the pier in the south.

In big S-SE swells and a low-mid tide, the north end(going under various names) produces a heavy hollow beach-break of serious power. Double overhead, spitting barrels are the order of the day in the right conditions, as is a serious pile-driving for the unwary or inexperienced. Try it at higher tides first up. Great, sucky little wave on the inside too. Crowded with all sorts when it's good. Loads of peaks for everyone if you go looking.

The Pier handles big swells and can fire on lower tides. It is variable according to the ever-shifting banks which hang on for a few weeks and then drift off for months at a time. Steep takeoffs and short, intense rides with heavy holddowns if you get it wrong. Experienced surfers. Even more crowded than other spots. Good spot to watch the locals shredding it (or battering each other!)

Map labels: 12 · Uncle Jimmys Landing · Rodanthe · SURFSIDE DR · South Rodanthe

WAVES & SALVO

Head S from Rodanthe past the pier into Waves to the beach. Go further S on Colony Drive past KOA campground in Salvo, let some air out of your tires, go to ramp 34 and onto the beach.

Waves, like a lot of other Outer Banks sandbar breaks, shifts about like mad after any decent swell. Perfection here can be short-lived. When you catch this place in glassy or offshore conditions after sand flows have settled, it is one great spot. The problem is.....

Salvo, on the other hand, has so many options up and down its isolated stretch of beautiful beach. The R at **Shipwreck** is a real quality break in S–SE swells at low tide. Check the strip from the KOA campground up to sand street. Clean, barrelling and mellow. Otherwise, just head S down the beach and pick your own sandbar. What surfing on the Outer Banks is all about. 3-10ft plus. Consistent. Summer crowds, but pretty spread out even then. All levels

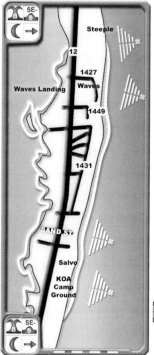

LIGHTHOUSE

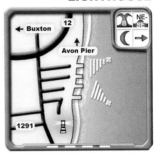

Head S on State Highway 12 all the way to Cape Hatteras. Turn L down Cape Hatteras Lane to the Lighthouse. 3 groin breaks in front of (what used to be the) lighthouse. The Ls off **1ˢᵗ Groin** are usually the most consistent, the Rs off **3ʳᵈ Groin** are a bit more challenging. Sand and rock bottom. Handles all swells but 8-10ft NE swell at low tide is the most likely to deliver the goods. Lineup gets gnarly – watch out for 'localism'. Head N to get away from the crowds to **Avon Pier** – N side in tropical SE swells or S side in nor'easters can be seriously good.

FRISCO

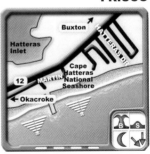

Continue S on Hwy 12 from Cape Hatteras through Buxton until you see the signs for the pier and turn L.

Unbelievably inconsistent break - often mush-burger but if you get lucky in S swells at low tide, a light offshore wind and the ocean gods are smiling, you'll find yourself alone out in 8ft glassy, top-to-bottom barrels of perfection. Warm waters add to the likelihood of a busy lineup, but the shark threat helps ease it! Head W on a rare summer S swell and take the ferry to secret spots in **Okracoke Island**.

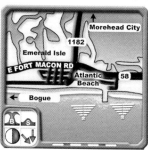

ATLANTIC BEACH

Come into Emerald Isle on the S24 (1182) and you hit Atlantic Beach. Take a left at the seafront and the pier is 5 streets down.

A solid S swell with an incoming tide and a light nor easter turns it on at AB Pier. In any form of south swell, **Bogue Banks** at W end of Emerald Isle are pretty consistent, and tend to get the lion's share of any hurricane action.

Iron Steamer Pier focuses S energy into lefts and rights, as does **Bogue Inlet Pier** at the west tip of the island. Both these spots will also take NE swell if it's huge, and are offshore in any north winds Higher tides work well on both.

COLUMBIA STREET

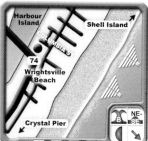

From Harbor Island in Wilmington, cross the causeway to Wrightsville Beach. L on Lumina Av, then second R.

Surprisingly hollow and consistent beach-break. Best in NE swell, low to mid tide and offshore NW wind. Very crowded with surfers of all abilities. Get out and head N on Hwy 17 to **Shell Island** for longboard action (or more in S storm swells) or a jelly-arm paddle across from there to the private breaks of **Figure 8 Island**. Head further on for **Topsail Island** and its 3 uncrowded pier options. Awesome area.

E7

WRIGHTSVILLE

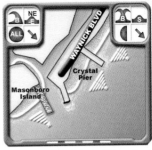

Same directions as for C Street. Once at Wrightsville turn R on Lumina Av and follow your nose.

Consistent, therefore crowded set-up at **Crystal Pier**. L&Rs breaking on sand bottom in S swells. Not as powerful as C St but works on all tides so busy. **South Jetty** holds good shape on low to mid. Paddle across the inlet (or even better, boat it) to the stunning **Masonboro Inlet** L, breaking off the jetty in NE swells at higher tides on sand bottom. Fast, long, hollow barrels of perfection in best conditions. Very crowded. Get further S onto the island for clear waters, empty peaks and beautiful beaches.

CAROLINA BEACH

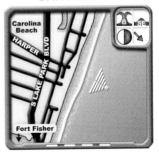

From Wilmington, take Hwy 17 S. Cross bridge onto the island. Take 421 S then L on Harper to Carolina Beach Av.

Hollow powerful barrelling beach-break, breaking close to shore in SE-E swells. Gnarly crowds, dirty water and a sniff of sharks makes it quite hard-core here. Experienced surfers break. Head S down the beach as far as the motel to **Pelican Watch** for nice barrelling beach-breaks in **Kure Beach,** or further on to **Fort Fisher** in N swells for uncrowded beach-breaks (where there used to be a great point-type wave).

MYRTLE BEACH - DUNES & THE PIER

From Georgetown, N on Hwy 17 to Myrtle Beach. Take N Ocean Blvd to the Country Club.

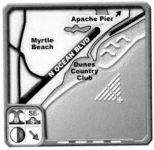

Dunes: Reasonable sandbar at the Rivermouth creates L and Rs, best in bigger S or SE swells. If the banks are working, a good hollow wave. Intermediate standard. Heading north for a few miles is **Cherry Grove**: Similar and often less crowded, it picks up S through NE swells. Best in NW winds. Other options in the Myrtle area include the town beach-breaks of **38-44th Av N** and **27-8th Av S** in bigger S swells, and at low tide, **The Pier** just S (expect crowds).

GARDEN CITY BEACH & PIER

From Georgetown, N on Hwy 17 to Garden City. Turn R on Atlantic Av to the beach, then R along the beachfront.

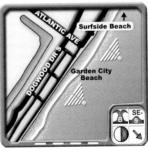

Head to GC Pier for the pick of the surf round these parts. Big S or SE hurricane swells and offshore in a nor'easter. Reasonable beach-breaks on sand bottom – the S side is normally a bit more consistent. All surfing standards, often crowded and watch out for fins – definitely known round here. Head N to **Surfside** where the **Pier** at **Springmaid Beach** can be fun in summer.

PAWLEYS ISLAND PIER

Take Hwy 17 from George-town N. Cross the bridge to Pawley's Island. Turn L then R into 2nd St and the pier.

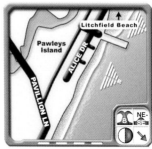

Reasonably consistent L&Rs over sand bottom either side of the pier. Handles all swells, although the Ls are probably your best bet in big NE swells on a higher tide and Rs handle up to 6ft in hurricane SE swells. Attitude in the lineup related to the size of the crowds. Keep an eye out for sharks. Head N to Huntington for **Murrells Inlet Jetty** in E and NE swells and **Litchfield Beach** for less-consistent but less-crowded options in similar conditions.

PAWLEYS ISLAND JETTIES

From Georgetown, head to South End on the Pawley's Island beach road. Take Vanderbilt Blvd to the jetty.

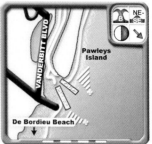

A real gem if the banks are working in hurricane SE swells, particularly in late spring/early summer. Plenty of hollow barrels either side of the jetty breaking over sand bottom. Does attract the sand sharks here. Can also get crowded, but you should be OK. Consistency is the main problem. You can also surf the pier, up north and more accessible, or avoid crowds and just keep walking to find your bank. Northern end has some good rights in a power NE swell too.

E8

DE BORDIEU

Head E out of Georgetown. Take Luvan Blvd to De Bordieu, then De Bordieu Blvd to the beach.

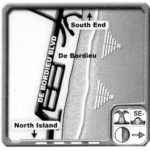

Average beach-breaks at a beautiful beach, breaking on sand bottom. Ideal for beginners. Best in W offshore winds and hurricane swells. Handles NE to SE swells but can be mushy. Surfing is just about tolerated here. There are much better options S of here for the surf traveller with access to a boat e.g. **N & S Islands** and further S (and more remote) **Cape Romain and Bull Island.** Otherwise you can trek down south towards the **North Island Inlet** (which gets good!) and find banks along the way.

ISLE OF PALMS

Head E out of Charleston on Hwy 17 to Mount Pleasant. Turn R on Hwy 517. L at Palm Blvd in Isle of Palms then R to the pier.

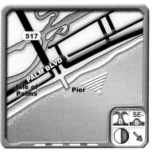

In SE swells, the pier area provides the most consistent surf round here. If the banks are good it can be quite hollow. However, if conditions are right, you can guarantee the crowds. There are some good banks to be found by making a trek north from here to the **Dewees Inlet**. The south side takes northeast swells and south winds, and is quality. Access a hassle ! Paddle across if you dare, and avoid crowds.

SULLIVANS ISLAND

From Charleston, Head SE on Ben Sawyer Blvd to Sullivans Island. Turn R on Bayonne St to the south end opposite the channel.

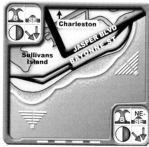

Powerful, dumping L&R over sand bottom in big NE ground-swells. It's almost offshore in north-easterlies here. Quality spot that can hold size. It is shielded from north oriented swell unless big, but the northern end of the island yields more consistent options in these conditions. Sharks. Currents. Some localism.

FOLLY BEACH

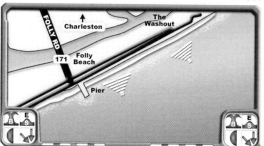

Hwy 17 S from Charleston, then Hwy 171 to Folly Beach. L on E Ashley Av, just past 10th Av. **The Washout:** Powerful, consistent, dumping beach-breaks off jetties. Currents on big days. S to **10th Street** for similar but smaller jetty breaks. S of **The Pier**, the Ls can be pretty hollow and barrelling at mid-tide. Less power but more glassy and fewer crowds than the Washout.

SEABROOK

Take Hwy 17 S from Charleston. Take Hwy 700 SW. Follow Baywood Dr or Seabrook Island Rd to the beach.

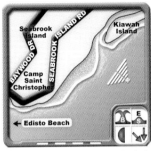

Inconsistent offshore sandbars will sometimes turn up nice hollow sandbar peaks at this isolated, beautiful beach spot. Bring your paddling arms. Needs a high tide. The bigger the better in swell terms. It's a long way out there to be alone, dudes. Big NE or E swells will get into **Kiawah,** particularly the N (private) end of the island. Adventurers, try Fripp and **Hunting Island** (the Lighthouse) off Beaufort but beware big currents, tides and fish.

TYBEE ISLAND

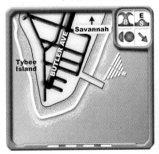

Take Hwy 80 E from Savannah to Tybee Island. Turn L on 16th then R into 18th to the jetty.

Great jetty break in E-NE swells, breaking on sand. Doesn't get much bigger than 4ft here, but still the best option on Tybee Island. All surfing standards. Big crowds if its on. Try **2nd St,** or from 17th street north to **Boardwalk** and **Sugar Shack** for small beach-breaks if there's a strong nor'easter blowing. All are mid-high tide spots. Long-boarders head to the S end of the island in summer SE windswells for offshore sandbars.

GOULDS INLET

From Brunswick, take the St Simons Island road then park at the E end of Beachview Dr.

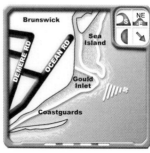

Head to the far E of St Simons Island to the Inlet and paddle across to Sea Island for nice long Ls in strong N and NE groundswells. Needs a mid-high incoming tide to work. There is filth and current to contend with especially after rains. Fishermen throw entrails in the water, attracting sharks. Big crowds, all standards. At high tide, try **Coast guards,** for long mellow Ls. If you're feeling lucky, try **5th-7th St, Jekyll Island**. All spots fickle.

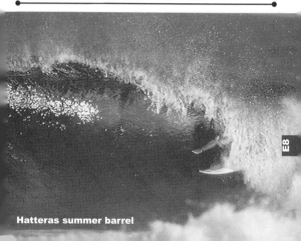

Hatteras summer barrel

E8

SOUTHEAST SURF SUPPLIES

North Carolina

Atlantic Beach - Beach Mart, 291 West Fort Macon Rd, 252-726-7505

Bert's Surf Shop, 304 West Fort Macon Rd, 252-726-1730

Water Co Surf Shop, 2610 West Fort Macon Rd, 252-726-3483

Wings, 200 West Fort Macon Rd, 252-240-5363

Avon - Ocean Roots Surf Shop, 41008 NC 12 Hwy, 252-995-3369

Buxton - Natural Art Surf Shop, 252-995-5683

Carolina Beach - Bert's Surf Shop, 808 Nth Lake Park Blvd, 910-458-9048

Cove Surf Shop, 604 North Lake Park Blvd, 910-458-4671

Charlotte - Wallerbears Surf Shop, 8334 Pineville Mathews, 704-341-3414

Corolla - Corolla Surf Shop, 55 Sunset Blvd, 252-453-9273

Corolla Surf Shop, Corolla Light Ship Court, 252-453-9283

Emerald Isle - 58 Boards, 8204 Emerald Drive, 252-354-5800

Bert's Surf Shop, 300 Islander Drive, 252-354-2441 / 6282

Emerald Isle Surf Shop, 3102 Emerald Drive, 252-354-8422

Hot Wax Surf Shop, 200 Mallard Drive, 252-354-6466

Wings, 8100 Emerald Drive, 252-354-5161

Greenville - Fusion Surf & Skate, 714 Greenville Blvd SE, 252-321-4884

Holly Ridge - Bert's Surf Shop, 310 North New River Drive, 910-328-1010

Ocean Waves, 204 North New River Drive, 910-328-3305

On Shore Surf Shop, 405 Roland Ave, 910-328-2232

Spinnaker Surf & Sport, 111 North Shore Drive, 910-328-2311

Wings, 106 North New River Drive, 910-328-5900

Jacksonville - Good Sessions Surf Shop, Jacksonville Mall, 910-353-7070

Saltwater Surf Shop, 345 Western Blvd, 910-353-2311

Kill Devil Hills - 17th Street Surf Shop, 1007 S Croatan Hwy, 252-441-1797

Bert's Surf Shop, 103 South Croatan Hwy, 252-441-1939

Pit Surf Hang Out, 1209 South Croatan Hwy, 252-480-3128

Vitamin Sea Surf Shop, 2407 North Croatan Hwy, 252-441-7512

Kinston - Bert's Surf Shop, 210 East New Bern Rd, 252-527-0846

Kitty Hawk - Bert's Surf Shop, 4009 North Croatan Hwy, 252-261-7584

Wave Riding Vehicles, 4812 North Croatan Hwy, 252-261-7952

Morehead City - Action Surfboards-Surf Shop, Hwy 70 West, 252-240-1818

Nags Head - Secret Spot Surf Shop, 252-441-4030

Whalebone Surf Shop, 2214 South Croatan Hwy, 252-441-6747

New Bern - Eastern Edge Surf Shop, 1908 S Glenburnie Rd, 252-633-2222

Oak Island - Bert's Surf Shop, 320 Norton St, 910-278-6680

Local Call Surf Shop, 609 Yaupon Drive, 910-278-3306

Ocean Isle Beach - Salty's Surf Shop, 12 East 1st St, 910-579-6223

SOUTHEAST SURF SUPPLIES

Raleigh - Vertical Urge, 7449 Six Forks Rd, 919-870-7766
Rodanthe - Hatteras Glass Surfboards, 252-987-2412
Rodanthe Surf Shop, NC 12 Hwy, 252-987-2412
Washington - Wings, 100 Morehead Drive, 252-240-2628
Waves - Hatteras Island Surf Shop, 252-987-2296
Wilmington - Alison Surfboards, 2034 Turner Nursery Rd, 910-686-0044
Aussie Island Surf Shop, 1319 Military Cutoff Rd, 910-256-5454
Bert's Surf Shop, 5740 Oleander Drive, 910-393-4501
Hawaii-Anas, 1100 Aloha Lane, 910-796-6599
Hot Wax Surf Shop, 4510 Hoggard Drive, 910-791-9283
Pride Surf Shop, 341 South College Rd, 910-799-7811
Wrightsville Beach - Surf City Surf Shop, 530 Causeway Dr, 910-256-2266
Sweetwater Surf Shop, 10 North Lumina Ave, 910-256-3821
Wrightsville Beach Supply Co, 1 North Lumina Ave, 910-256-8821

South Carolina
Conway - Wallerbears Surf N Sport, 2709 Church St, 843-365-1962
Florence - Atomic Skate & Surf, 812-C South Cashua Drive, 843-317-6880
Folly Beach - Barrier Island Surf Shop, 32 Center St, 843-588-6666
Mckevlin's Surf Shop, 8 Center St, 843-588-2247
Ocean Surf Shop, 31 Center St, 843-588-9175
Hilton Head Island - Billy's Beach Club, 11 Coligny Plaza, 843-842-6003
Mount Pleasant - Liquid Motion Surf Shop, 1909 Nth Hwy 17, 843-881-2898
Murrells Inlet - Perfection Surfboards, Atlantic Ave, 843-651-6396
Myrtle Beach - Berts Surf Shop, 806 31st Ave South, 843-272-7458
North Shore Surf Shop, 110 Hwy 17 South, 843-280-5071
Pacific Sunwear, 10177 North Kings Hwy, 843-272-6862
Surf City, Myrtle Square Mall, 843-626-5412
Village Surf Shop, North Kings Hwy, 843-626-8176
WallerBears Surf Shop, 4723 Hwy 17 South, 843-238-4079
X-Treme Surf & Skateboard, 515 Hwy 501, 843-626-2262
North Myrtle Beach - Head Shots Surf Shop, 215 Main St, 843-281-2324
Surf City, 3300 Hwy 17 South, 843-272-1090
Pawleys Island - Surf The Earth, 47 Da Gullah Way, 843-235-3500

Georgia
Tybee Island - High Tide Surf Shop, East Hwy 80, 912-786-6556

FLORIDA

Background

A lack of consistency and size is more than well documented, and it is true that flat periods throughout this state can linger on for weeks or more. What is less appreciated, is the fact that there are some superb quality inlet, pier, jetty and even reef breaks. The fickle nature of the swell, and the absence of cold weather to scare people off nurture some incredible crowds. When swell is mid-sized, many beach-breaks are long enough to spread any numbers, so getting in the car and exploring is good policy. Pack your smile and your lucky charm.

When to go

Winter swell is the most reliable action, and cold fronts tend to focus, intensify and produce better quality as one heads south. Hurricane swells that occur late summer, are about as safe a bet as the Miami Dolphins, but when they come, provide a semblance of big wave surfing. Fall is best, to catch early winter north swell or late mid-lattitude storm pulses and occasional hurricanes.

Hazards

Crowds. Parking hassles. Private beach-front land. Always check about parking in your area. Lightning. The data below is at Daytona Beach, and may vary up and down the coast.

M	Swell Range		Wind Pattern		Air		Sea	Crowd
	Feet	Dir'	Am	Pm	Lo	Hi		
J	0-6	ne	nw	ne	48	70	60	hi
F	0-6	ne	nw	ne	52	70	64	hi
M	0-6	ne	nw	ne	54	75	68	hi
A	0-6	ne	w	se	56	79	70	hi
M	0-5	s-e	w	se	60	85	75	hi+
J	0-3	s-e	w	se	66	88	77	hi+
J	0-3	s-e	w	se	70	92	80	hi+
A	0-6	s-e	w	se	70	90	80	hi+
S	0-6	s-ne	w	se	68	85	75	hi
O	2-10	ne	nw	ne	65	80	70	hi
N	2-10	ne	nw	ne	58	75	65	hi
D	2-8	ne	nw	ne	52	72	62	hi

E9: FLORIDA NORTH

95
A1A

105

Jacksonville
90

Ponte Vedra

1

Cresent
Beach

Flagler Beach

N

95
Daytona Beach

17

Stanford
415

441

FERNANDINA

Head N from Jacksonville on Hwy 17. Turn off on Hwy 200 to Fernandina. Go L on Tarpon to main beach or R on A1A to the pier.

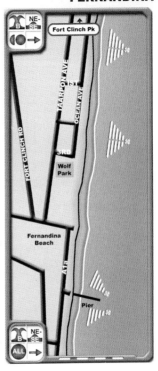

This area is known as North Side (N of St John's River), where peaky L&R beach-breaks break over sand bottom. Open to all swells. Best at mid-high incoming tides on winter N, or fall hurricane swells when it becomes a hard-dumping hollow break. Expect fast barrels. Easy paddl-eout, even when it's big – although the currents are strong. Not too crowded and not too gnarly. Intermediate-plus break. Options include N into the **Forth Clinch State Park** for a similar beach-break, or **The Pier** for a better novice option working all tides and north through south swells. 2-8ft. All levels.

There's plenty of beach-break options here if it's crowded. **Amelia Island** State Recreation Area, south on the A1A, has acres of peaks taking all swells; quantity not quality. Most spots handle up to about 6ft and like middle tides incoming and westerly winds. All levels.

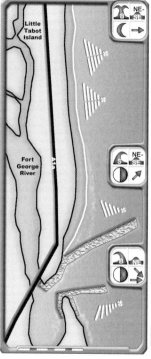

From Jax, head N on Hwy 17, then turn off on 9a. Turn onto 105 / A1A to Talbot Island. R to Huguenot. Cross the bridge up to Little Talbot.

Long, peeling Rs break off the Fort George River breakwall at the southern end of the island in most swells (prefers sizey hurricane SE swells) and all tides. When the wind drops, this wave is a wedging peak, especially on higher tides. Very heavy, crowded local scene. Walk N up **Huguenot** Beach for other sandbar peaks in similar conditions, or head N through the **Little Talbot Island State Park** for powerful, barrelling sandbar options, best in big, clean, hurricane swells and at low incoming tides. Advanced surfers break. Gets sharky in these parts.

The south side of the river hosts an array of beachbreaks towards the **Hanna State Park**. Of note is **The Point** up by the south jetty. It's a fickle left-hander on north-east ground-swells, and offers some protection from north-east winds. 3-8ft plus. All levels. When on it is crowded, but peaks a short walk south can be good and slightly more peaceful.

307

KATHRYN HANNA PARK

From Jax, head N on the A1A until you reach Mayport Road. Head to Naval Base. Enter Kathryn Abbey Hanna Park.

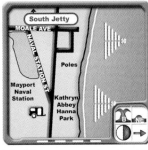

Long beach consistent in all conditions. Handles big NE swells (the S Jetty cleans them up) and is best at low incoming tides. Then, you'll witness a power beach-break with fast, deep-pit barrels. **Hanna** is a good spot, and just north is **The Poles** (by the naval station) & numerous good peaks up as far as the jetty (see previous page). Handles size and holds shape. Rips, and heavy paddle-out when it's pumping. All standards but advanced in big conditions. Always crowded, but plenty of peaks.

JACKSONVILLE BEACH

In the centre of Jacksonville, take the 212 to 3rd St (A1A). Follow it till you reach 6th Av S. The pier is at the E end.

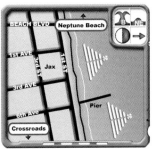

The Pier handles bigger swells and prefers higher tides, but works in most conditions with high consistency over sand bottom. Clean, groomed lines with hollow L&Rs off both sides of the pier, dependent upon wind/swell direction. 3-6ft+. Intermediate to advanced waves but the shore-break is OK for novices. Head N up to **Atlantic & Neptune Beach** for other less-crowded beach-break options, often more suitable for intermediates and kids.

PONTE VEDRA BEACH

From Jax, take the 212 to Jax Beach. Head S on A1A to Ponte Vedra. Take PV Blvd to the junction with Solana Rd.

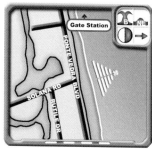

Solana Rd is a mid-high tide inside sandbar break, and a low tide outside L&R on reef . Best in hurricane swells – NE or southerly swells will work. Low-mid incoming. PV bars are fickle and shifting. All standards. **Mickler's Landing** or **Crossroads**, further S, is another inside beach-break, needing hurricane swells, low tides and the bars to be right. If so, powerful barrels break close to shore, for the crowds of kids. Sharky. Get away from it all further S to **Gate Station** – average beach-breaks near the gas station.

VILANO

S from Jax on A1A. Or, head S on State Hwy 5 or Hwy 1 to St Augustine. Take Vilano Beach Bridge road to the Jetty.

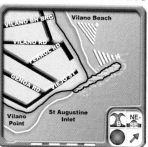

Big S swells come out of the deep water of the inlet and hit the shifting sandbars to produce powerful, hollow and peaky L&Rs over sand and coral bottom. Good possibility of getting barrelled here at high tide. Maxes out at 6ft. Offshore in SW-W winds. Inconsistency is the big problem. Heavy crowds of bodyboarders hang out at the shore dump. High-tide only break. Intermediate standard. Watch the currents when it's big.

ANASTASIA STATE PARK

Head out from St Augustine on Anastasia Park Road into the state park. Park at the beach access ramp.

Several quality breaks here – **Blowholes,** half a mile up the beach from the ramp, is a consistent low-tide barrelling break, on sand bottom. Will handle double overhead (and more in heavy hurricane conditions, when the paddle-out is a mission). Powerful, very hollow Ls with long, bowling Rs. Famous spot. Lots of locals. Advanced to expert break.

Further N up the beach, are heaps of peaks working best in SE hurricane swells on low incoming tides. This time, the Ls are long and bowling; the Rs steep and hollow. There's acres of beach-break peak up and down this strip, and a stroll might yield an unmanned bank. Beach disappears at high tide.

2-6ft plus. All levels. All seasons. Acceptable crowd factor.

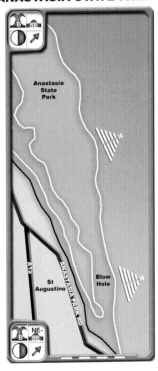

ST AUGUSTINE - FA'S

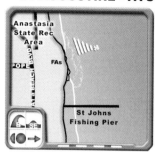

Head SE from St Augustine on Anastasia Park Road into the state park. Follow the A1A round to the right. Its 200m N of the pier.

Left and right beach-breaks in this heavily dredged area. Used to be a nice jetty but now a beginners beach-break on most tides. It does work in solid NE swells but the currents are heavy. You're near the pier and the State Park so there are worse places to park yourself (the parking's actually OK) and find a nice peak. All levels. Crowded but spread out.

ST AUGUSTINE - "A" STREET

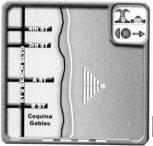

Head SE from St Augustine on Anastasia Park Road into the state park. Follow the A1A S to A St.

A great little beach-break – consistent in all conditions, although best at high tide and on a SE swell. Peeling, long L&Rs get going at 3ft although tends to max out at 6-8ft, breaking on consistent sandbanks. Crowds, crowds and more crowds. All standards.

E9

MATANZAS INLET

From Jax, take the A1A S past A Street for about 15 mins. It's off the beach in front of the Inlet bridge.

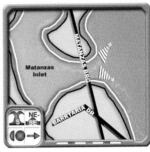

Ls and Rs break on the sandbars out in front of the bridge over shifting sandbars at this isolated spot. You'll get a wave in pretty much any conditions here. If things are stacking up, fast, peeling barrels are the order of the day. However, the currents are big, locals are heavy and it being an inlet, is known to have an active big fish population! Advanced surfers only. You can head south into **Crescent Beach** for consistent but average quality beach-break action on any tide.

FLAGLER BEACH

From Jax, take the A1A S for about 20 miles to Flagler Beach. The pier is just past the Moody Blvd junction.

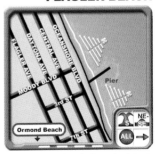

Quality barrelling L&Rs off the pier breaking on sandbar bottom. Powerful even when small. Best conditions are at low tide with any swell. Attracts the crowds, as it's really the only break in town, particularly in summer. Pretty mellow environment normally. All standards break. Prevalent shark hazard. The **State Park** running south from here can have good peaks in a less crowded environment if its 3-5ft and off-shore.

x

ORMOND BEACH

From Orlando, take State Hwy 4 NE to Daytona Beach. L on 95, then R on 40 to Ormond Beach and the pier.

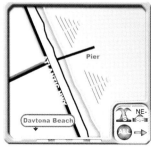

The remains of the pier tend to hold the banks together well here, so that good, consistent 3-6ft beach-breaks work on all swells, breaking on sand bottom. In big swells the outside starts to break, but the paddle-out is heavy. There is a shark threat here, and the currents can be a hassle in bigger swells. Intermediate-plus break.

DAYTONA - MAIN STREET PIER

From Orlando, take State Hwy 4 NE to Daytona Beach. L on Hwy 5 then L on 600. L on Atlantic Av to the pier.

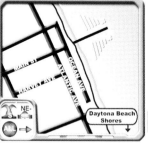

The famous Main Street Pier is the center of the action. Fairly standard pier set-up – Rs are better on the N side in SE swells and Ls on S side in NE swells, over sand bottom. This is definitely a fall or winter spot. At spring break and in summer it is overcrowded, parking is non-existent and the atmosphere is anything but mellow. All standards.

DAYTONA - SUNGLOW PIER

From Orlando, take State Hwy 4 NE to Daytona Beach. R on Hwy 5 then L on 421. Pick up the A1A (Dunlawton Av) to the pier.

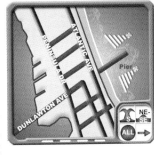

Similar pier set-up to Main Street Pier, although tends to break on the banks further out (paddle out is challenging in big swells). Handles all swells and often has a couple of feet more size than Main Street. The S side is more consistent and offers a better quality wave, best in NE swells. Always crowded. Try to avoid spring and summer if you can.

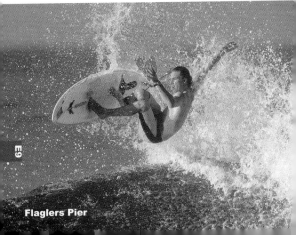

Flaglers Pier

ⓘ PONCE INLET & NEW SMYRNA

From Orlando, take State Hwy 4 NE, then the 44 to New Smyrna then N to the Dunes Park. For Ponce, follow Atlantic Av S from Daytona Beach.

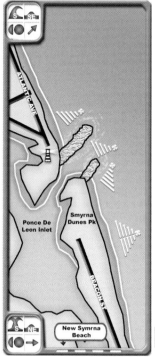

Consistent Rs off the **North Jetty** in SE swells, breaking over sand bottom. At best, in higher tides and on fall storm swells, this is a big, jacking takeoff followed by long, peeling top-to-bottom barrels. Advanced surfers. However, if it's cranking expect huge crowds, a heavy line-up vibe, currents and more crowds. If that wasn't enough, there are sharks too. 2-10ft. Gets bigger. All levels.

The **South Jetty** on New Smyrna side is famed for the break next to the jetty, which is consistent, very good and very crowded. It handles all the size the ocean can throw at it – particularly in big NE swells, when it creates a spitting & hollow L breaking over sand. Rights can work into the inlet on solid south swells and a higher tide. Beach peaks everywhere and an outer bombora on bigger days. 2-12 ft. All levels. Advanced to expert when big. Many small sharks about, and they bite people more regularly than any other surf spot anywhere.

NEW SMYRNA BEACH

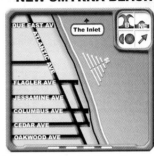

From Orlando, take State Hwy 4 NE, then the 44 to New Smyrna. Follow the 44 (it becomes Flagler Av) to the beach.

You will always find a wave here, but it's best to avoid S swells, particularly in summer. L&R peaky beach-breaks (best at 3-6ft) up and down the beach, breaking on sandbars. Mid-high tide is best to get the swell in over the outside banks. Always crowded, plus there is a definite local scene. Gets sharky, being so close to the Inlet.

BETHUNE & APOLLO BEACH

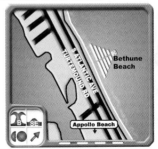

From Orlando, take State Hwy 4 NE, then the 44 to New Smyrna Beach. Take S Atlantic Av S for 10 mins to Bethune. Good long L&R beach-breaks, breaking on sand bottom are found here. Best in larger SE swells, when the waves, particularly the Rs, will get hollow and peel down the beach. Gets hollower at low tide. Lots of kids on the inside, very close to the beach. All standards of surfers. The expansive **Apollo Beach** that runs south on the A1A, yields shifting beach-break peaks that get good on solid southeast swells on most tides and a SW wind.

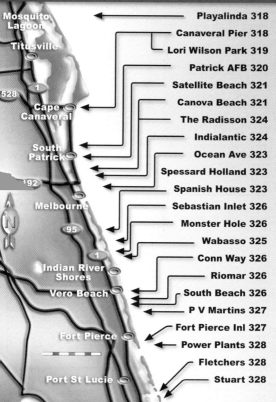

E10: FLORIDA CENTRAL

Mosquito Lagoon

Titusville

528

Cape Canaveral

South Patrick

192

Melbourne

95

Indian River Shores

Vero Beach

Fort Pierce

Port St Lucie

Playalinda 318
Canaveral Pier 318
Lori Wilson Park 319
Patrick AFB 320
Satellite Beach 321
Canova Beach 321
The Radisson 324
Indialantic 324
Ocean Ave 323
Spessard Holland 323
Spanish House 323
Sebastian Inlet 326
Monster Hole 326
Wabasso 325
Conn Way 326
Riomar 326
South Beach 326
P V Martins 327
Fort Pierce Inl 327
Power Plants 328
Fletchers 328
Stuart 328

PLAYALINDA

From Orlando, take Hwy 50 then get onto I-95 and head S. Turn off on Hwy 406 E, then take the 402 and follow to the beach.

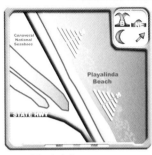

A long duned beach with many peaks up and down the it over sand bottom in a beautiful area overlooked by the Space Center. Best in NE swells and at low tides. A total gem of a spot – a long way off the beaten track. Never crowded, but threats include sharks, currents and the isolation.

COCOA BEACH - CANAVERAL PIER

From Orlando, take 528 E to Cape Canaveral. South on A1A to Cocoa Beach. L on Meade Av to the pier.

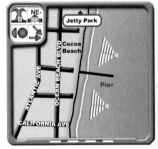

The home of Slater. Dependable L&R sandbars, either side of the pier, breaking on sand bottom. Works on all swells and tides, although fall or winter NE storm swells and higher tides will produce the best quality. All standards of surfer. Other options include **Jetty Park** and **Kennedy Space Center** to the N for OK beach and jetty breaks. Consistent.

COCOA BEACH - LORI WILSON PARK

From Orlando, take 528 E to Cape Canaveral. South on A1A to Cocoa Beach. L on Meade Av to the pier. From Canaveral Pier, head south on A1A till you see the park.

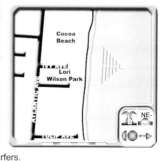

More average L&R beach-breaks, breaking over sand bottom. You'll find a peak on any swell and in most tides, although your best bet is in big NE or SE hurricane swells. This is a fun spot for all standards of surfers.

Cocoa Beach flyer

E10

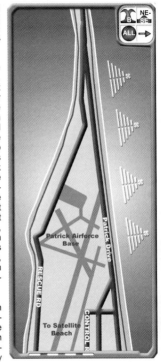

From Orlando, take 528 E, then I-95 south. Turn off on 509 east, then 404 east, then L on the A1A north to the base.

A variety of options here on the Air Force Base. Most of the spots are best at 3-4ft on a higher tide, or lower tides if it is big. The bottom is sand with an outer shelf of dead coral that ensures it can handle size. This same shelf also means that some swells get blocked and then back off, meaning you have to surf the re-form. Higher tides tend to save the day. Works on northeast to southeast swells, but when swell is very north, is usually smaller than Satellite Beach and spots further south. Conversely, it will be bigger here than Cocoa Beach spots. Westerly winds are perfect.

Always crowds, even though there's plenty of options. The best spots are often in front of the main gates and up by the picnic tables. There are many named spots, but these can all melt into one with the sand movement, so the best advice is to drop your car in the parking lot and take a walk up the beach.

SATELLITE BEACH

From Orlando, take 528 E, then I-95 south. Turn off on 509 east, then 404 east, then R on the A1A. park anywhere N of Ellwood Ave.

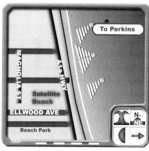

RC's is a bit of a legend in these parts. It is a rocky reef ledge out from the beach that can handle very big waves. Best on a N-NE swell and mid-high incoming tides. This is a jacking L and R that walls up to create top-to-bottom barrels with thick-lip. **Race Track Lefts** is a fast reef peak just north. When crowded, other similar peaks in area can absorb. 3-15ft. Pretty consistent. Advanced to expert.

CANOVA BEACH

From Orlando, take the 528 east, then I-95 south. Catch 518 east (Eau Gallie Blvd) right to the beach.

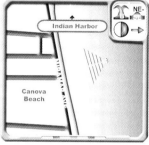

Average beach-break, breaking on shifting sand-bar and coral bottom needs big NE hurricane swells and higher tides to get challenging. Otherwise you'll still catch 3ft peaks. Never too crowded but there are rips and currents running. All standards spot. Similar options just N at **Indian Harbor Beach.**

CANOVA BEACH - THE RADISSON

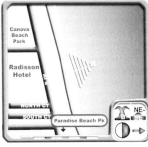

From Orlando, take the 528 east, then I-95 south. Catch 518 east (Eau Gallie Blvd) right to Canova beach. South down the A1A.

There's a rocky shelf outcrop here, which helps to produce good Ls in NE hurricane swells breaking over sand reef bottom. Probably the best spot in Canova in these conditions. Expect 4-6ft and pumping. Watch out for the currents when it's bigger. Pretty solid local crew. There are more beach-break options just S on A1A at **Paradise Beach Park**.

INDIALANTIC BOARDWALK

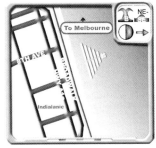

From Orlando, take 528 east to I-95 and head S. Turn off on the 192 through Melbourne to Indialantic. Turn R on A1A to Boardwalk.

Small dumping 3-5ft beach-breaks up and down the beach, over sand and coral bottom. Breaks best at high tide very close to the shore, however, in medium NE swells, at mid tide, there is an outside bank that works. Low tide is not an option unless you want a pile driving or ride a bodyboard. Not surprisingly, heavy crowds of grommets.

MELBOURNE - OCEAN AVENUE

From Orlando, take Hwy 50 to I-95 and head S. Turn off on the 192 to Indialantic. Turn R on A1A. In Melbourne, take Oak St to Ocean Av.

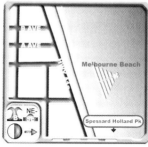

An average quality beach-break with working outside sandbars. Handles all swells and tides, although better in low-mid incoming tides. Maxes out at 5-6ft. The breaks close to the shore get crowded with grommets. Unless you live here, it's a stop-off on the way to Sebastian. Head S for similar action at **Spessard Holland Park** on your way down.

SPANISH HOUSE

From Orlando, take Hwy 50 to I-95 and head S. Turn off on the 192 to Indialantic. Head S on A1A through Melbourne. 15 mins drive is Ballard Pines. Park just past Long Point Park.

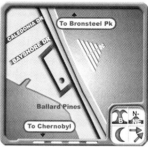

Inconsistent, but high-quality spot. Sandbar beach-breaks that need bigger N-NE swells and at low tide to get going. In best conditions, you could find yourself pitted in a grinding overhead barrel. Very crowded local scene but doesn't tend to be too hardcore. A less accessible shore-break known as **Chernobyl** is found just S, but it still always seems to be crowded too.

E10

323

From Orlando, take Hwy 50 to I-95 and head S. Turn off on the 192 to Indialantic then S on A1A for 30 mins to the North Jetty at the Inlet.

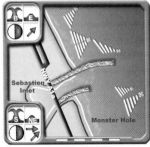

Has the potential to be FLA's best wave, but conditions have to be right. An often great right peels off the northern jetty edge over sand bottom with a few stray boulders. In big swells at any tide, it is possible to get a fast, grinding, double overhead barrel with a thick lip and real power. Always crowded with aggressive, wired-in locals. It likes a lower tide, with highs creating back-offs and brutal back-wash. The next section of the wave keeps firing towards the beach, and with more north in the swell, can incorporate quality lefts. More peaks up the beach, in particular an often closed out but sometimes great left-hander on winter swells. Shifty peaks though and it often simply does not look like the same place you see in the magazines.

Way off the end of the south jetty is an off-shore sandbar, **Monster Hole.** It is thus named after the men in grey that frequent the area, particularly after heavy rains. Not all fishermen like to see surfers around, and are only to happy to throw fish entrails into the water on their way home, making this a feeding zone. N-NE swells and low incoming tides get huge Ls working. These run for yards and yards, and the more north the swell, the more lined up they are. It is a long paddle out there in greeny brown water, and not seeing the bottom merely adds to the sensation that you are out of your element. The sweep pulls you off target when it's big, so rubber-arms are common. More east/southeast swells get the rights happening. These can be good and fast, or just plain ole bumpy. Scary, isolated spot, full of sharks with very strong currents. Can handle anything from 3 to 15ft if swell is north. Advanced. Semi Consistent.

WABASSO

From Orlando, take 528 east to I-95 and head S. Past Sebastian, turn off on the 512, then 510 to Wabasso Beach. L on A1A to Sand Dollar Lane.

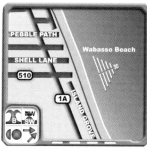

Wabasso handles much more size than most breaks in the area. It's a pounding beach-break that needs a big N-NE swell and high tide to get the swell in over a rock reef on the outside. It then forms spitting, powerful L&Rs that deliver a pile driving to the unsuspecting. Good surfers break. Crowded when it is on, particularly with bodyboarders putting their bodies on the line.

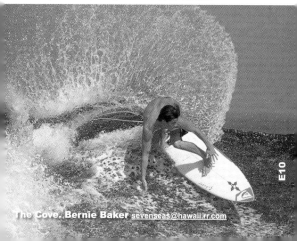

The Cove. Bernie Baker sevenseas@hawaii.rr.com

E10

VERO BEACH - CONN WAY

From Orlando, take Hwy 50 to I-95 and head S. Past Sebastian; turn off on the 60 to Vero Beach. Go to the pier or head S on A1A to Conn Way.

Two options in Vero Beach: **Conn Way**, which is a pounding, peaky L&R beach-break, breaking on all tides in big N-NE swells. Regularly barrelling. **The Pier**, which offers L&Rs either side of the pier in incoming mid-high tides and

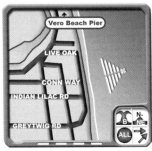

big NE or SE swells. At best, powerful, hollow overhead barrels for advanced surfers. Sadly, the sandbars shift heavily and it's very inconsistent at the moment. Most surfers bypass Vero for this reason and head N to Sebastian or S to Fort Pierce.

RIOMAR

From Orlando, take Hwy 50 to I-95 and head S. Past Sebastian; turn off on the 60 to Vero Beach. S on A1A through Vero Beach, then L on Riomar Drive.

An offshore reef breaks on rock bottom in big N-NE swells and at low tide, mainly in fall or winter. At it's best, it's a hollow-pitted, thick-lipped, double overhead-plus thumping beast. Never crowded.

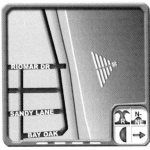

Experts only when big. Long paddle through sharky piece of seaway. 3-10ft plus plus. For a more consistent, often powerful beachbreak for all standards, head S to **South Beach.**

PV MARTINS

From Fort Pierce, take Hwy 1 N. Turn onto N-A1A past the Inlet and head N for 10 mins to the restaurant.

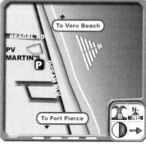

An out-of-the-way spot for reasonable L&R beach-breaks, breaking on sand at incoming low tide in big N-NE swells. Can get quite hollow and peaky in fall or winter ground-swells. Great spot to escape the crowds for mellow surf, with easy parking. Options for all standards of surfers, just watch out for the currents in big swells and for fins.

FORT PIERCE INLET

From Fort Pierce, take Hwy 1 N. Turn onto N-A1A to the Inlet. Head S on Ocean Dr into Tamarind Dr to Atlantic Beach Blvd.

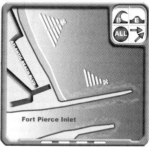

Two main options here: a peeling, long R works off the jetty, breaking on sand and patchy rock bottom in big NE-E swells and best at higher tides. Needs a good sou'wester to groom the face. Alternatively, up the beach, peaky L&R beach-breaks give plenty of options (just as well, when you see the crowds here). Currents and, being close to the inlet, sharks are potential problems. All standards, but good surfers rule the jetty R.

327

POWER PLANTS

From Fort Pierce, take Hwy 1 S. Turn onto S-A1A to the Inlet onto S Hutchinson Island. Head S on A1A for 10 mins to the nuclear plant.

A pumping L and a hollower, more dangerous R break over sand covered coral reef here. Handles overhead-plus. Totally fickle – it really needs a strong NE swell, low-mid incoming tide and lighter SW offshore winds. Rarely crowded. Advanced break, due to the reef hazard and the local shark population. Many uncrowded reef and sandbar spots in the area. Try N to **Blind Creek Park** or S for **Jensen's Beach** area and classic beachbreaks.

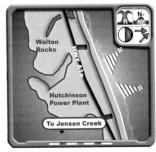

STUART

From Fort Pierce, take Hwy 707 S. Turn onto A1A to Stuart Beach on Hutchinson S Island. Turn R to Stuart Rocks.

A small headland is home to a shallow sand-covered reef with a long, point-style L and a hollow, gnarly R reef break. Best in solid NE swells and low incoming tide. Crowded. Localized. Shark sightings. Advanced to expert. **Fletcher's,** a L&R reef break, breaking on coral reef bottom 400m N of The Rocks. Works to overhead in solid N-NE swells and low incoming. **Stuart's Beach,** outside reef and grom-filled beach-break.

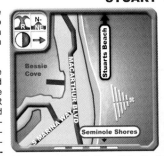

E11: FLORIDA SOUTH

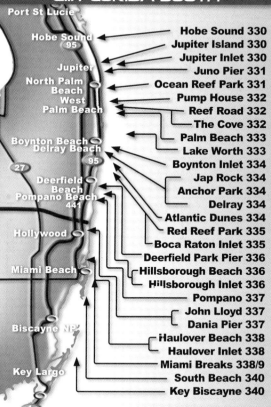

Port St Lucie

Hobe Sound

Jupiter

North Palm Beach

West Palm Beach

Boynton Beach
Delray Beach

Deerfield Beach
Pompano Beach

Hollywood

Miami Beach

Biscayne NP

Key Largo

JUPITER ISLAND

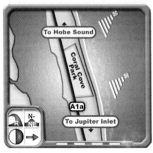

From Fort Pierce, take Hwy 707 S to Hobe Sound. Join Hwy 1 going S to the Island S Causeway. Follow the A1A Beach Rd N.

Coral Cove is a sand-covered reef L on most tides (there is a rarer R). Fast, hollow head-high barrel. **Blowing Rocks Beach** has a shallow L reef-break, breaking in strong NE swells. Gets big. Always a shark threat in these parts. Head N into the **Hobe Sound Refuge** for isolated beach and reef break options – the beaches can handle big NE swells to produce 6ft plus dumping beach-breaks. Watch out for rips, currents and lots of sharks. Advanced to expert surfers.

Ⓟ JUPITER INLET SOUTH JETTY

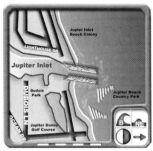

Head N on Hwy 5 out of West Palm Beach to Jupiter. Turn off Ocean Dr to the Beach County Park and the Jetty.

Big-wave R breaks off the outside sandbar on the S side of the S Jetty. In big NE-E swells it turns on steep-drop into a hollow, spitting barrel section. Stick to low incoming tides as there's a very strong rip along the jetty. Advanced surfers only. Always crowded with a heavy local scene. The inside bar works in smaller swells at low tide for intermediates. Beach-break options on the other side of the Inlet at **Beach Colony.**

JUNO PIER

Head N on Hwy 5 out of West Palm Beach to Juno Beach. Turn off on Donald Ross Rd to the beach and turn L to the pier.

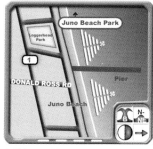

The long pier, kindly built in 1998, holds the sandbars together well on either side of the pier to produce high quality L&Rs in big N-NE swells on low-mid incoming tides. These are cranking, hollow overhead barrels at best. Inside bars work at higher tides, particularly if the swell is pumping. Always very crowded, as it's the most consistent spot in the region. Strong currents and big rip near the pier. Experts only when it is big.

OCEAN REEF PARK

Head N on Hwy 5 out of West Palm Beach. Head E on Hwy 9 at Riviera Beach to Singer Island. Take N Ocean Dr (703) to the Park.

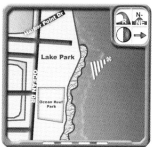

Good, fast Ls peeling over two sand-covered coral reefs. Best in solid N-NE swells and on low incoming tides. Best at 4-6ft when it's pretty fast and powerful. The main hazard is the reef, which is shallow and sharp in places. Good surfers will enjoy this break. Not too crowded.

PUMP HOUSE

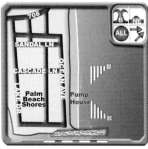

From West Palm Beach go N of the Inlet and take the 708 to N Ocean Dr. Go S on Ocean Av to the N Jetty.

Off the N Jetty is an inconsistent, but awesome L&R sandbar break, working in massive E-NE swells on a low incoming tide. Big, overhead-plus, thick and powerful wedges of water charge in for only the best surfers. Heavy currents make holding your place in the lineup a mission in itself. Then there's the paddle-out, getting caught inside, word of sharks and the shallow bar...! Inside the jetties is a rare, current-ridden shallow left-right reef-break...hard to get to, long paddles, adventure!

REEF ROAD

For Reef Road, head into Palm Beach then take N Ocean Blvd north. Park at the meters and walk 15 mins N to Reef Rd.

This is a monster L peeling down from outside the south side of the south jetty and breaking over a sectiony sandbar bottom. Gets big (10-15ft) in heavy NE swells with powerful, fast barrel & a stack of moving water. Inside is a

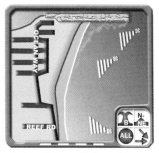

smaller more protected setup that can link up with the main wave. Rights too. Experts. Good in smaller swells too at 4-6ft, where it's hollow. Currents. Sneaker sets. Hard access. Nearly consistent.

PALM BEACH

From West Palm Beach, take the 704 (Royal Palm Way) to the beach. Flagpoles is out front. Turn L on Ocean Blvd for the jetties.

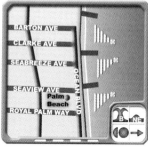

If not from around here, you will freak at the gaudy opulence juxtaposed with pretty good waves. Almost consistent 3-5ft L&R jetty breaks, breaking on sand, work at mid-high tide on big NE-E swells. On rare monster N swells, lefts get long and workable. There are heavy crowds because the spot is consistent. If you can't handle the crowds and there's a bit of a S wind-swell, head S on A1A for 10 mins to the **Hilton Hotel**, for mid-tide L&R beach-breaks.

LAKE WORTH PIER

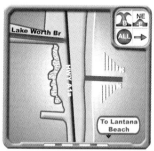

Head S on Hwy 1 / 5 from West Palm Beach to Lake Worth. Turn L on 802 to the beach, then R on A1A to the pier area.

On big N-NE swells, a solid sandbar on the S side of the pier produces a hollow, fast and grinding L that is a reform of the S pier sandbar break. On SE wind swells, the N side produces a fast, peeling R. Potential for double overhead makes it an expert break in these conditions. The inside banks work to 4-6ft on smaller swells. Notorious heavy local scene has calmed in recent years but be warned. Head S to the beach-breaks of **South Palm Beach** if there's enough swell.

BOYNTON INLET

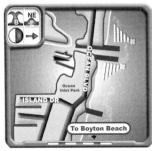

Head S on Hwy 1 / 5 from West Palm Beach to Boynton Beach. Cross the causeway, then L on A1A to the Inlet.

Long, hollow Ls break on an outside bar off the S jetty on sandy rock bottom in big N-NE swells and on low incoming tides. In E-SE wind swells, peaky Rs break off the N Jetty on sand bottom, again on low incoming tides. Experienced surfers only – the main hazards are the powerful current and, it being an inlet, the presence of sharks. There is a solid crew of very good local surfers here who will snaffle the best waves, so be patient and you will get rewarded.

ATLANTIC DUNES

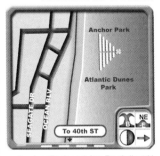

Head S on Hwy 1 / 5 from West Palm Beach to Delray Beach. Cross the causeway on 806, then R on A1A to the park.

A wide variety of L&R sandbar beach-break options in this area. N-NE ground-swells or E-SE wind swells will produce a peak somewhere round here. Best on incoming tides and offshore in westerlies. Breaks for all standards of surfers. Check **Delray**, **Anchor Park** and **Jap Rock** (just N of 40th St) for consistent options, particularly in solid swells.

RED REEF PARK

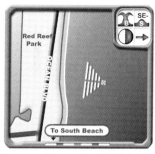

Head S on Hwy 1 / 5 from West Palm Beach to Boca Raton. Take the 808 to 798, then L on A1A to the park.

The sandbars and reefs in this area are plentiful, but the big N-NE swells don't get in to many of them. Best on E-SE wind swells, although will handle something with a bit of north in it. This spot produces good peaky and wedgy beach-breaks, breaking on sand-covered reef. Walk just S to **South Beach** for other options in similar conditions. Something for everyone.

BOCA RATON INLET

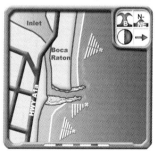

Head S on Hwy 1 / 5 from West Palm Beach to Boca Raton. Take the 808 to 798, then S on A1A to the inlet.

The beach to the S of the Inlet handles a big N-NE ground-swell on all tides, although incoming is best. Good, peaky 3-5ft L&R beach-breaks, on sand bottom. Also works in E-SE wind swells. Can get pretty crowded, as the good days are short-lived and there's an extremely talented local contingent. Small but nippy sharks enjoy the feed washing out of the inlet. All standards will find something here.

DEERFIELD PARK PIER

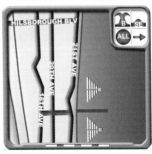

Head S on Hwy 1 / 5 from West Palm Beach to Deerfield Park. Take the 810 across the waterway then SE 21st Av to the pier.

Quality L&R beach-breaks are possible at the pier, breaking on sand bottom. Only really works on short-lived E-SE wind swells (or a really, really powered up north to northeast, which brings surprising quality) and low incoming tides.

All standards of surfers. Although this is the focal point of surfing in the county, you might find some more consistent and less crowded options further north, and within easy reach.

HILLSBOROUGH INLET & BEACH

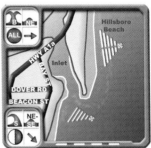

From Fort Lauderdale, head N on the A1A through Pompano Beach to the inlet.

The Beach can throw up some very peaky L&Rs breaking over sand-covered reef bottom in higher incoming tides. Needs a hurricane N-NE swell to fire. Handles some size – has been known to get overhead here. In similar conditions, the S side of

The Inlet produces long, reeling Ls, breaking over sandbar bottoms in all incoming tides. Intermediate-plus standard. Always crowded if the surf's up.

POMPANO - 2ND ST & COMMERCIAL PIER

From Fort Lauderdale, head N on the A1A to Pompano Beach. Take the N Pompano Beach Blvd to the Wharf Pier at 2nd St.

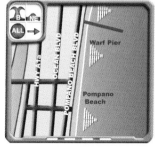

Named breaks in the region include **2nd Street**, **Anglin's** and **Renaissance Hotel**. There are a variety of pier and beach-break options, breaking mainly on sand bottom. Normal conditions are N-NE winter and fall groundswells or E-SE windchop. Most breaks work on all incoming tides. There's a break for every standard, but they are always crowded and there is often hassle. Be polite. Similar options S at **Fort Lauderdale Beach**.

DANIA PIER & JOHN LLOYD PARK

From Fort Lauderdale, head S on Hwy 1 past the airport and turn L to Dania over N Ocean Dr to N Beach Rd.

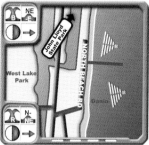

There are two options at Dania Pier: the N side has a sandbar L&R which works in E wind swells and low incoming tides; the S side has a sand-covered coral reef that needs N-NE hurricane winter swells to produce a L&R. The L is long, hollow and grinding – watch out, as there are submerged and visible pilings. Rs are smaller but peakier. Crowds and locals are an ever-present reality. Intermediate break. Head N on A1A into **John Lloyd** when there's a big NE swell, to the **Harbor Inlet**.

HAULOVER INLET

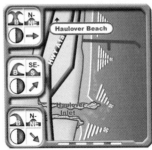

From Miami, take State Hwy 195 to the beach. Pick up the A1A and head N to Haulover Beach Cross the inlet to the pier.

Head to the S Jetty in hurricane N-NE swells and on incoming tides for long, peaky Ls over sand bottom. Hit the N Jetty in E-SE wind swells and low incoming tides for reasonable sandbar Rs. The crowds are big all the time, but massive in summer. This is also a known shark zone. All standards can, and do, surf here!

21ST STREET MIAMI

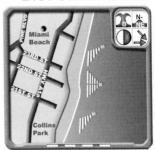

From Miami, take State Hwy 195 to the beach. Pick up the A1A and head S to 21st St.

Long, peeling Ls break here over sand bottom; best in hurricane winter N-NE swells and on lower incoming tides. Wave quality can be surprisingly good. However, crowds are massive, there's an aggressive scene and all sorts of people end up in the surf. All standards. There are other options in Miami for the more intrepid, such as **14th** or **96th Street**.

5TH STREET MIAMI

From Miami, take State Hwy 195 to the beach. Pick up the A1A and head S through Collins Park to 5th St.

Peaky L&Rs break over sand/patch reef bottom. If a power winter north swell should stray in, there are lined up lefts that the lucky will rave about between extended flat spells. Otherwise its summer wind-chop. Heavily crowded when it's on, and there is some real talent among the local surf population, who will be on it as soon as the conditions present. An outer bombora works low tide or big swell, but luck required to catch it perfect.

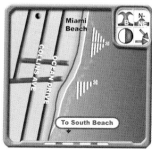

Miami summer performance

E11

From Miami, take Hwy 41 to the beach until it becomes the A1A. Go S on any road until you hit Biscayne St and Ocean Front Park.

Big hurricane swells produce wedgy L&Rs breaking over sand. The Rs can be long, peeling off the north jetty and on the beach. More common though, are small SE wind swells. On the rare occasion that a massive winter swell negotiates the coast this far down, the lefts are superbly lined up, and downright heavy barrel machines. Combined with west wind and low-mid tide, they produce a short-lived goofyfoot paradise. If its good there will be many in the water. If its bad there will be many in the water. The Jetties attract the big crowds, so check the strip for a quiet spot before committing. On the Other side of the inlet, **Key Biscayne** does not have much surf, but if South Beach is a crazy 8 feet on a massive northerly bust-up swell, head over here. Otherwise, get the next flight to San Juan. The rum there is frankly excellent, and in the above conditions you'll be scaring yourself in 8 foot right-hand reef pits at Tres Palmas.

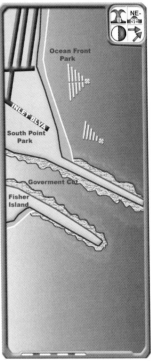

Ocean Front Park

INLET BLVD

South Point Park

Goverment Cut

Fisher Island

Background

There are waves here. Luck and patience are required to score a rare combination of major gulf storm and no local associated wind. Texas and Florida beaches tend to cash in on these conditions, as they are less hampered by shallow sand flats that dog Alabama and Mississippi. Scoring Bob Hall Pier on a solid south hurricane swell is a unique surfing experience that you'll remember.

When to go

Well, it's rarely cold here, and the fishing and cuisine are generally superb. Swell happens when winter storms cross the gulf, or late summer / fall hurricanes. These systems are extremely hard to predict, making long-range surf trips somewhat of a lottery. Generally, the best chance of unsettled swell creating weather is September through December. This is the juiciest half of hurricane season, and the beginning of the winter storm window.

Hazards

Spicy food. Flat spells. Seriously nice people. Over-eating. Hearing happy surfers say "should've been here yesterday".

The data on the chart is for Tampa Florida area.

M	Swell Range		Wind Pattern		Air		Sea	Crowd
	Feet	Dir'	Am	Pm	Lo	Hi		
J	0-4	se-sw	off-shore	on-shore	50	66	65	lo
F	0-3	se-sw	off-shore	on-shore	54	70	70	lo
M	0-3	se-sw	off-shore	on-shore	58	78	72	med
A	0-3	se-sw	off-shore	on-shore	60	80	75	hi
M	0-3	se-sw	off-shore	on-shore	65	86	80	hi
J	0-2	se-sw	off-shore	on-shore	70	90	85	hi
J	0-2	se-sw	off-shore	on-shore	75	92	86	hi
A	0-5+	se-sw	off-shore	on-shore	75	90	85	hi
S	0-5+	se-sw	off-shore	on-shore	70	86	80	hi
O	0-5	se-sw	off-shore	on-shore	68	78	78	med
N	0-4	se-sw	off-shore	on-shore	60	75	76	lo
D	0-4	se-sw	off-shore	on-shore	56	69	70	lo

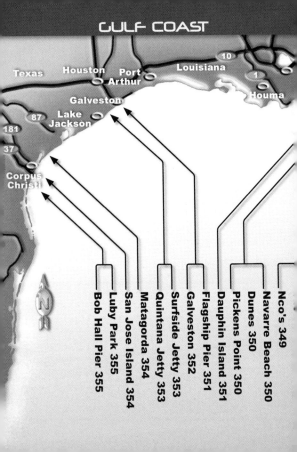

GULF COAST

Texas Houston Port Arthur Louisiana 10

Galveston Houma 1

Lake Jackson

87

181

37

Corpus Christi

Bob Hall Pier 355

Luby Park 355

San Jose Island 354

Matagorda 354

Quintana Jetty 353

Surfside Jetty 353

Galveston 352

Flagship Pier 351

Dauphin Island 351

Pickens Point 350

Dunes 350

Navarre Beach 350

Nco's 349

GULF COAST

Mississippi

ns

e

Pensacola

Panama City 10
319 **Jacksonville**

95

75

Apalachicola

92

Clearwater

St Petersburgh

Venice

Cape Coral

75

Key West

Naples Pier 344

Englewood 344

Fishing Pier 345

Venice Jetties 345

Whitney Beach 345

Bradenton Piers 345

Holmes Beach 346

Anna Maria Island 346

Upham Beach 346

Chateau 346

Indian Rocks 347

Shell Island 347

St Andrews Inlet 347

Cement Pier 348

Crystal Beach 348

NAPLES PIER

From Miami, take Hwy 41 to Naples. Take 5th Av W to Gulf Shore Blvd then 12th Av S.

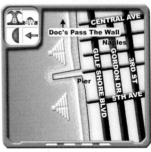

The most S break in the Gulf. Pretty consistent L&Rs over sandbars either side of the pier. S works best when the bigger cold fronts come through, otherwise heading north. Offers better quality. Watch out for the pilings and the big crowds when it's on. Meter parking. If winds are N, try **Docs Pass Jetty** or **The Wall** at Vanderbilt.

ENGLEWOOD

From Venice, head S on 775 to Englewood. Take 776 to Beach Rd, then N to the pier.

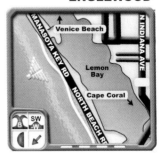

Plenty of small A-frame beach-breaks, breaking on sandbars. Should be able to find a wave to yourself. Very relaxed scene – good spot to avoid the crowds in Venice. Watch out for the odd big fish. All standards.

VENICE JETTIES

Hwy 41 from St Pete S. In Venice, go R on Venice Rd to the beach. N on Tarpon Center Dr to S Jetty Pk.

South Jetty is a relative swell magnet – not as big as the north jetty but a NW swell produces steep Ls and flatter Rs over a sand bottom. N is best on hurricane SW swells so look out for big winter lows. It holds the biggest swells and attracts the biggest

crowds (not just human). Check S for the **Fishing Pier**.

BRADENTON PIERS

Hwy 41 S from Tampa to Bradenton, then Cortez Rd W to the beach. Turn L for the piers.

Great feel in Bradenton – head for the beach around the 2 piers (there's 3!) off Gulf Dr for good little beachies on sand bottom in winter NW or summer Southerly swells. Head S for smaller but similar at **Whitney Beach** or to **Siesta, Turtles** or **Lido Beach** if it's too crowded.

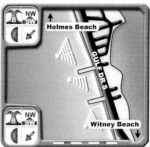

ANNA MARIA ISLAND

Hwy 41 S from Tampa to Manatee Road that ends at the Pier. N on Nth Shore Dr to Anna Marie.

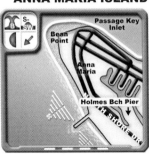

Hit the pier on SW ground-swell in hurricane season. Quite powerful little beach-breaks on sand. Gets crowded too. Holmes Beach gets good too, to the south. It has another pier setup that is similar to here, taking SW swells and delivering lefts and rights to 5 feet.

UPHAM BEACH PARK & CHATEAU

Both are in St Pete. Upham is S on Gulf Blvd to Corey, then 68th St. Chateau is at Sunset Beach on Treasure Island.

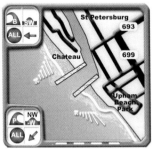

Upham offers a really good R point set-up in NW swells. It's a peeling clean 100m long longboard wave at its best. At **Chateau** there's a nice L on the outside bars and a punchy beach-break inside in summer SW swells. Up the beach is a L off the pier. Pretty mellow atmosphere.

INDIAN ROCKS BEACH

From Chateau, head N on Gulf Blvd or take the 688 from Tampa straight to the jetty.

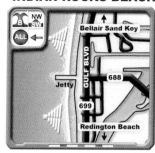

Average beach-breaks on shifting sandbars up and down the beach – some will pack a punch. The rule is go N of Central in N swells and S in S swells. Waves for all standards. Head S for **Redington Breakwater** (small but fun) or N for **Bellair** or **Sand Key** in more N swells.

SHELL ISLAND/ST ANDREWS INLET

From Panama City, go over the bridge and L on Thomas Dr into St Andrews State Pk. Take a boat to the jetty at Shell Island.

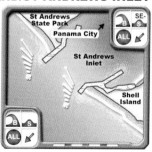

The Park is home to a grinding barrelling L, very close to the jetty breaking on a sand bottom. There's also a L&R near the beach which can pack a punch. Next stop is **Amazons (The Pass)** - a powerful, classy barrelling L point break inside the inlet at the E jetty in E-SE swells which can hold up to 10ft. Very crowded always. If you go to the E side of the jetty you'll find a hollow, heavy L&R A-frame peak too. Probably the premier spot in these parts. Advanced to expert standard.

CEMENT PIER

From Hwy 231 in Panama City, head W to PCB on Front Beach Rd. Look for the 2 piers and park up in the lot.

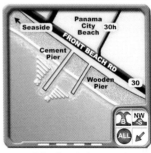

A fickle outside break and peaky A-frame inside are found at the pier over sand bottom. Either side of the pier breaks dependent on whether it's a W or E swell. Try the wooden jetty for a less challenging option with fewer crowds in S-E swells. Head W out of town to **Inlet Beach** for a good, quiet pier option or further on to **Bud's** at Seaside for small beachies at this expensive resort.

CRYSTAL BEACH PIER

East from Destin. Next is **Crystal Beach Pier** (not much of a pier anymore), a good peaky inside break on sand bottom. Likes a southeast swell, the bigger the better, and north to northeast winds are offshore. It gets the usual crowds when on but isn't the worst place. Further east, if there's swell, head to more remote beaches like **Blue Mountain,** down the cliffs for a nice outside peak.

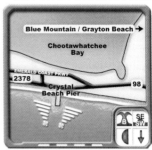

Alternatively, **Grayton** hosts a small but clean sandbar break at the lake entrance. It needs rare bigger swells to be worth the trip, but has reeling shape on solid SE swell and NE winds.

THE POINT & HMO'S

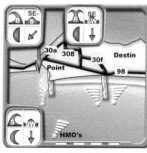

From Panama City, head west on Hwy 98 to Destin and take the 293 to Holiday Isle and the beach.

A wide variety of options in the beach area, Holiday Isle, just S of Destin. At the inlet entrance, there are consistent spots like **The Point** - a very fickle jetty L with quite a hike to get there and good beach & jetty peaks. Further out is the big wave R called **HMOs** (Half Mile Out!!).

Expert only spot with dangerous currents and big fish.

NCO'S

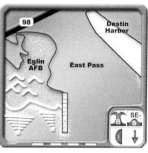

From Holiday Isle, head west across the bridge past the AFB on Hwy 98. Turn L into NCO Club parking lot.

Year round consistent spot from the West Jetty through to the beach club, best in S-E swells. In best conditions, hollow A-frame peaks breaking fast on sand bottom are more consistent in the middle of the beach. Just outside the club it's normally a bit fatter. All standards. Does get crowded.

NAVARRE BEACH & PIER

Beach Road 399 E from Pensacola or Hwy 98 W from Fort Walton for 30 mins. Cross the bridge. Park in the lot at the end.

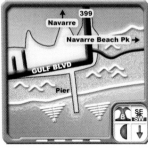

A consistent, quality pier set up, breaking on both sides over sand bottom – the old pier was destroyed in a storm and a new one built to make the spot even better then before. Can hold 10ft plus on the outside sandbars in big E-SE swells. Mellow and uncrowded, just beware the old pier pilings. Check out the Beach Park for lone peaks to yourself.

PICKENS POINT & DUNES

From Pensacola Beach, head W for 20 mins through the dunes of the Park. Walk 10 mins E to the Fort.

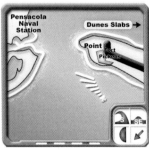

Quality but fickle sandbar break (the bars can get trashed by the hurricanes that come through). Long-walling L that hollows out as it wraps into the inlet. Solid 6ft SE-E swell to work. If you get it at 10ft & clean, it's rumored to be world class. If…Try the **Dunes,** or other options include E for **Pensacola Pier** or 400m on for the consistent beach-break, **Slabs** (crowds). Go W for **Johnsons Beach.**

DAUPHIN ISLAND

Not exactly easy to get to. Head S from Mobile across to the Island or try SE round the bay to Orange Beach.

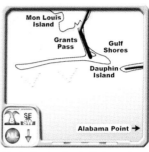

Very fickle but you may score something if its spring / solid ground-swell. There's a mushy L&R at **Stumps** in the east or a bit better at **Serigny St**. **West End** can work to 2-3ft in SE ground-swells. Rumor has it the point at **Sand Island** goes off. Probably the best option in Alabama is on the mainland at **Alabama Point** at Orange Beach, which can handle 6ft, most likely in bigger SE winter swells. That's it.

FLAGSHIP PIER

From Houston, take Hwy 45 to Galveston. Follow Broadway Av then R on 25th St to Seawall Blvd and the pier.

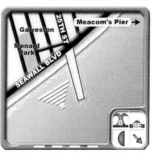

In the right conditions, a Long R and good peaky Ls off the T-Head breaking on sand bottom. Really needs big SE or E swells to get good. There's a good paddle-out channel next to the pier – watch the locals. Does attract the crowds. If you happen to be on the east side, head to **Meacom's Pier** for the best wave options on that side.

GALVESTON 37TH STREET

Follow the same Galveston directions from Hwy 45 to Seawall Blvd. Turn R on the Blvd to 37th St.

In the right conditions, a reasonable peaky L breaks over sandy bottom here at the jetties. Can be quite ledgy in the bigger S – SE swells but watch out for the side currents. Offshore in N-NW winds. Head further W along the Blvd to the **San Luis Hotel** for other beach-break options.

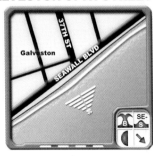

GALVESTON 61ST STREET

From Houston, take Hwy 45 to Galveston. Follow Broadway Av then R on 61st St to the Seawall.

Two options here – outside the pier there's a reasonable L&R over sandy bottom in biggest S – SE swells. There is also an inside break off the jetty which is a more powerful bowling wave. In big swells the side currents can be a problem, but the jetty protects the break from this.

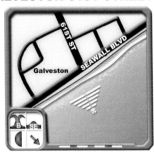

SURFSIDE & QUINTANA JETTIES

From Houston, head S on 288 or 227 to Lake Jackson. S of Lake Jackson, take the 332 to Surfside, turn R and head for the pier on the N side of Freeport Channel. Turn R off the 332 before Surfside for Quintana.

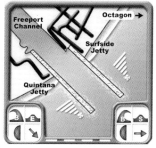

The most consistent swells in this part of Texas. **Surfside Jetty** is a long pier which provides protection from S winds for Surfside beaches. There's a beast of a paddle-out to get to the end, where in strong NE - E winds and a S swell, you'll find steep jacking waves break on sandbars – the locals say it can hold 8ft plus. Look for the channel between the jetties to make the paddle easier (Locals jump from the jetty to avoid the paddle). Always crowded.

Head up the beach for about a half-mile to reasonable beach-break spots such as **Octagon** (named after a building which isn't there anymore!), **Texas Street** or go further N for **Boilers.**

On the S side of the channel is **Quintana Jetty** that provides protection from NE and E winds. Here you'll find less consistent jetty breaks over sand bottom – best in E swells which wrap around the jetty. All standards. In the biggest spring / summer E swells there's talk of a 10ft plus big wave breaking in the shipping channel for up to 400m. Expert break only.

MATAGORDA

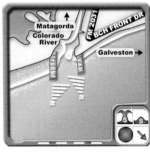

From Houston, head to Lake Jackson, then take the 35 to Bay City. Head S on the 60, then follow 2031 to Colorado Rivermouth.

Good quality L&R break on the sandbars in the deep-water Rivermouth. 6ft plus in big hurricane swells. The pier on the N side holds the sandbanks together and produces quite powerful barrelling waves. Light NW – W winds groom the swell nicely. Heavier winds make for big currents. Experienced surfers wave.

SAN JOSE ISLAND

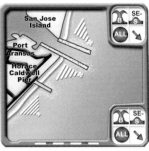

From San Antonio, head S on Hwy 37 to Corpus Christi. Follow the road to Port Aransas then head to the jetty. Take Beach St for Horace Caldwell. Take the ferry to San Jose Island from the port.

Aransas Pass Jetties turn on inconsistent L&Rs on sand bottom in stronger NE swells. Tend to be mushy and can get crowded during holiday periods. Just to the S, in the park, is **Horace Caldwell Pier,** for a short, peaky pier beach-break in similar conditions. Both breaks are for all surfing standards.

BOB HALL PIER & LUBY PARK

From San Antonio, head S on Hwy 37 to Corpus Christi. Take the 358 to the S of the City, then Encantada Av to the park.

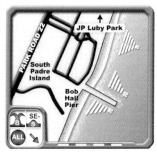

JP Luby has the remains of an old pier that produces peaky L&Rs breaking on sand bottom in stronger SE-E swells and W winds. Gets very crowded during holiday periods. Watch out for currents and rips. **Bob Hall Pier** is just S and probably offers the most consistent quality break in the area. Heavy crowds and big fish. Other options – N are the jetties at **Fish Pass,** or S is **Big Shell**. For the most southerly options, heads S to **South Padre Island** where you'll find consistent and powerful surf in big E–SE swells at spots such as **Mansfield South Jetty, Steamers, The Jetty** and the **Old Pavilion.**

The real deal is at **San Jose Island,** where, in strong SE–E swells and an offshore NW wind, you may find a really good quality L&R break on sand bottom at the N Jetty. Watch out for the currents and the surprising power this spot can produce. Experienced surfers break. Even though you need a boat or take the ferry, still gets crowded when its on.

FLORIDA

Atlantic Beach - D Sea International, 52 West 3rd St, 904-247-0808
Boca Raton - Boca Surf & Sail, 3501 North Federal Hwy, 561-394-8818
Bradenton - Village Surf Shop, 2820 34th Ave Drive East, 941-346-7873
Brandon - Cove Skate & Surf, 1303 Kingsway Rd, 813-689-8143
Captiva - Yolo Watersports, 11534 Andy Rosse Lane, 239-472-0004
Clearwater Beach - Mandalay Surf Co, 499 Mandalay Ave, 727-443-3884
Cocoa Beach - Ocean Sports World, 3220 S Atlantic Ave, 321-783-4088
Ron Jon Surf Shop, 3850 South Banana River Blvd, 321 799 8888
Quiet Flight Surfboards, 109 N Orlando Ave, 321 783 1530
Natural Art, 2370 S Atlantic, 321 783 0764
DG Beachwave, 1275 N Atlantic Ave, 321 783 1848.Also 5490 N Atlantic Ave
Lightwave Surfboards, 82 S Orlando Ave, 321 799 9822
Daytona Beach - Mad Dog Surf Shop, 3634 S Atlantic Ave, 386-761-5999
Maui Nix Surf Shop, 635 North Atlantic Ave, 904-253-1234
Pure Atlantic Surf & Skate Shop I, 2540 South Atlantic Ave, 386-322-1144
Pure Atlantic Surf & Skate Shop II, 2739 North Atlantic Ave, 386-677-6388
Salty Dog Surf Shop, 700 East International Speedway, 386-258-0457
Sandy Point, 3109 South Ridgewood Ave, 904-756-7564
Upfront Surfboards & Surfwear, 2750 South Ridgewood Ave, 386-756-5700
Deerfield Beach - Island Water Sports, 1985 NE 2nd St, 954-427-4929
Delray Beach Epic Surf & Swim, 1122 East Atlantic Ave, 561-272-2052
Nomad Surf & Sport, 4655 North Ocean Blvd, 561-272-2882
Eastpoint - Ricks Surf Shop, 49 West Pine Ave, 850-927-4141
Edgewater - C B Surfboards, 2050 West Park Ave, 386-423-9283
Orion Surfboards, 2036 Guava Drive, 386-423-0609
Richenberg Surfboards, 424 West Park Ave, 386-428-8556
Surf Hut, 139 East Gorrie Drive 850-927-4600
West Wind Surf Designs, 2050 West Park Ave, 386-428-1814
Fernandina Beach - Pipeline Surf Shop, 2022 1st Ave, 904-277-3717
Flagler Beach - Z Wave Surf Shop, 400 South Hwy A1A, 386-439-9283
Fort Lauderdale - B C Surf & Sport, 1495 North Federal Hwy, 954-564-0202
Ron Jons Surf Shop, 2610 Sawgrass Mills Circle, 954-846-1880
Surf Syndicate, 4828 N Federal Hwy, 954 489 1335
Surf This, 112 Commercial Blvd, Lauderdale 954 491 7172
Fort Myers - Jetset Surf Shop, 5780 Harborage Drive, 239-489-4321
West Coast Surf Shop, 1035 Estero Blvd, 239-463-1989
Fort Pierce - Spunky's Surf Shop, 602 North US Hwy 1, 772-466-7048
Fort Walton Beach - Fluid Surf Shop, 112 Elgin Parkway SE, 850-244-3554
Innerlight Surf & Sport, 246 Miracle Strip Parkway S, 850-244-2223 / 2469
Islander's Surf & Sport, 191 Miracle Strip Parkway South, 850-244-0451
Gainesville - Freeride Surf & Sport, 420 Northwest 13th St, 352-373-7873

SURF SUPPLIES

Gulf Breeze - Bucks Surf & Sport, 45 Via De Luna Dr, 850-932-2290/6442
Innerlight Surf & Skate, 8711 Navarre Parkway, 850-936-4842
Innerlight Surf & Skate, 203 Gulf Breeze Parkway, 850-932-5134
Islander's Surf & Sport, 400 Quietwater Beach Rd, 850-916-7565
Hutchinson Isl - Sunrise Surf, 561 229 1722
Indialantic - Longboard House, 101 5th Ave, 321-951-8001
SurfStyle, 101 Mirmar Ave, 321 726 9966
M T B Surf Emporium, 2334 North Hwy A1A, 321-777-3685
Shaggs Surf & Sport, 2 Wavecrest Ave, 321-727-8400
Indian Rocks Beach - Island Surf Shop, 435 Gulf Blvd, 727-596-2244
Jacksonville - Big Ocean Surf, 12041 Beach Blvd, 904-646-0615
Clean Ocean Surfboards, 11215 Saint Johns, 904-642-5088
Core Surf & T's, 10300 Southside Blvd, 904-363-3834
Outer Limitz SK8 & Surf, Regency Square Mall, 904-805-0044
Outer Limitz SK8 & Surf, 11018 Saint Augustine Rd, 904-260-2320
Quiksilver Boardriders Club, 10300 Southside Blvd, 904-363-8898
Sunrise Surf Shop, 834 Beach Blvd, 904-241-0822
Surf and Skate Surf Shop, 239 1st St North, 904-241-5088
Waves Surf Shop, 1712 3rd St North, 904-247-6830
Wishnant Surfboards, 48 Penman Rd South, 904-246-6120
Jensen Beach - Island Water Sports, 3291 NE Indian Rvr Dr, 772-334-1999
Sunrise Surf Shop, 11013 South Ocean Drive, 561-229-1722
Jupiter - Juno Surf Shop, 602 North US Hwy 1, 561-575-6649
Ocean Magic Surf & Sport, 103 South US Hwy 1, 561-744-8805 / 8925
Seafari Dive and Surf, 75 East Indiantown Rd, 561-747-6115
Key West - Shirley Cant Surf, 624 Duval St, 305-292-1009
Lake Mary - Beach Scene, 3681 Lake Emma Rd, 407-333-0865
Lake Worth - Fox Surf Shop, 5 Ocean Blvd, 561-582-3806
Island Water Sports, 728 Lake Ave, 561-588-1728
Lantana - Tommy's Surf Slalom & Guitar, 308 E Ocean Ave, 561-586-0073
Madeira Beach - Mad Beach Surf Shop, 13107 Gulf Blvd
Marco Island - Jetset Surf Shop, 674 Bald Eagle Drive, 239-394-5544
Salt Water Insanity, Mission Plaza, 239-389-9222
Melbourne - 24-7 Surf, 7777 North Wickham Rd, 321-751-6300
24-7 Surf, 1700 West New Haven Ave, 321-984-3984
G A K Surf, 450 Stan Drive, 321-676-5008
Kechele's Matt Surfboards, 2840 Allen Hill Ave, 321-259-5443
Rainbow Surfboards, 2840 Allen Hill Ave, 321-757-0922
Miami - B C Surf & Sport, 11401 Northwest 12th St, 305-715-9912
Bird Surf Shops, 250 Sunny Isles Blvd, 305-940-0929
Island Water Sports, 16231 Biscayne Blvd, 305-944-0104
Impact Zone, 401 Biscayne Boulevard, 305-374-6528

FLORIDA & GULF

Naples - Board Room Surf Shop, 4910 Tamiami Trail N, 239-649-4484
Bondi Surf Shop, 1200 5th Ave South, 239-263-4375
Hurricane Beach & Surf, 2055 Tamiami Trail North, 239-403-7910
Olde Naples Surf Shop, 1311 3rd St South, 941-262-1877
Neptune Beach - Aqua East Surf Shop, 696 Atlantic Blvd, 904-246-2550
Secret Spot Surf Shop, 115 1st St, 904-270-0526
New Smyrna Beach - Inlet Charley's Surf, 510 Flagler Ave, 386-423-2317
Nichols Surf Shop, 411 Flagler Ave
Quiet Flight Surf Shop, 508 Flagler Ave, 904 427 1917
Red Dog Surf Shop, 801 Hwy A1A, 386-423-8532
Orange Park - Board City, 410 Blanding Blvd, 904-272-6996
Core Surf & T's, Orange Park Mall, 904-269-7167
Momentum Surfboards, 2175 Kingsley Ave, 904-537-9697
Orlando - Performance Ski & Surf, 8086 S Orange Blossom, 407-859-7544
University Surf & Skate, 7536 West Sand Lake Rd, 407-248-6522
University Surf & Sport, 12299 University Blvd, 407-380-7427
Quiet Flight, Universal Studios Citywalk
Ormond Beach - Aloha Ocean Sports, 394 S Atlantic Ave, 386-673-4280
Palm Beach - Ground Swell Surf, 811 Donald Ross Drive, 561-622-7878
Juno Surf Shop, 13205 US Hwy 1, 561-626-3569
Lazydaze Surf & Skate, 12189 US Hwy 1, 561-625-9283
Panama City Beach - Blue Room Surf, 610 Thomas Dr, 850-235-0401
Mr Surf's Surf Shop, 7220 Thomas Drive, 850-235-2702
New Wave Surf Shop, 2196 North Cove Blvd, 850-747-0696
Open Seas Surfboards, 7610 McElvey Rd, 850-230-9451
Salty Dog Surf Shop, 11930 Front Beach Rd, 850-230-3430
Sunjammers, 17644 Front Beach Rd, 850-235-2281
Trader Ricks Surf Shop, 12208 Front Beach Rd, 850-235-3243
Pensacola - Innerlight Surf & Skate, 1020 North 9th Ave, 850-434-6743
Pompano Beach - B C Surf & Sport, 2868 N University Dr, 954-345-7528
Miami Blues, 3400 E Atlantic Blvd, 954 781 3501
Point Saint Lucie - Blue Planet Dive & Surf, 1317 Northwest Saint Lucie
West Blvd, 772-871-9122
Ponte Vedra Beach - Island Style Custom Builders, 904 Ponte Vedra Blvd,
904-285-6488
Ponte Vedra Water Sports, 880 A1A North, 904-285-1676 / 6271
Salty Dolls, 240 Sawgrass Village Drive, 904-285-4311
Saint Augustine - The Surf Station, 1020 Anastasia Blvd, 904-471-9463
Sanibel - Sanibel Surf Shop, 1700 Periwinkle Way, 239-472-8185
Tahitian Surf Shop, 2015 Periwinkle Way, 239-472-3431
Westwind Surf Shop, 2075 Periwinkle way, 239-472-3490
Satellite Beach - Balsa Bill Surf Shop, 1773 Hwy A1A, 321-779-8580

SURF SUPPLIES

Bat Surfboards USA, 131 Tomahawk Drive, 321-779-3996
Ocean Ave Surfboards, 1365 South Patrick Drive, 321-777-9494
RC's Board Shop, 252 Hwy A1A, 321-773-1800
Stuart - Aqua Kulture Surf Shop, 2462 Southeast Federal Hwy, 772-287-3378
Surf Central, 1830 Southeast Federal Hwy, 772-283-9002
Titusville - Playalinda Surf Shop, 327 South Washington Ave, 321-383-1633
Treasure Island - Suncoast Surf Shop, 9841 Gulf Blvd, 727-367-2483
Venice - V-Town Surf & Skate, 101 West Venice Ave, 941-488-3896
Vero Beach - Inner Rhythm Surf & Sport, 2001 14th Ave, 772-778-9038
Beach Surf Shop, 1025 Easter Lily Lane, #7, 772 231 5390
West Palm Beach - 365 Surf Five Surf, 10225 Southern Blvd, 561-790-6445
Epic Surf & Swim, 13873 Wellington Trace, 561-795-5470
Island Water Sports, 2501 North Ocean Drive, 561-844-6983
Miller Surfboards, 6215 Georgia Ave, 561-547-1424
Mr's Surf & Skate, 319 Belvedere Rd, 561-651-7700
Sun Sports, 1736 South Congress Ave, 561-641-1144
Winter Park - Blue Surf Shop, 130 East State Route 436, 407-331-3323

TEXAS
Freeport - Breaker Sports, 979-233-8308
Good Vibrations Surf Shop, 2211 East Hwy 332, 979-230-9000
Galveston - Beach-break, 2402 Ave Q, 409-762-8740
Surf Specialities, 4116 Seawall Blvd, 409-763-1559
Surf Styles, 2410 Strand Street, 409-763-0147
Underground Surf Depot, 4700 Seawall Blvd, 409-765-1463
Houston - Maxwell Surfboards, 11729 South Garden St, 713-774-2990
Shannons Street Waves, 17776 State Hwy 249, 281-890-5392
Source Board Shop, 510 Iowa South, 713-946-0414
Surfhouse, 1729 West 34th St, 713-686-3300
Los Fesnos - Blue Liquid, Hwy 100, 956-233-5340
Pasadena - Fry Surfboard, 609 Jackson Ave, 713-473-7888
Port Arsansas - Pat Magee's, 124 West Ave G, 361-749-4177
Pier House, 230 North On The Beach, 361-749-2031
Webster - Adrenaline Sports, 1185 West Nasa Rd 1, 281-557-8897
Fox Den, 540 El Dorado Blvd, 281-486-4848

ALABAMA & MISSISSIPPI
Gulf Shores - Island Recreational Serv, 360 East Beach Blvd, 251-948-7334
Bay Saint Louis - Da, 604 South Beach Blvd, 228-467-1108

Carribbean Clarity. Bernie Baker

PI: PUERTO RICO

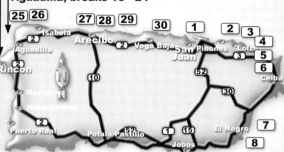

Rincon Area, breaks 9-15
Aguadilla, breaks 16 - 24

Background

The Caribbean island that Florida calls it's own. Year round temperatures between 68 and 88 degrees, with water temperatures bottoming out at 75 in winter. It's well on the way to becoming a surfer's paradise lost, but some careful conversations in local surf shops, and wise expedition strategies, will still yield uncrowded perfection.

The island is fringed by coral, creating many world class reef breaks. Many of these are on the west coast, in and around Rincon and Aguadillo where prevailing northeasterly trade winds blow off-shore all year round. This west coast varies in consistency, depending on it's exposure to the north. It holds most of the primo spots like Gas Chambers, but these only fire up a few times a year. The north coast, however, is consistent year-round although it is best surfed early morning before trade-winds arrive to ruin most spots. Most of the east coast is blocked by fringe islands, so is very dependent on narrow swell windows. The south coast may get some rare summer / fall hurricane action, but is rarely worth a look.

When to go

Winter swell is the most consistent, coming from the northwest to northeast, and starting in November. It's also drier here in winter, with trade-winds more consistent outside the unsettled summer season. Humongous straight north swells pile in from November through February, then tail off slowly till April. **Summer** is humid and flat. Northern shores benefit from wind swells and opportunistic mid-latitude storm pulses, while south coasts get rare hurricane swell.

Hazards

Urchins abound on most reefs. Look for cracks when walking out. If you get a spine in your foot, scream a lot and squeeze fresh lime juice to help dissolve it. There are a few sharky spots by ports and Rivermouths. As everywhere in the Caribbean, some coral heads are sharp and hard, and some sting or infect - see a doc if you get cut. Be nice to locals and learn a few key Spanish phrases out of basic respect.

SAN JUAN AND FAJARDO AREA

La Perla
From San Juan, head north through La Perla, to El Moro off the tip of the point. A-frame reef-break on dead coral heads. Works on winter N swells, any tide, best early as trade-winds destroy it. 3-8ft. Consistent. Urchins. Intermediate plus. Medium crowds.

Islita 🖐
Head east from San Juan on Calle Delta (Hwy 26) to Carolina, opposite the Empress Hotel in Isla Verde. Rights and lefts over an A-frame reef. Very shallow at low tide. Likes winter N or NE swells and early morning before the wind gets up. Light northerly trade-winds OK. 3-10ft plus. Consistent. Advanced. Medium crowd.

Chatarra
Head from Pinones to Loiza. Beach just before village on left. Long hollow tube lefts but must be caught before trade-winds rip it up. Winter swell, any tide. Rights too. 3-8ft plus. Inconsistent. All levels. Crowds.

Aviones 🖐
West side of Luquillo towards Loiza. Well known, crowded, excellent R L reef break. High tide and rare southwest winds best. Super hollow but must be caught early a.m. Consistent. 3-6ft. Crowds. Intermediate plus.

El Faro
Trek to the lighthouse in Fajardo. A mission to get there, but therefore uncrowded. Right and Left reef in north to east swells. Low tide is super-hollow. Northerly winds best. 3-6ft plus. Advanced.

Indo Lefts
In Fajardo. South of the swimming pools. Fast, hollow left-hander in winter N to NE swells and southerly winds. Gets blown out by afternoon in the trade-winds. Fickle. 2-8ft. Intermediate plus. South from here are a range of inconsistent, urchin infested reef breaks at **Yabucoa** and **Maunabo.** Both need solid east or huge northeast swells to wrap in, or rare south storm swells.

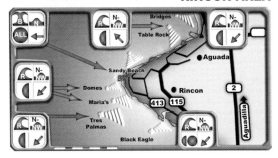

Black Eagle 🅿
By the Black Eagle restaurant on the south side of Rincon. Fickle, shapely right reef-break on solid north swells and trade winds from the east. Mid to high tide. 3-6ft. Intermediate.

Tres Palmas ⭐ ❗ 🅿
Opposite the Black Eagle restaurant at Rincon. Awesome right-hand reef break reeling for long distance over some off-shore coral formations. Works in solid to big winter north - northeast swells, from 3-10 feet plus, has been seen at 20. NE winds. Quite fickle. Fire coral and rocks. Advanced. Inside and to the north is **Dogman's**, a rare goofy-foot option that shares a channel with Maria's.

Maria's 🅿
Just north and in-shore of Tres Palmas. Coral right-hander, very lined up but fun. All tides. N - NE swell. NE winds. 2-8ft. Medium Consistent. All levels. Crowds.

Domes 🅿
South of the Pools Beach breakwater. Consistent right-hand reef break with some peakier lefts. Any tide. North swells, east winds. Intermediate plus. 3-8ft plus. Crowds on weekends.

Sandy Beach

Beach-break with patches of reef. All levels. 2-6ft. Semi consistent. N swell E wind. Medium crowds.

Table Rock

North of Franks. Fast, jacking right-hand reef break with boils and close-out sections. North swells, east winds. 3-6ft plus. Advanced. Outside Tables is **Frank's**, a consistent option when tables is crowded or too small. Works on same swells and wind direction. **Schoolyards,** just north in Aguadilla town is a right-hand reef break best at mid to high tide, NW swell, east winds. Fickle. Fast, hollow. 3-6ft. Advanced.

AGUADILLA AREA

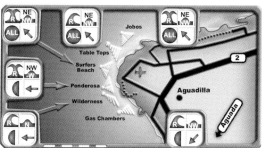

Bridges P

Yet another reef right. Inconsistent and crowded, but quality. Some lefts off the peak too. 3-6ft. All levels. Nearby **Hole in the Wall** is a fun spot.

Gas Chambers ⭐ 🅿️
Hollow, fast, barrelling right-hand coral reef. Likes a solid N to NW swell and easterly trade-winds. Any tide, but entry and exit are scarey. 3-10ft. Very inconsistent. Advanced plus.

Wishing Well
Hollow coral reef break that gets very shallow. Hazardous reef and urchins, low tide= advanced only. Inconsistent. 3-6ft.

Pressure Point
Shallow coral reef break. Rights mainly, and some lefts. North swell east wind.

Wilderness 🅿️
Lined up right-hand reef break in solid north swells and easterly winds. Sucks like mad at low tide, There's a peaky, often closed out left. 2-8ft. Inconsistent. Experts.

Ponderosa 🅿️
Right left reef setup. Very peaky in a north swell, but lined up lefts in a NW-W swell.

Surfers Beach
Reef and sand setup. Likes north swells and early morning calm or rare southeast winds. 2-6ft. Consistent. All levels.

Table Tops ❗
Between Aguada and Aguadillo, off Surfers Beach. Powerful, jacking reef break, primarily rights from 3 to 10 feet. North swell, east winds. Consistent in winter. Expert.

Jobos 🌀
Right left reef break, shallow and fast. Northeast to northwest swells, southerly winds. 2-8ft. Consistent. Advanced.

ISABELLA TO DORADO

Las Dunas
Head west from Isabella. Rights and lefts on dead coral reef. Consistent in winter swells NE through NW, but messy in strong trade-winds: likes southeast winds. 3-6ft plus. Intermediate plus.

Porto Hermieto
Right and left patchy sand / reef-break in any north swell and south winds/early morning glass. Any tide. All levels. 2-8ft plus.

Los Tubos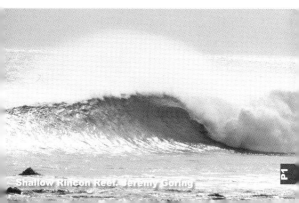
Manati. Reef break rights and lefts, with great lefts in NW swell. Hollow, fast, with urchins galore. 3-8ft. Consistent in winter. Advanced. Check the nearby reef break **Palmas**.

Pupuland
Off the beach road in Dorado. Right left reef with re-forms on the inside, in northwest to northeast swells and south winds. Low tide best. Consistent in winter. 2-10ft. Advanced. Crowded as in town. **El Puerto** in the fishing port is also a good bet, as is **Kikitas**.

Shallow Rincon Reef. Jeremy Goring

P1

BREAK INDEX

In search of the BIGGEST WAVE

featuring ACE COOL
the Evel Knievel of surfing

EDDIE WOULD TOW.

www.acecool.net

SURF FORECASTING SITES

Hawaii
www.northshorenews.com
www.stormsurf.com

Southern California
www.wetsand.com/wavecast

Northern California
www.surfpulse.com

Oregon
www.oregonsurfpage.com

Washington
www.buoyweather.com

Northeast
www.nesurf.com

New York
www.newyorksurf.com

Southeast & FLA Coast
www.stormsurf.com

Fla Gulf Coast
www.specsci.com/outside/smap.html

Texas Gulf Coast
www.thirdcoastsurf.com

Puerto Rico
www.buoyweather.com/swell4cast.jsp

CONVERSIONS AND INFO

Temperature

To convert °C to °F
Multiply by 1.8 and add 32

To convert °F to °C
Subtract 32 and divide by 1.8

Distances	Multiply by
inches to cm	2.54
cm to inches	0.39
feet to meters	0.30
meters to feet	3.28
yards to meters	0.9
meters to yards	1.1
miles to kilometres	1.6
kilometres to miles	0.6

Finding Wave-finder

Wave-finder USA - Hawaii, and Wave-finder Australia are available at all decent surf shops, and surf-friendly bookstores. For details of your nearest stockist, email info@hedonistsurf.com.

We welcome any comments, corrections or questions, and these can be emailed to the same address.

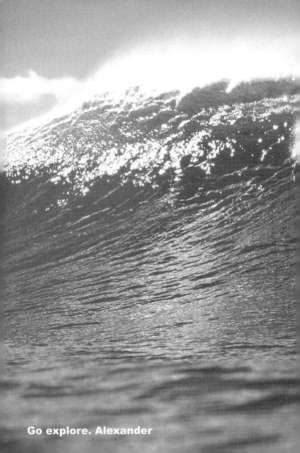

Go explore. Alexander

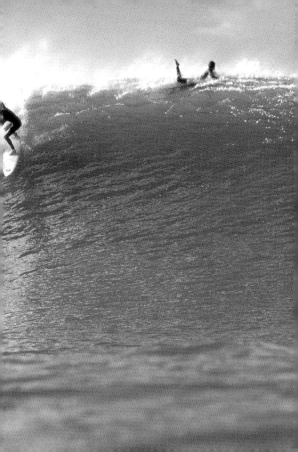

wave-finder.com

evolved surf guides & forecasts